OPTICALMAGIC

More than 300 Optical Illusions

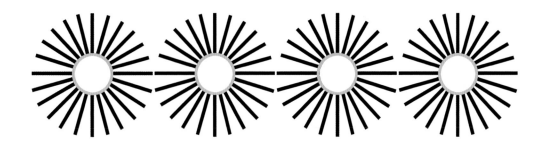

Robert K. Ausbourne

STERLING
New York

STERLING
New York

An Imprint of Sterling Publishing
387 Park Avenue South
New York, NY 10016

ISBN 978-1-4549-1425-9

Distributed in Canada by Sterling Publishing
⅗ Canadian Manda Group, 165 Dufferin Street
Toronto, Ontario, Canada M6K 3H6
Distributed in the United Kingdom by GMC Distribution Services
Castle Place, 166 High Street, Lewes, East Sussex, England BN7 1XU
Distributed in Australia by Capricorn Link (Australia) Pty. Ltd.
P.O. Box 704, Windsor, NSW 2756, Australia

For information about custom editions, special sales, and premium and corporate purchases,
please contact Sterling Special Sales at 800-805-5489 or specialsales@sterlingpublishing.com.

Manufactured in China

2 4 6 8 10 9 7 5 3 1

www.sterlingpublishing.com

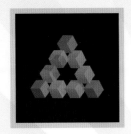
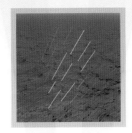
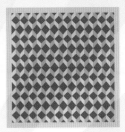

CONTENTS

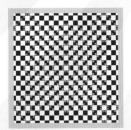

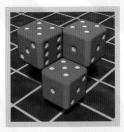

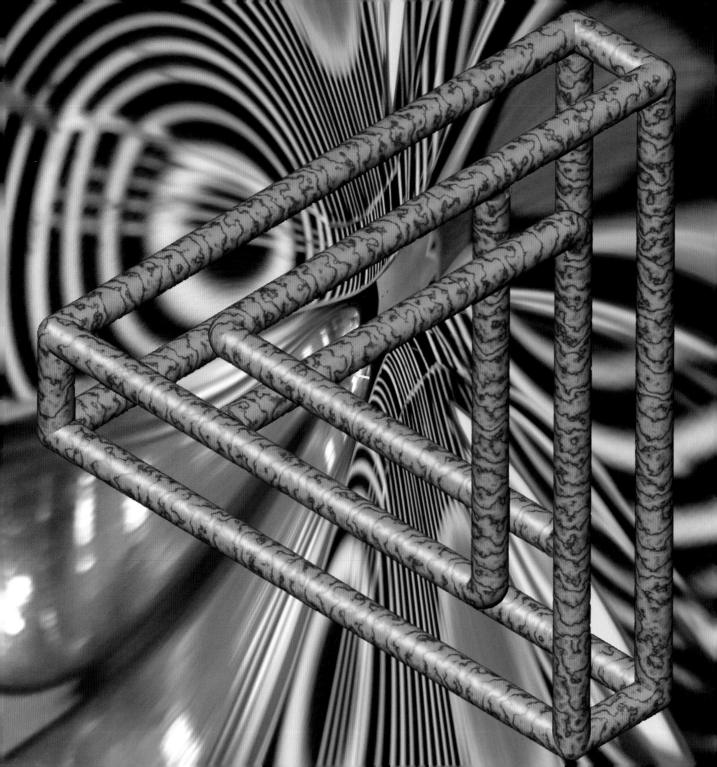

INTRODUCTION

Everything we see is an illusion. We are bombarded by a constant storm of them every day as we move about in a 3-D world. The amount of calculations the brain performs every second of every day in order to map 3-D space is staggering. And that's not all our brains do; they also take into account lightness and darkness, color, distance, shape, texture, and size. If we had to perform these calculations on a conscious level, we would freeze in place from data overload, and it would take us forever to find our way to the other side of a room. Hence, the brain's visual system has become a master in the art of assumption, using mental shortcuts to process visual scenes based on prior knowledge of reality.

Optical illusions are contrived to cajole our brains into returning tiny visual errors based on erroneous assumptions. The more we learn about how the brain works, the easier it becomes to target obvious assumptions that the brain makes, time and again, and then construct working illusions like the examples in this volume. I have loved optical illusions all my life. Collecting them has been a passion, figuring them out is sometimes a challenge, and sharing them is icing on the cake. Drawing illusions can be difficult. If an illusion is meant to fade out, or disappear, or exhibit illusory movement, it will—while the artist is working on it. I can tell you that drawing illusions is often like trying to paint a leaf while it's falling.

This vibrant compilation of more than 300 optical illusions presents an astounding array of visual trickery. Entertaining turn-of-the-century illusions and anamorphic messages appear alongside impossible 3-D objects and ambiguous figures. Other colorful examples enable the perception of afterimages and illusory movement. Optical illusions help us to understand reality. They serve to sharpen our focus and to firmly map our place within the colors and dimensions of everyday life. Just as we measure the quality of goodness against a villain in a favorite movie, we can measure the character of reality against the quirkiness of optical illusions.

CLASSIC & HISTORICAL
ILLUSIONS

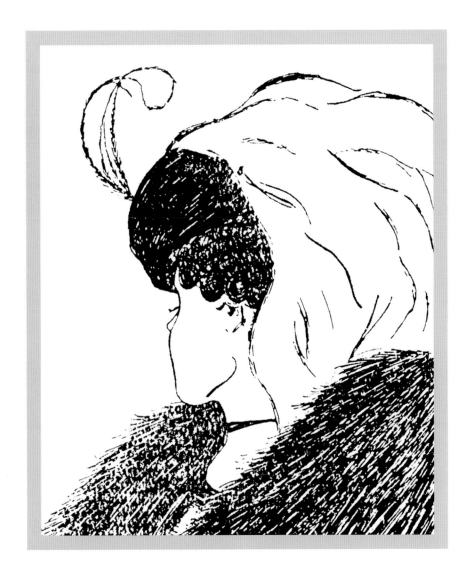

Is this an old woman or a young girl?

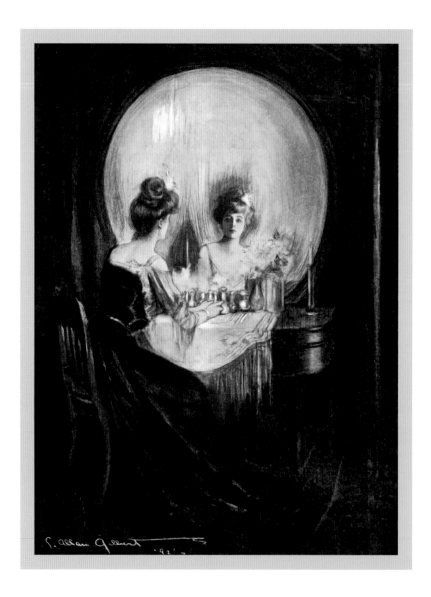

This allegorical drawing from 1892 makes an ominous statement about vanity. Can you see why?

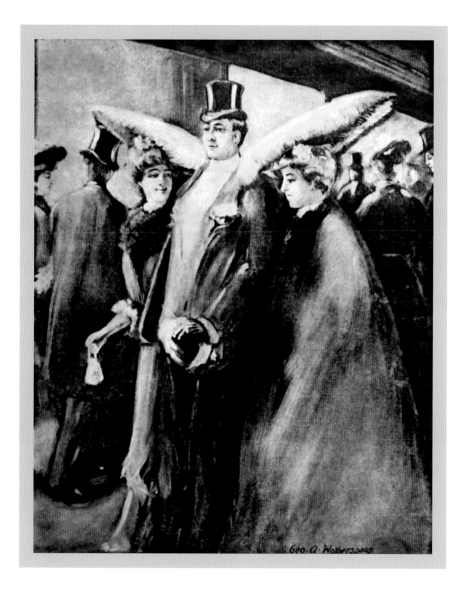

Geo. A. Walberspoog

In another allegorical illusion, this image can be seen as a dapper gentleman out on the town. If you look closer, however, you will see an animal associated with foolishness. Can you find it?

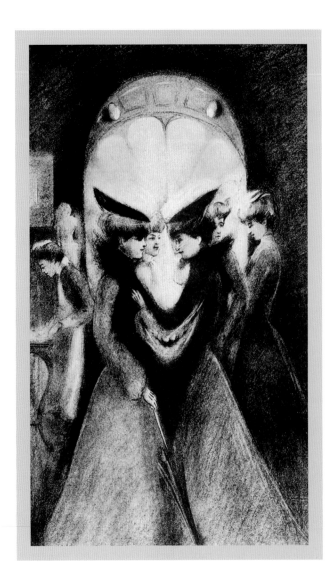

This allegorical illusion from the nineteenth century can be seen as two lady gossipers, but look closer and you will see the devil lurking in the background.

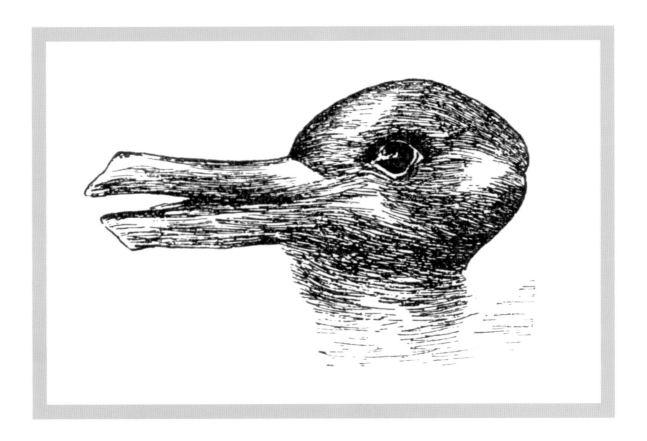

In this classic illusion, do you see a rabbit facing right, or do you see a duck facing left?

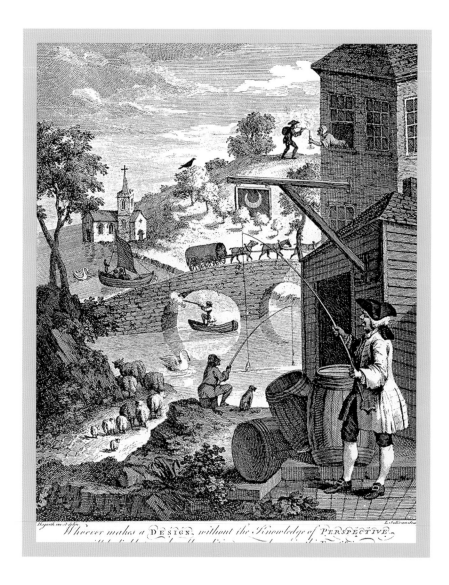

The caption in this William Hogarth engraving reads, "Whoever makes a Design without the Knowledge of Perspective will be liable to such Absurdities as are shown in this Frontispiece." How many mistakes in perspective can you spot?

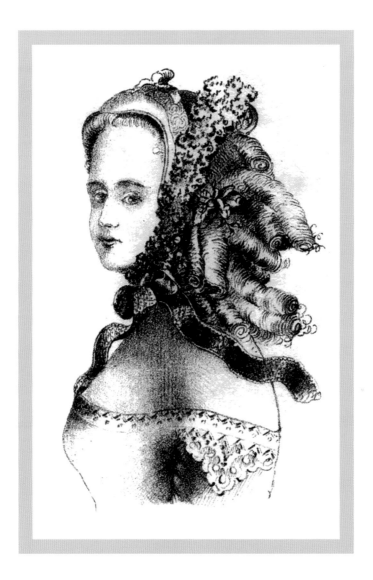

This young woman's curly locks reflect the fragile nature of her beauty.

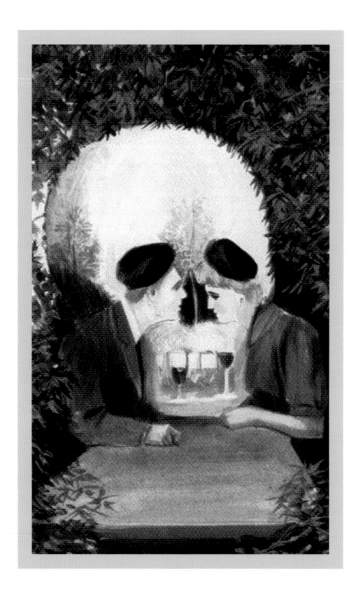

Do you see two lovers on a picnic with wine or a giant skull?

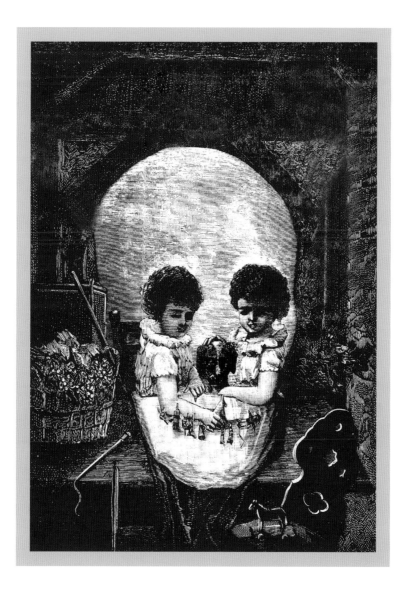

This antique print is titled *Yesterday, Today, and Tomorrow*. Can you tell why?

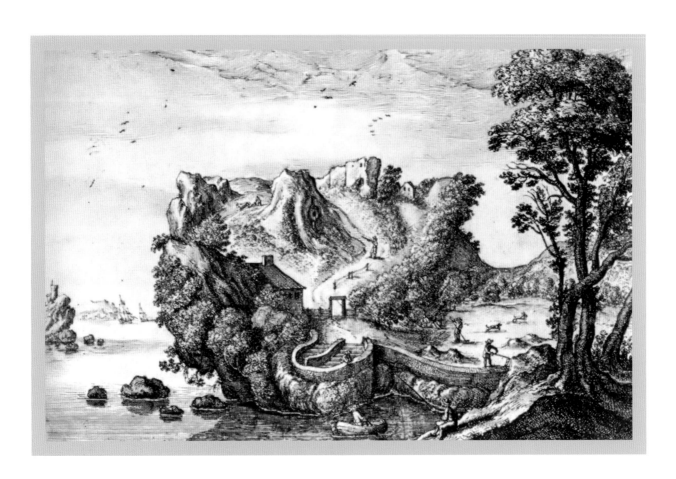

This seventeenth-century drawing shows an idyllic country
scene, but look closer, and you'll see a face.

There are many hidden animals and figures in this drawing from a *c.* 1888 puzzle card.
How many can you find? (See page 314 for the solution.)

There are three faces in this illusion. Can you identify them?

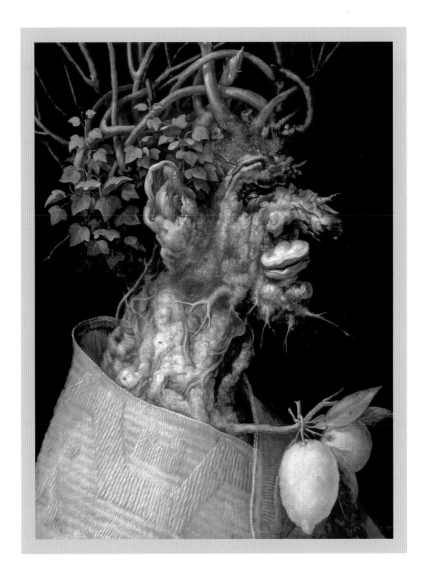

The Winter by Italian painter Giuseppe Arcimboldo, 1563. Notice how the knotty stump covered in moss, ivy, and fungus has a curious resemblance to an old man.

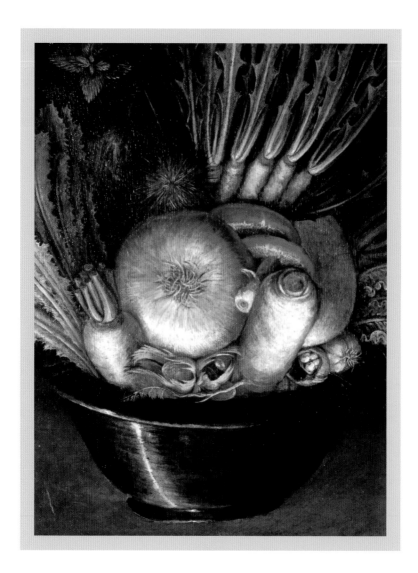

A student of Leonardo de Vinci, Arcimboldo pioneered the style of art we now call topsy-turvy. Turn this image upside down, and you will see the grocer who sold these vegetables.

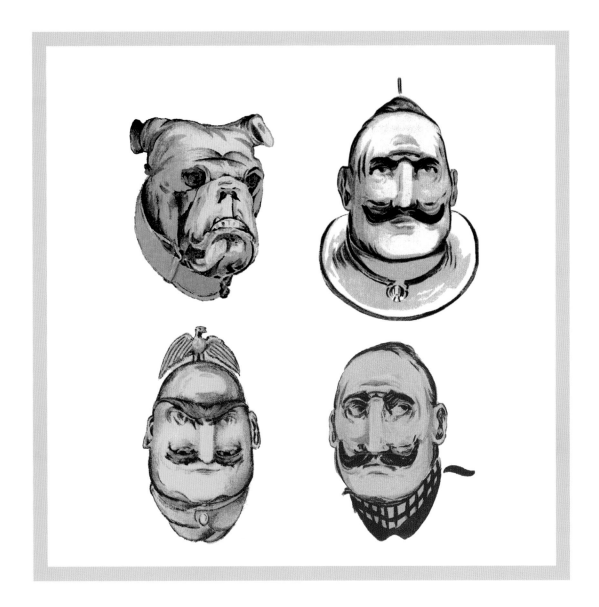

British WWI war posters often used topsy-turvy designs featuring the former German emperor Kaiser Wilhelm II. Turn the images upside down, and you'll see that the former British secretary of state Lord Kitchener (the "British Bulldog," top left) has the upper hand.

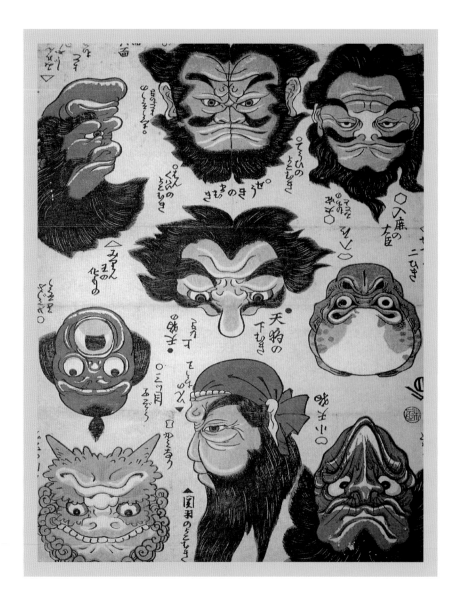

This antique Japanese print shows a variety of unique topsy-turvys.
Flip the image upside down to see them!

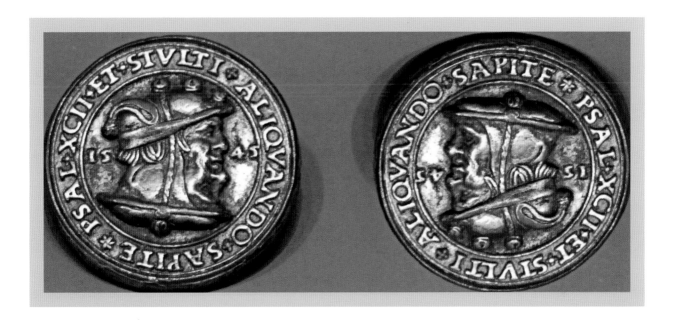

A sixteenth-century satirical medal from Nuremburg, Germany, shows the likeness of a court jester (left). Turn the medal upside down, and the more dignified likeness of a Catholic cardinal (right) is shown.

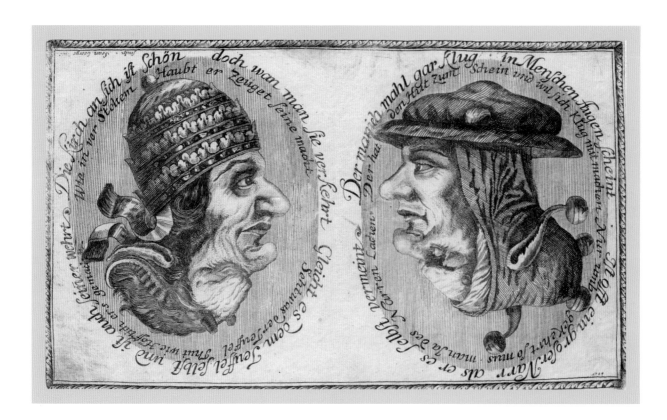

This old engraving shows the pope (left) and scholar (right). Turn the image upside down, and you'll find their archenemies: the devil and court jester.

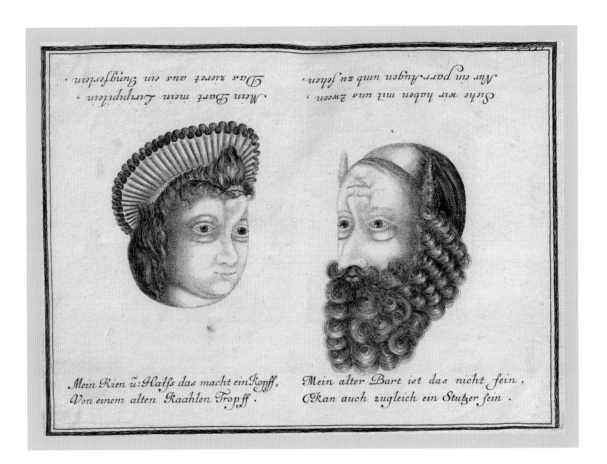

A young man with a headpiece faces an older bearded man in a cap. Turn the portraits upside down, however, and you'll find a lady and a nobleman.

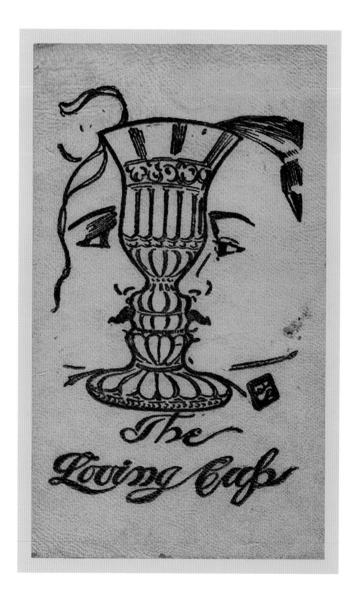

A handmade leather postcard from 1864 shows two lovers, with an ornate goblet occupying the space between them.

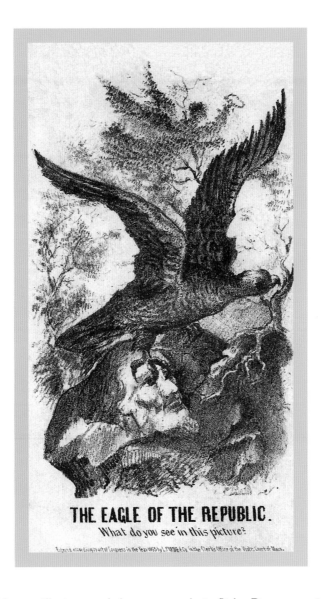

THE EAGLE OF THE REPUBLIC.

What do you see in this picture?

Entered according to act of Congress in the Year 1865 by L. PRANG & Co. in the Clerks Office of the District Court of Mass.

This Civil War-era illusion card shows an eagle in flight. Do you notice the angel, the first U.S. president, the issuer of the Emancipation Proclamation, and the president of the Confederacy sharing the same space?

ANAMORPHIC & STEREOSCOPIC
ILLUSIONS

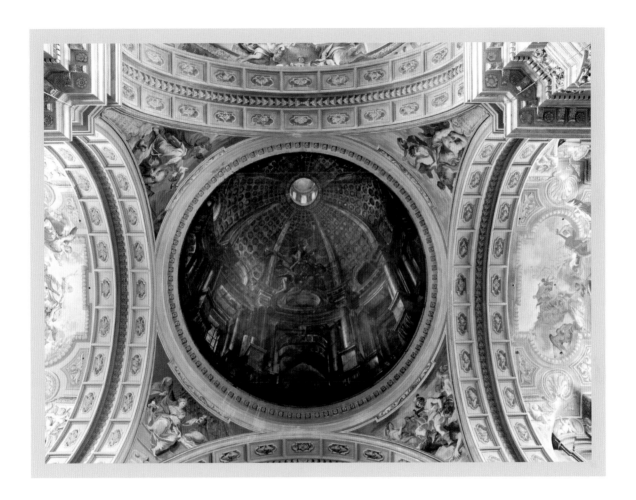

A classic example of anamorphosis—in which a distorted image appears normal when viewed from a particular position or with a suitable mirror—is shown on the ceiling of Rome's Church of Sant'Ignazio. Believe it or not, the dome is an illusion.

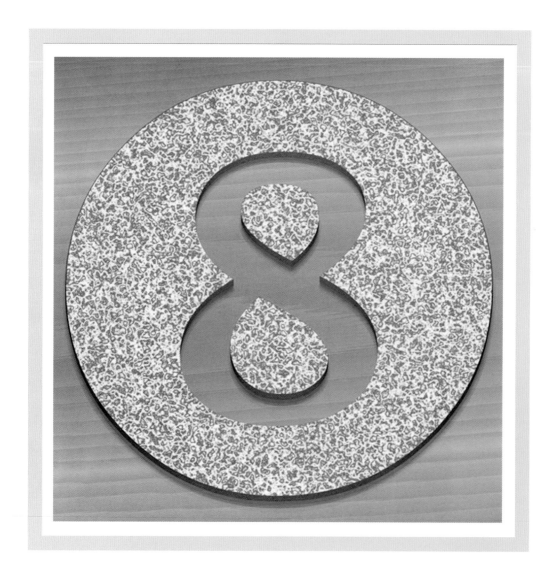

At first the image looks like a figure eight cut out of particleboard with the center pieces put back in place. Turn the image upside-down. Now what does it look like?

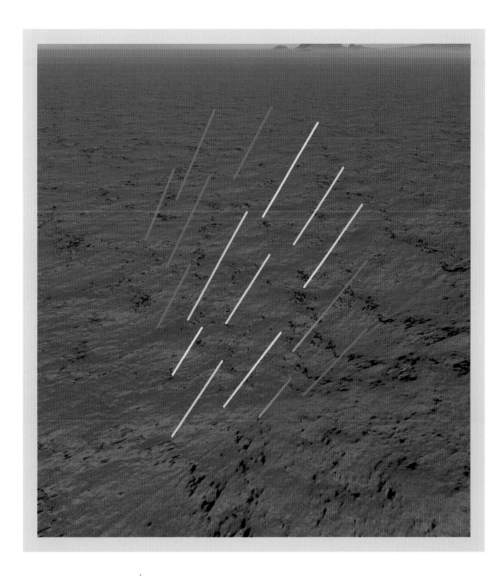

Turn the page counterclockwise one-quarter turn and then tilt the book away from you until it is almost horizontal. If you examine the page from the bottom left-hand corner, the lines will stand up in 3-D.

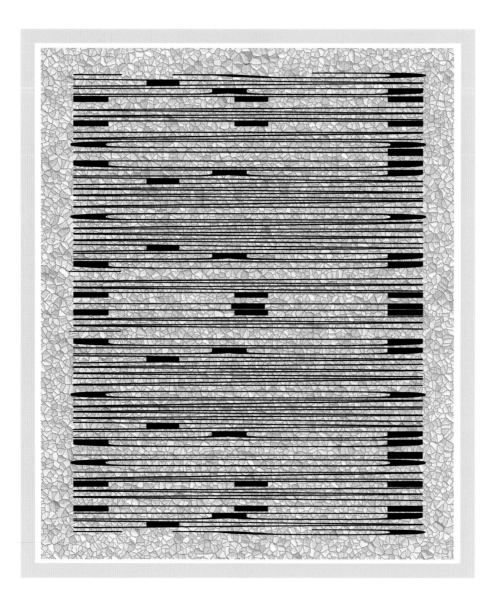

Tilt the image and view the picture along the plane of the page to reveal the hidden message, which is also a palindrome (a word or sentence that reads the same way forward as it does backward). See page 314 for the solution.

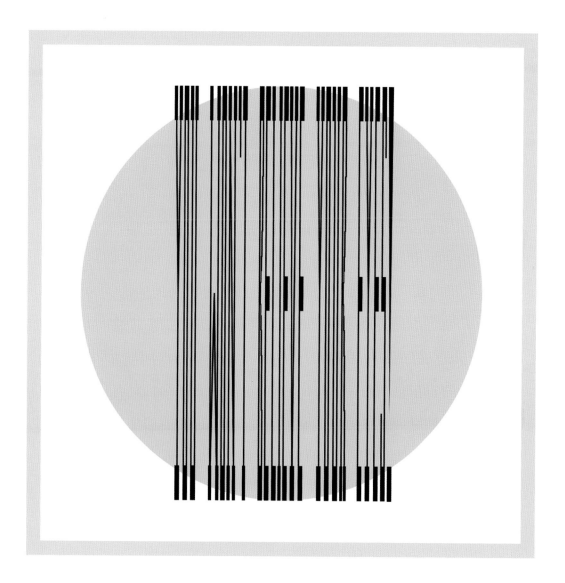

The message in this image is hidden in plain sight. If you stare at the image in the right way, it will reveal itself. See page 314 for the solution.

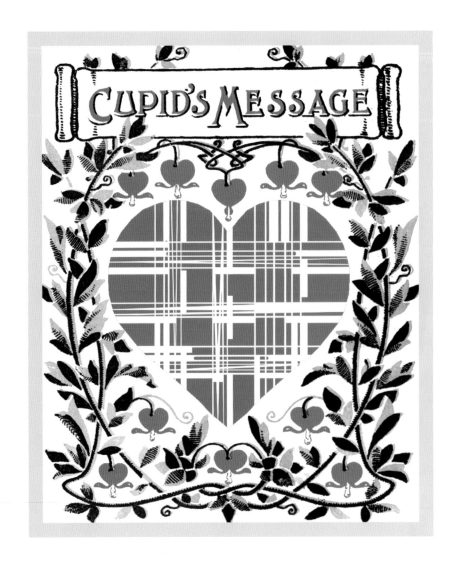

Tilt the image and view the heart in this vintage postcard from a low angle.
See page 314 for the solution.

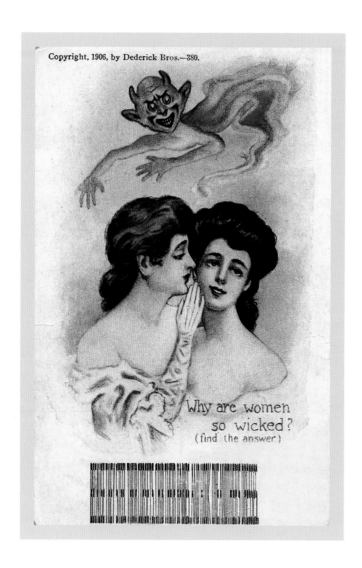

Why are women so wicked? To discover the answer,
tilt the image forward and view from below.
(The answer can be found on page 315.)

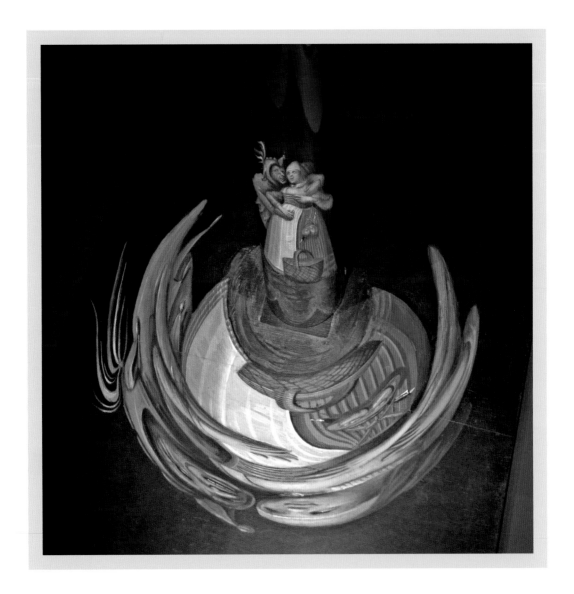

Anamorphosis by Swiss painter Hans Heinrich Glaser, 1650.
In this diabolical form of anamorphic illusion, a coherent image can only
be seen by placing a mirrored tube in exactly the right spot.

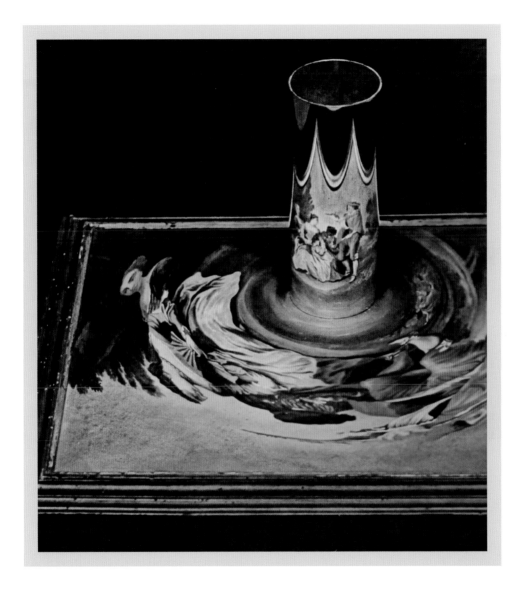

Here is an antique anamorphic print with the solution mirror shown in place.
The print is a copy of a popular painting from the beginning of the
nineteenth century, when these puzzles were popular.

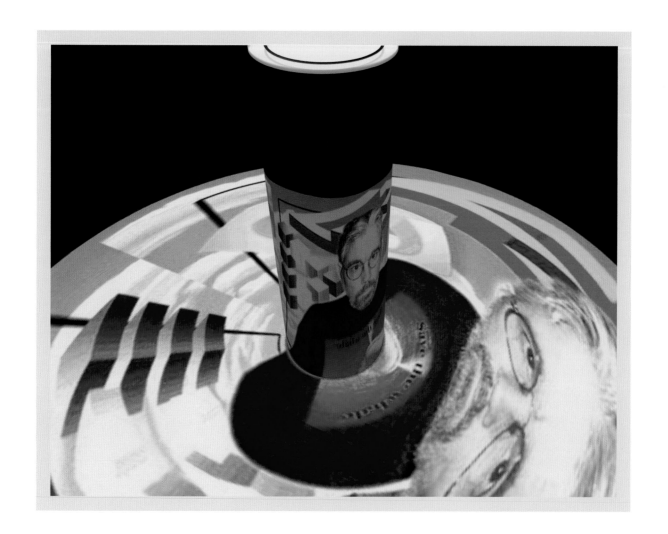

Save the Whales by Tony Azevedo, 1999.

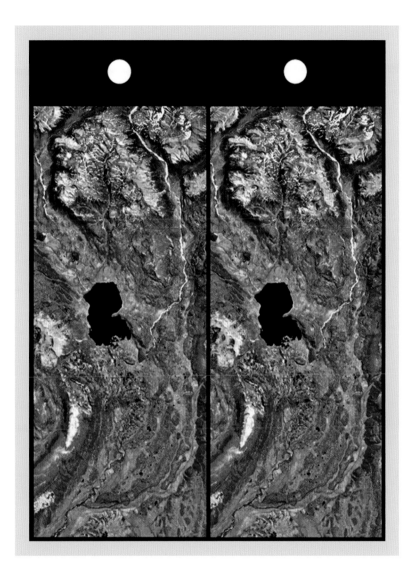

These are actual photos of Lake Palanskoye in Russia, taken from orbit.
Stare at the photos and cross your eyes slightly until a third white
dot appears between the two. The new, center image is in 3-D!

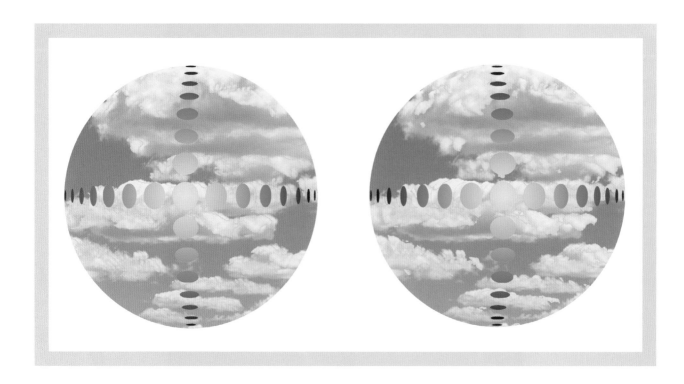

The dots do not appear to converge in the exact center of each circle in this stereogram (which consists of 3D images hidden within another image). How will they project in 3-D? Focus on the centers of the circles and gently cross your eyes, placing an index finger on your nose to focus on, if necessary. If you see four images, you have gone too far!

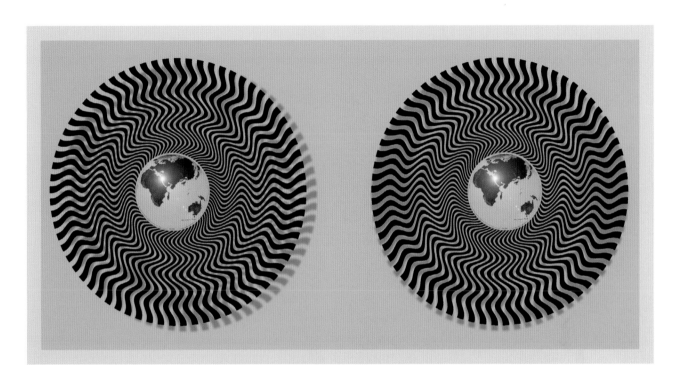

To view this flashing design in 3-D, focus between the pair of images from a comfortable distance, and then gently start to cross your eyes. Are the images merging in the center?

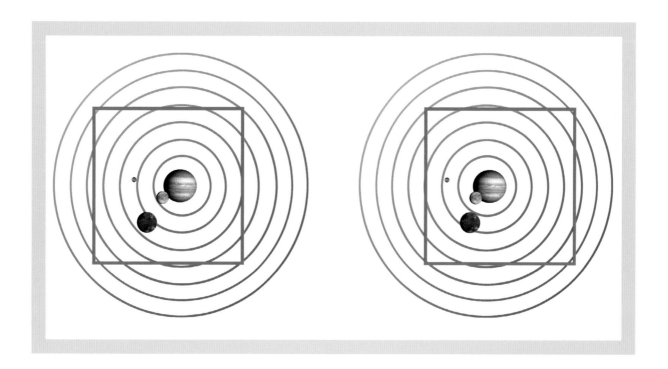

This is the *Distorted Square* illusion as a stereogram, including the planet Jupiter with three of her moons. Follow the directions on the previous page to see the 3-D effect.

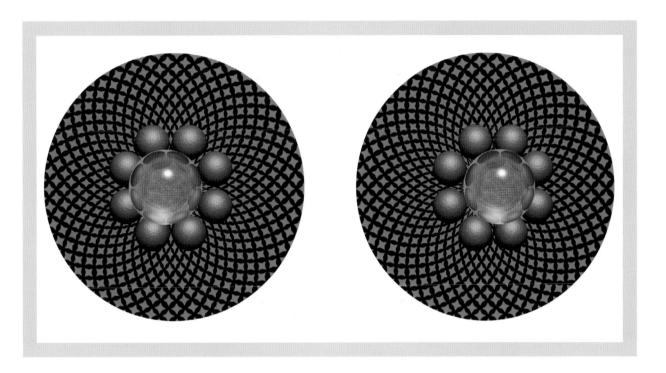

This stereogram has three layers: the rose crystal sphere, the gunmetal balls, and the background pattern. Follow the directions on page 36 to see the 3-D effect.

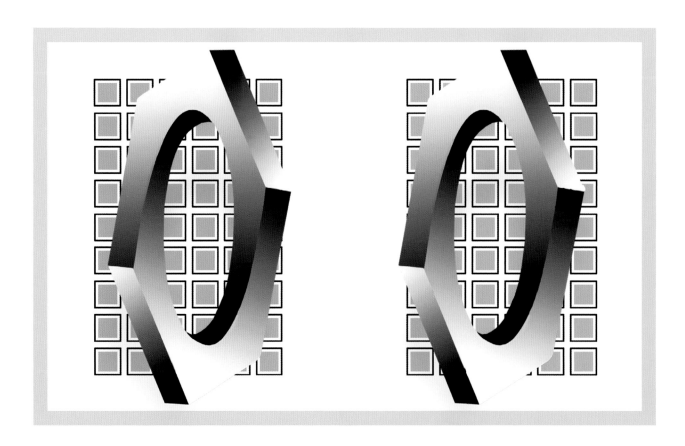

This stereogram will produce an impossible hexagon floating
over a multi-colored background if you view it correctly.

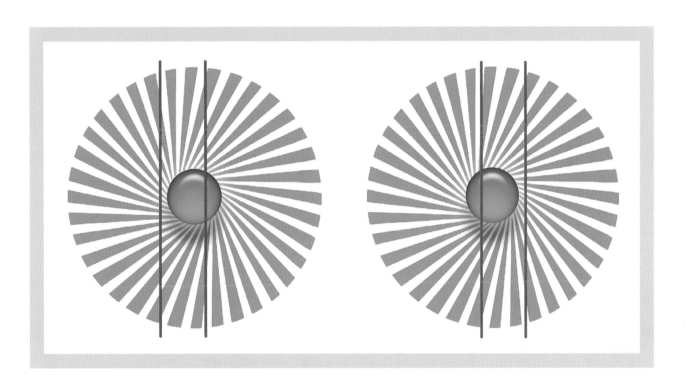

Parallel bars look bent in this stereogram. Follow the
directions on page 36 to see the design in 3-D.

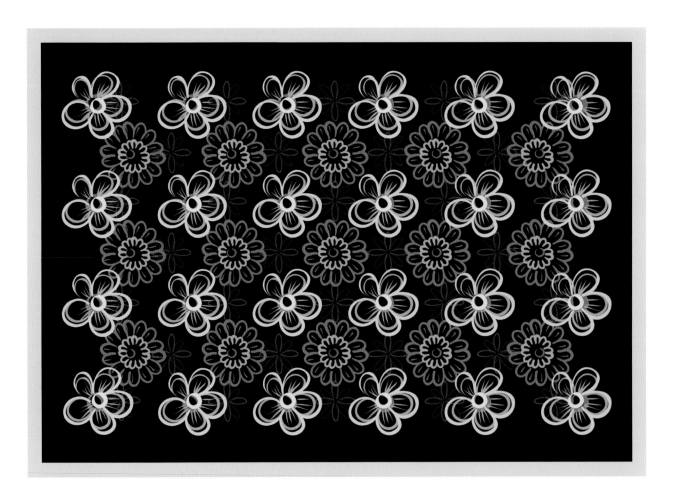

If you focus your eyes on a point beyond the pattern, you'll see the flowers arrange themselves into layers. On what layer are the purple flowers? What about the yellow flowers?

These beige flowers will also arrange themselves into layers if
you view them correctly. How many layers do you see?

COLOR CONTRAST EFFECTS &
AFTERIMAGES

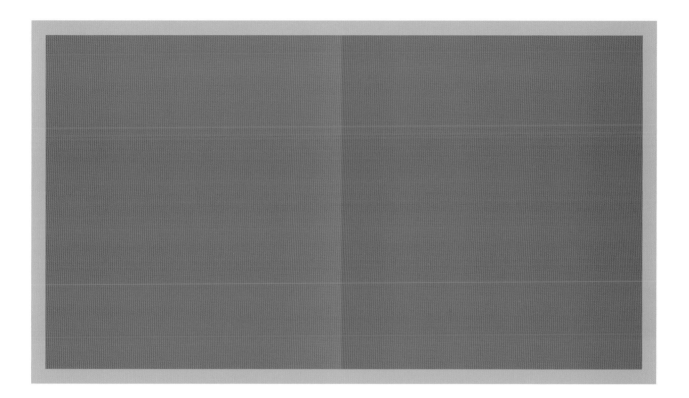

Cover the thin shadow line with your index finger.
Is the entire right half of the image really darker?

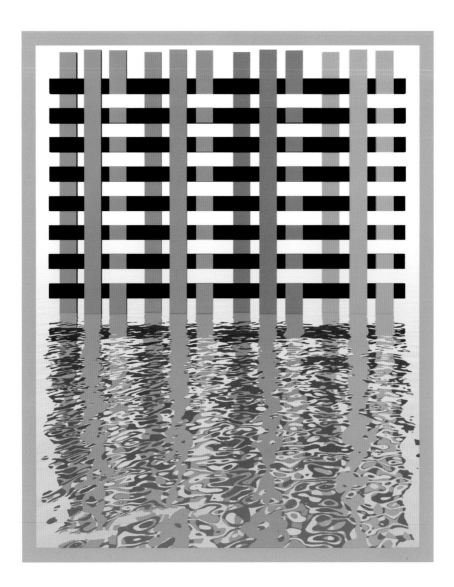

How many different colors are represented in this illustration? Note that varying amounts of black nearby create the illusion of additional shades of color.

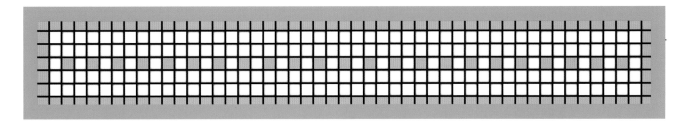

Squares with color borders seem to be tinged with a light version of the border color.
Color spreads into open white areas freely, but not across solid, dark borders.

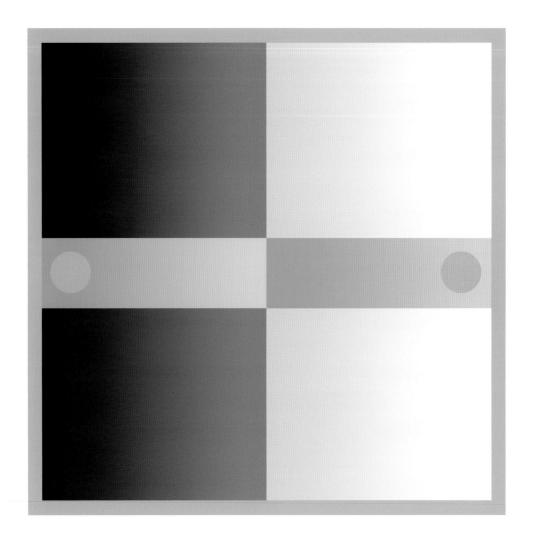

Are the orange circles the same color and value, or do they differ?

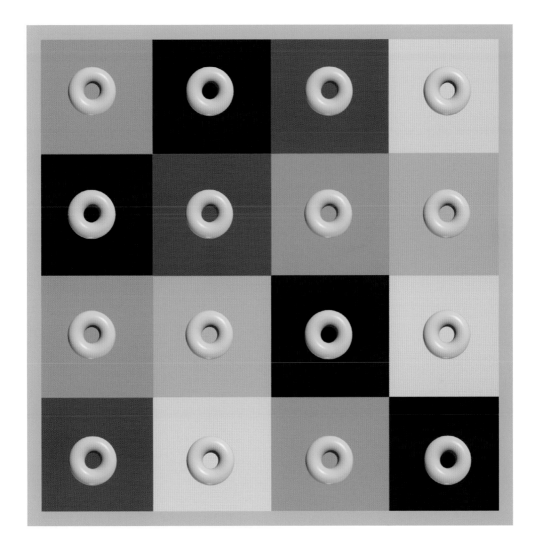

Are all the yellow donuts really the same color and hue? Note how the differing shades of gray in the grid each have an influence on our perception.

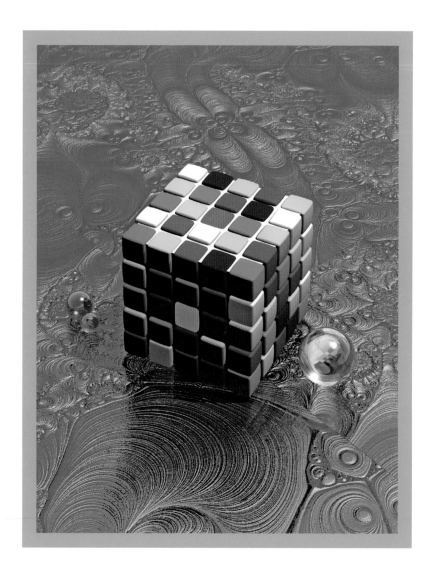

Examine the middle squares on the top and front faces of the cube. Are they really displaying different colors? Cover the squares between them with your hand to check.

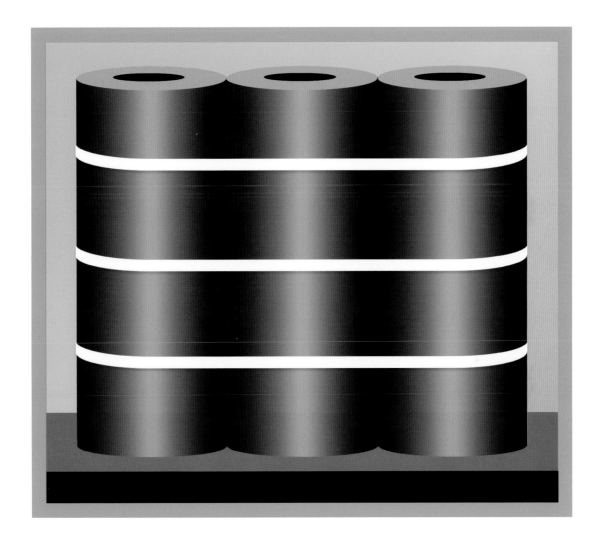

The tape that holds these rolls of factory cargo together appears lighter when passing areas of high color contrast and darker in areas of low color contrast.

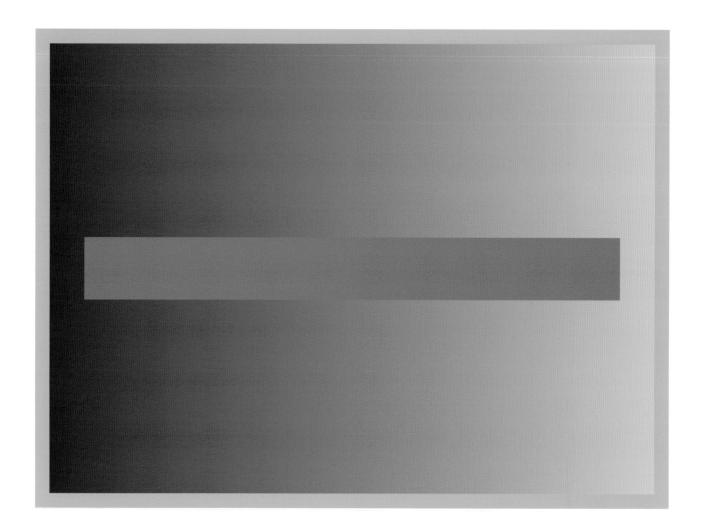

This illusion demonstrates how context influences our perception of color.
At every point along the gray band, as we look we cannot help but
compare its uniform color with the surrounding gray scale.

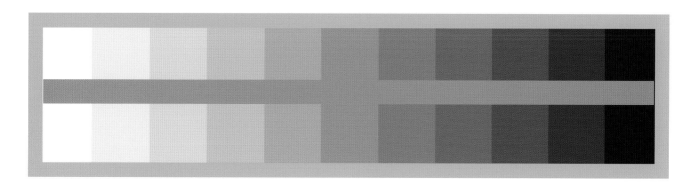

Each block is ten percent darker than the block before it, and, this time,
the thin solid gray bar appears to lighten from left to right.

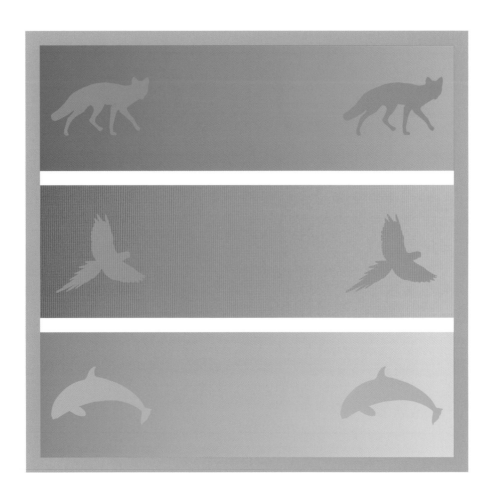

Is each animal on the right side of the image the same color and shade as the same animal on the left side of the image?

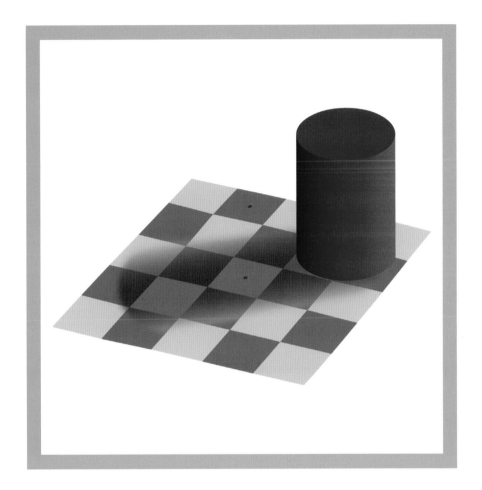

In this checker shadow illusion, you are asked to compare the shades of gray on the squares indicated by a dot. Is one square really darker than the other?

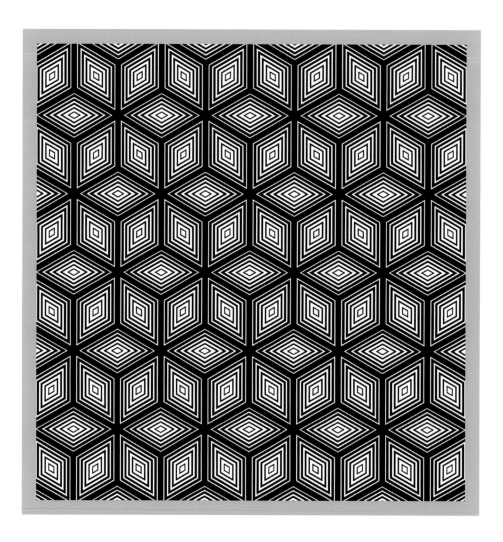

Do you perceive shimmering lines crisscrossing every
diagonal of every face of this stack of cubes?

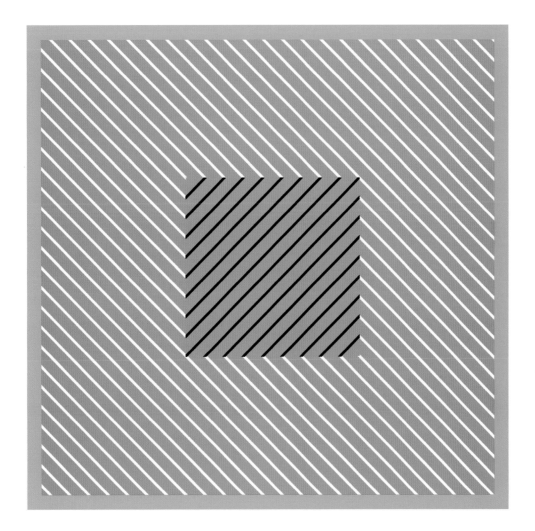

Does the shade of blue in the central square match the shade of the surrounding blue?

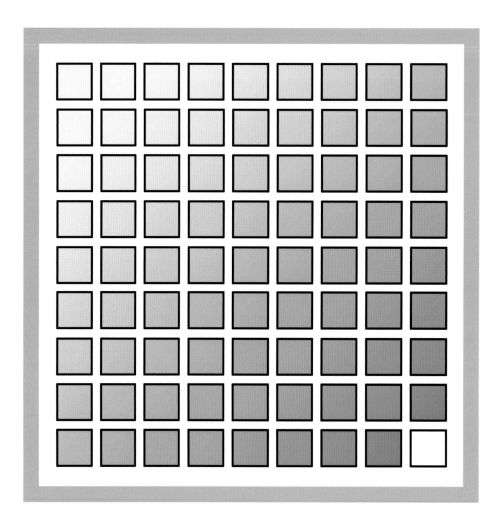

Do you see fuzzy pink dots appear in the intersections between the squares in this design? Do they appear where you are not looking?

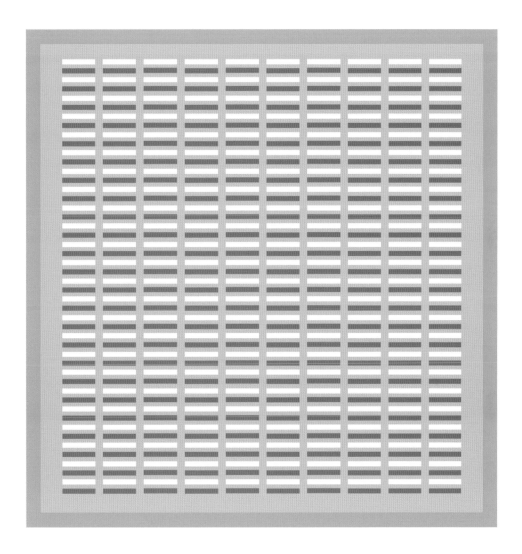

Look between the columns of alternating red
and white bars, where fuzzy shadows are lurking.

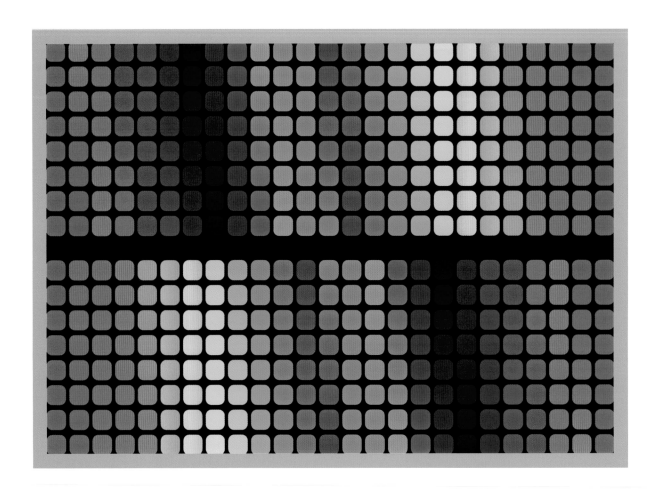

As you run your eyes over this rainbow grid, do you see ghostly dots appear at the intersections of the colored blocks?

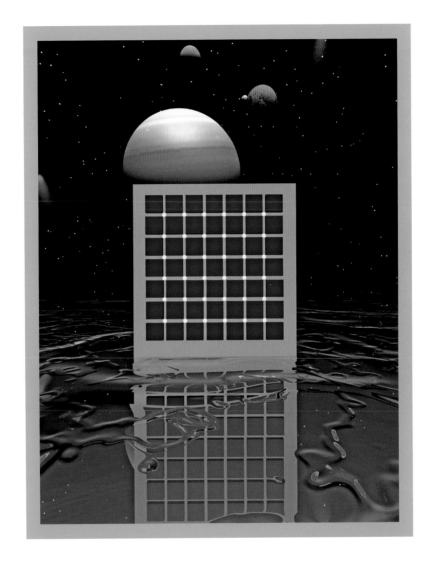

Count the black dots as they appear on the grid in this otherworldly design. As you count them, they disappear!

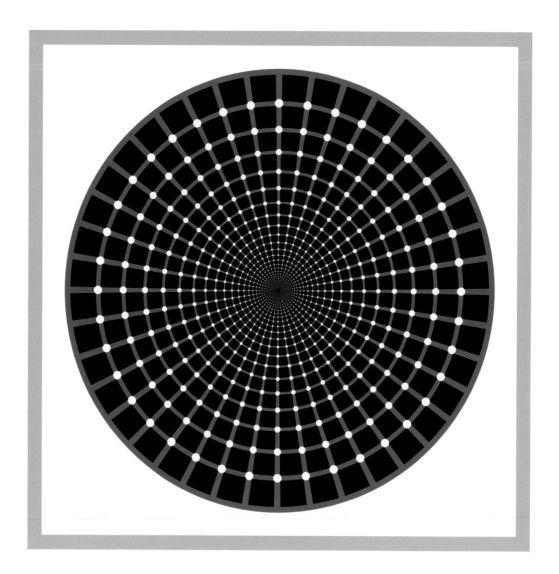

The appearance and disappearance of black dots over the white
intersections in this circular grid provide a scintillating effect.

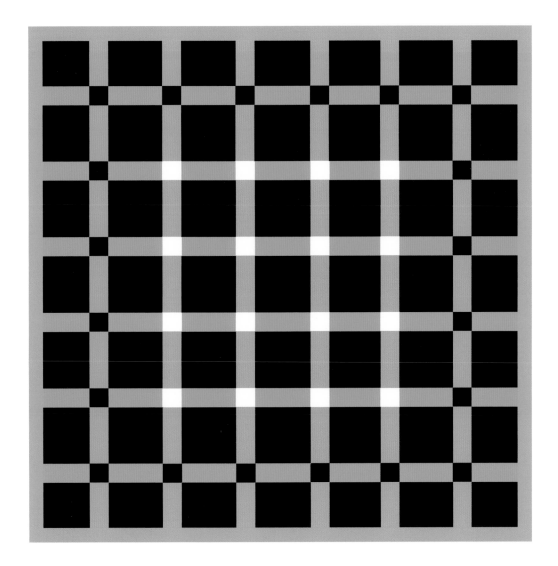

Do you see a light blue color in white squares that you are not looking directly at?
Note that the yellow hues create a faint blue afterimage effect on the nearby white areas.

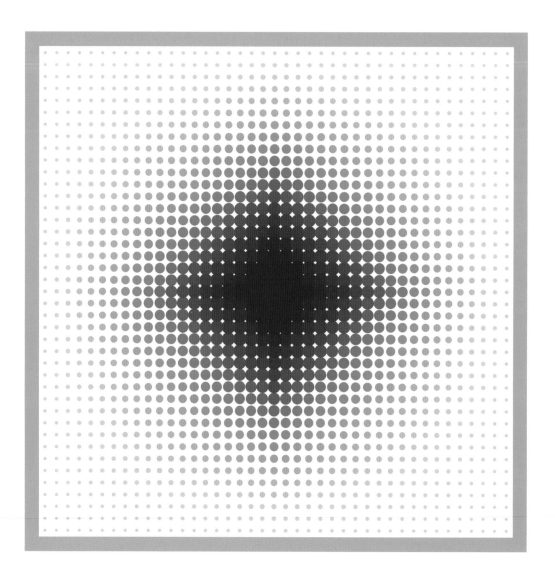

Relax your eyes as you stare at this image. Notice how the background takes on a purple tint.

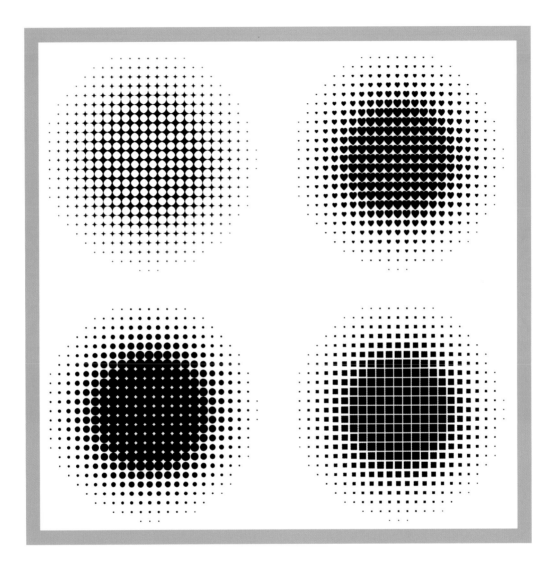

A vibrating effect is achieved with patterns of black and white, no matter their shape, as ghostly patches appear against black areas in our peripheral vision.

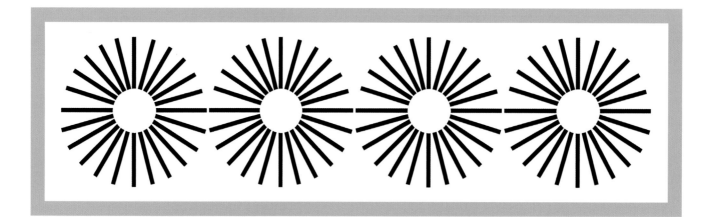

In the well-known *Ehrenstein* illusion, a bright illusory patch appears in the center of a series of radiated lines around an imaginary circle.

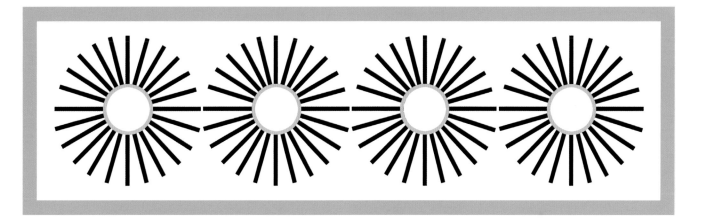

The bright patch is enhanced by a light-colored border around the circle. Surprised scientists gave the phenomenon a name: anomalous brightness induction.

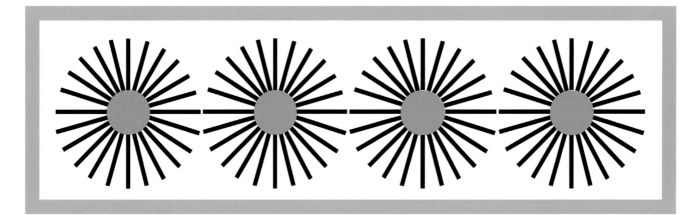

After a gray disk is added to the central patch of the *Ehrenstein* illusion,
the patch begins to emit a shimmering effect as the eye pans over the figure.

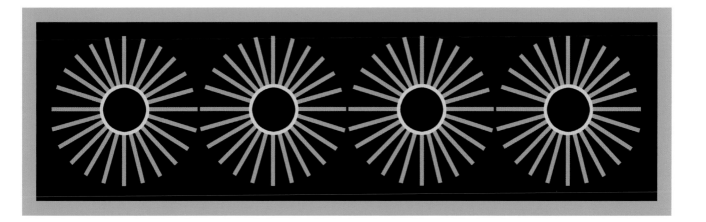

The power of contrast now reverses itself with a vengeance, as the bright patch now appears to be blacker than the surrounding black.

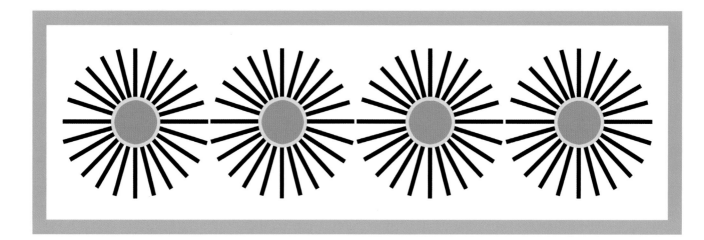

Here, the central patch appears to shimmer and seems to be tinted with the complementary color of the border's color (in this case, dark blue).

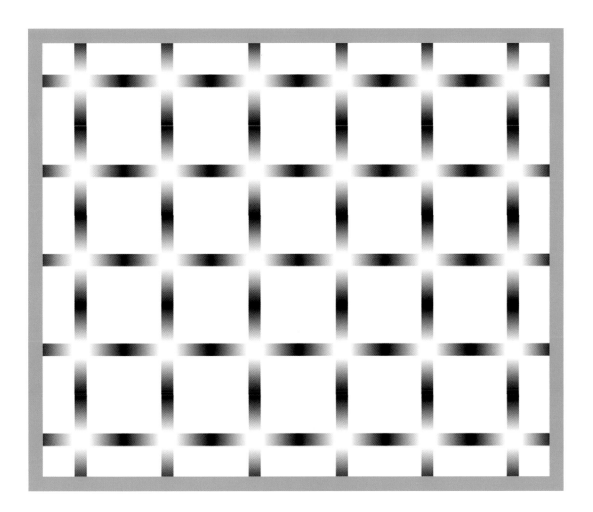

This pattern of bright crosses is achieved by forcing high
color contrast, using ramps of black to gray at the intersections.

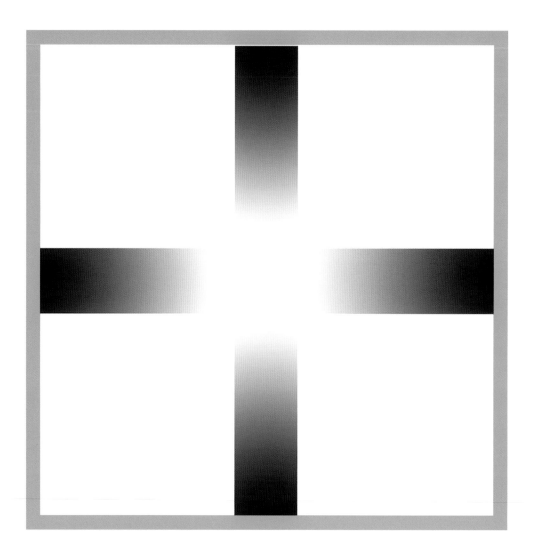

This figure is so bright that it looks like hot metal near the center—
hence the name of the illusion, *Burning Fuse*.

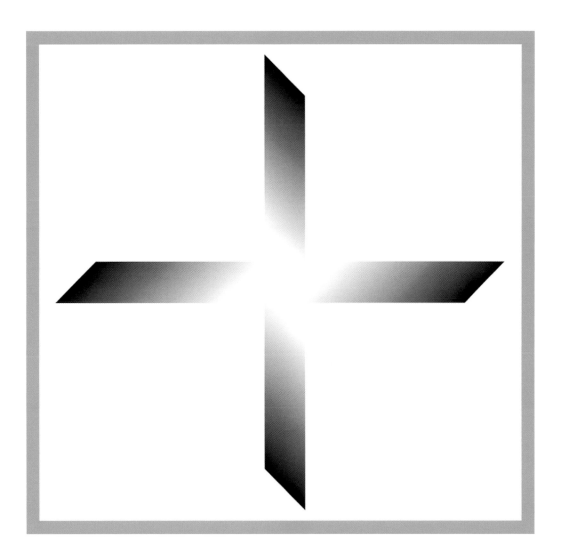

The fading dark bars define a central patch of brightness,
surrounded by an illusory dark halo.

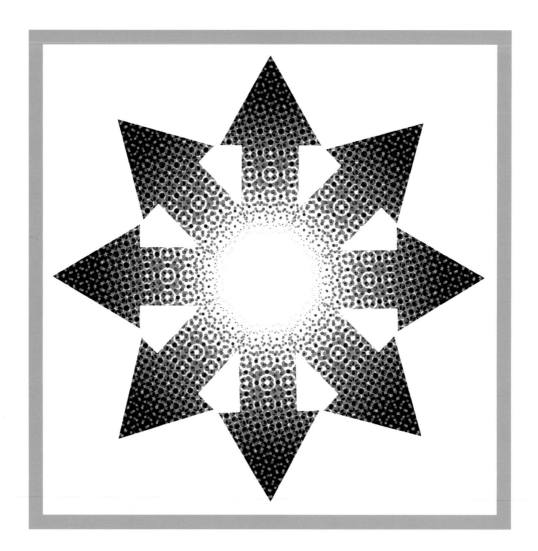

The burning fuse effect persists when color dots decrease
in size as they approach a central white patch.

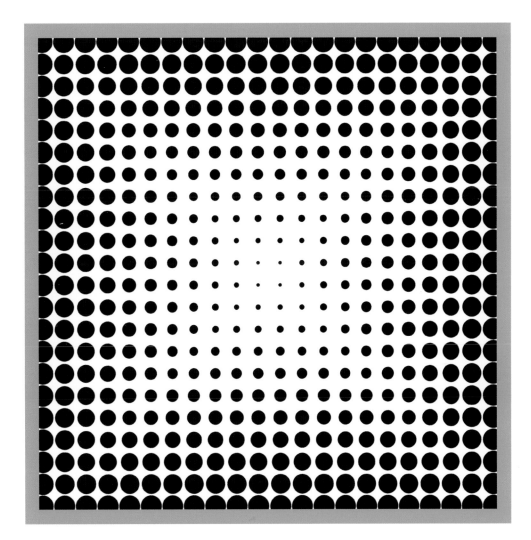

Do you notice that the center of this image has a gray tint? Decreasing amounts of black make the surrounding white look darker.

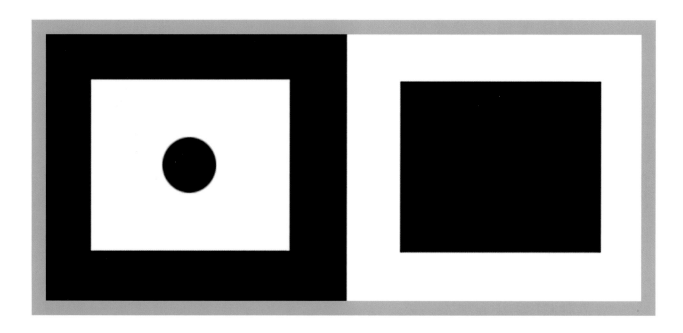

Stare at the black dot on the left for about 15 seconds; then shift your gaze to the black square on the right. Do you see a wispy gray dot?

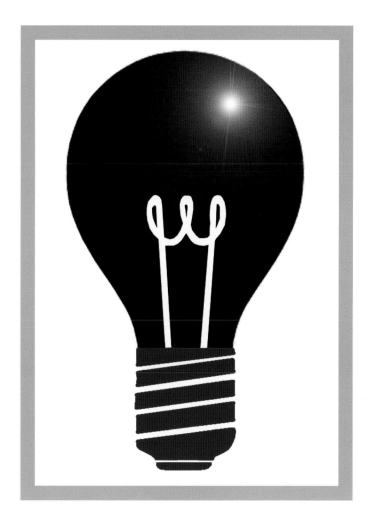

This incandescent lightbulb can be illuminated if you stare at it for 15 to 25 seconds
and then stare at a blank piece of paper or any convenient, neutral light-colored surface.

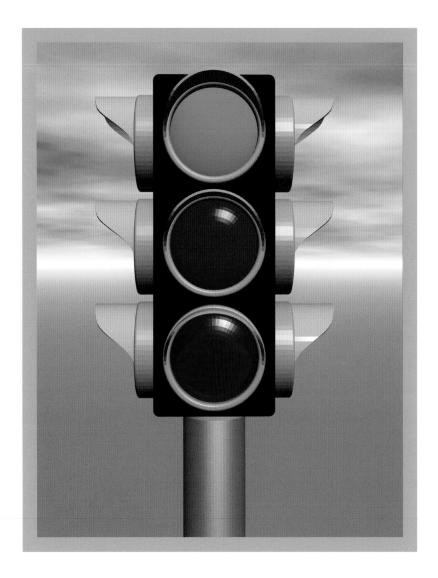

To see the correct colors for this traffic light, stare at the center light for about 15 to 25 seconds and then look at a neutral light-colored surface.

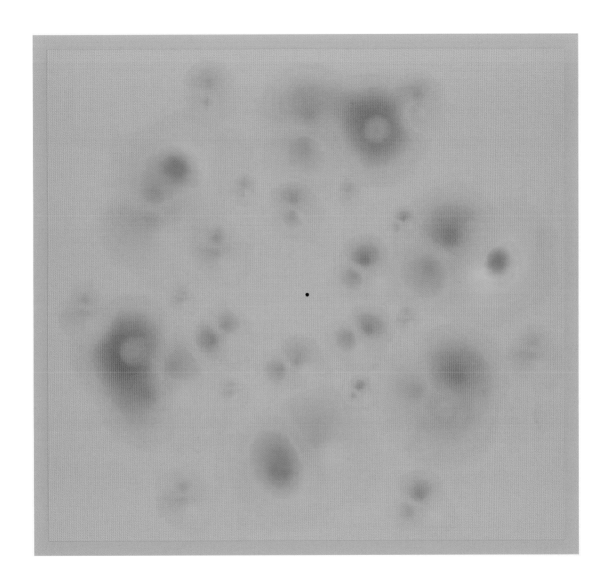

To make the colored clouds disappear, stare at the black dot and
watch them fade, little by little, out of the corner of your eye.

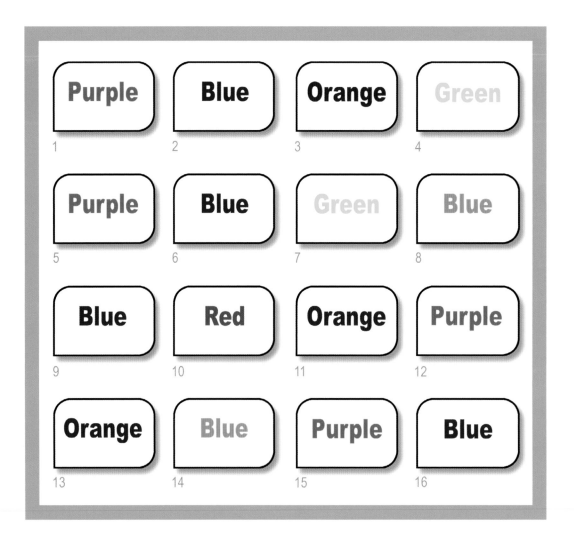

In this Stroop test, the color names do not match up with the actual colors of the words—ignore the names! Rather, identify out loud the actual color of each word, starting with number 1. See how fast you can get through the test without making any errors. It's more challenging than you might think!

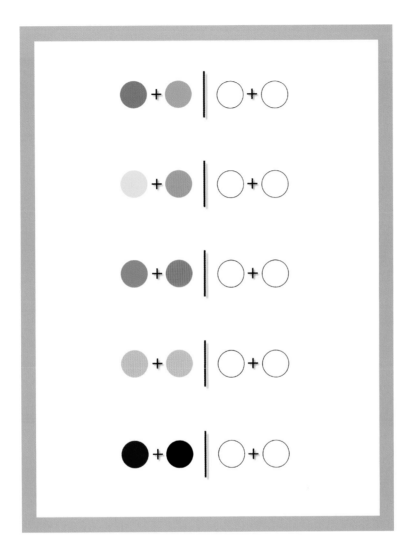

Try to guess what the afterimage color pairs will be for each of these examples.
Charge up your photoreceptors by staring at the cross symbol between the two
test colors on the left for about ten seconds. Then shift your gaze to the
opposite cross to see an afterimage. See page 315 for the solutions.

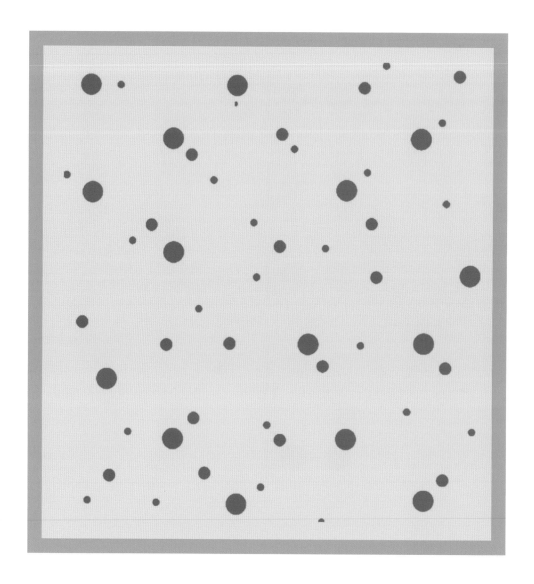

Look at any green dot for about three seconds, and then move your
eyes very slightly in any direction. A matching pattern of afterimages
floats nearby. What color is the afterimage pattern?
(The answer can be found on page 315.)

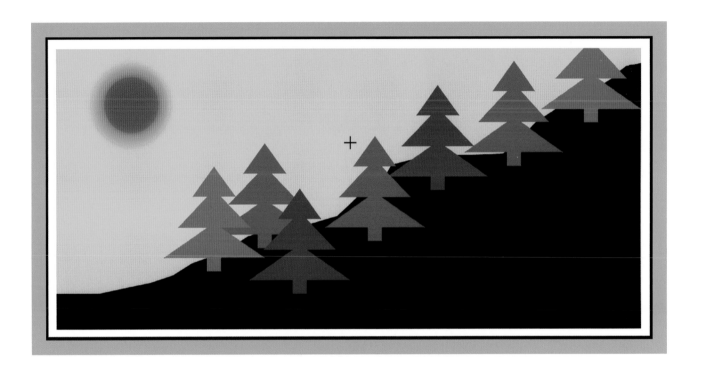

This simple mountain snow scene displays some odd colors.
Follow the directions on page 78 to see the proper colors.

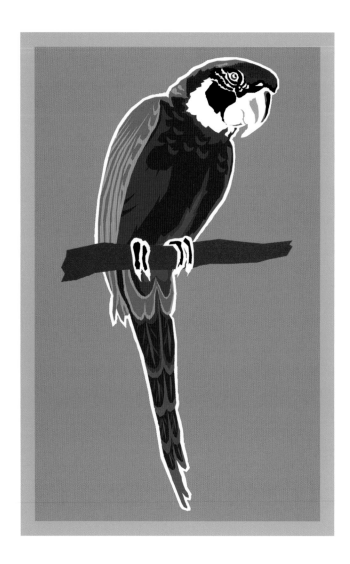

This macaw parrot has some odd-colored plumage.
Stare at the parrot for 30 seconds to see the correct colors.

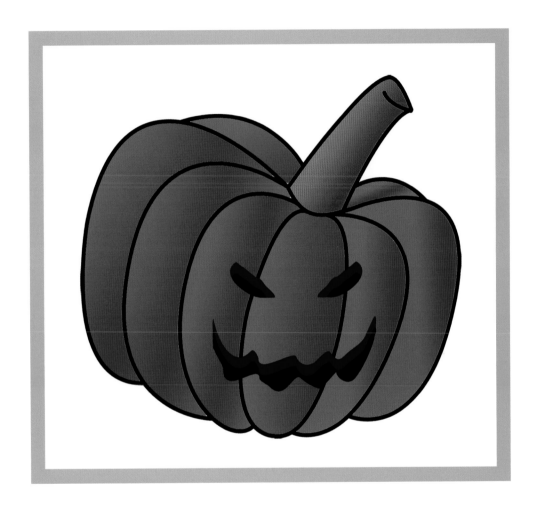

I don't know about you, but I've never seen a blue pumpkin on planet Earth. Stare into its menacing eyes for about 15 seconds to see its true colors.

All hail to the Green, Black, and Orange! Hey—that's not right.
This image requires a 20-second photoreceptor charge.

If you follow the directions on page 78, you'll discern
the likeness of this book's author and illustrator.

DISTORTION
ILLUSIONS

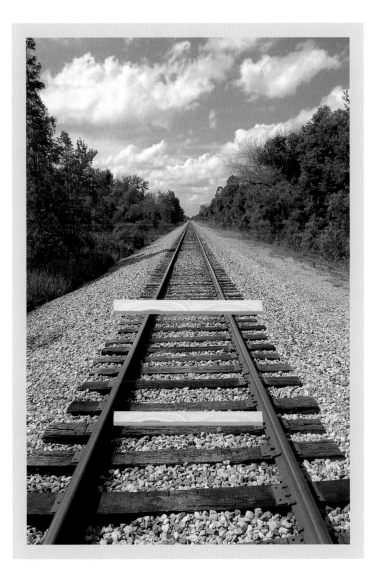

In the classic *Ponzo* illusion, parallel horizontal lines are compared to railroad ties that appear shorter in the distance. Accordingly, we expect the top line to be shorter in length, but since the top line is actually the same length as the one below it, we perceive it as longer.

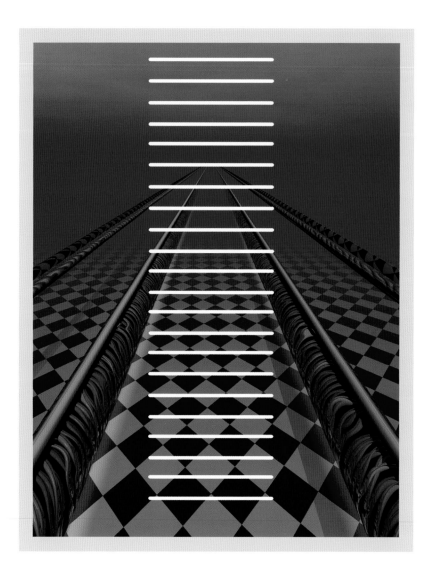

The white parallel lines that extend above and below the horizon appear to be of consistent length. What about the white lines intersecting the horizon lines? Are all white parallel lines the same length?

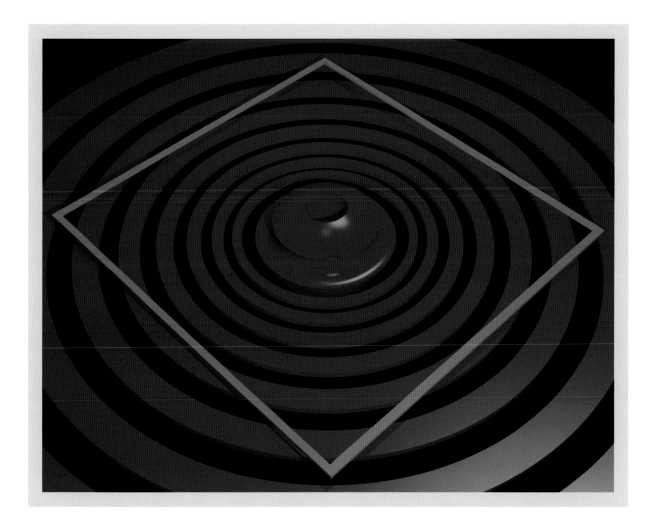

In this 3-D version of the *Bent Square* illusion, the sides of the square are not curved, yet the circle shapes behind appear to pull the square's sides inward.

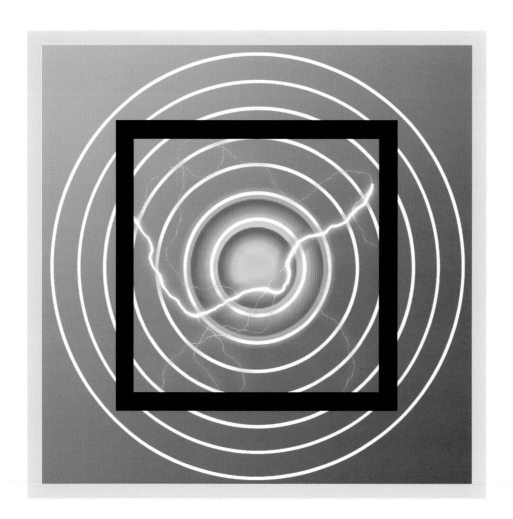

Is this square really bent, or is it just an illusion?

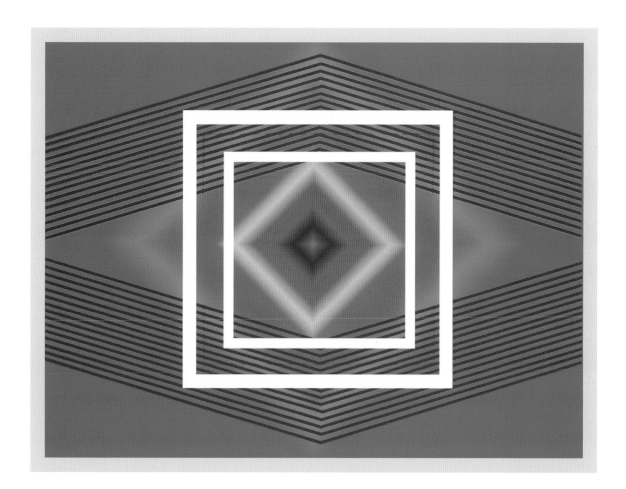

Are the white squares bent or straight? Use your ruler.

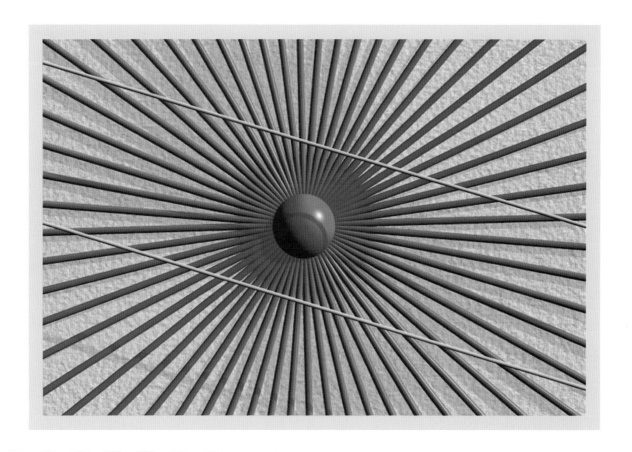

The diagonal bars that appear slightly bowed are actually as straight as an arrow.

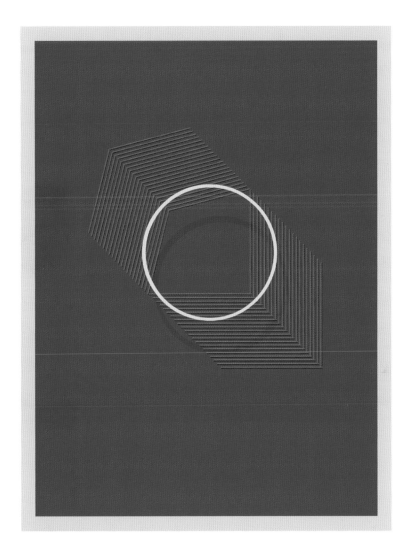

A battle of shapes, and this time the chevron's stripes appear to pull the circle out of shape. The circle is perfectly round—really!

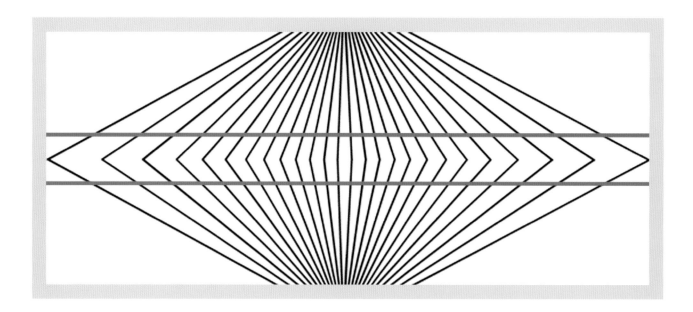

Are the red horizontal lines really straight? Use your ruler.

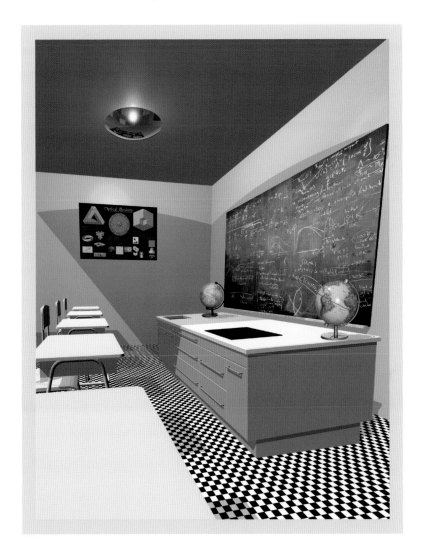

In this scene, the desk nearest the far wall is only a fraction of a size of the desk at the bottom of the image. Despite the apparent size difference, our experience tells us that they are actually the same size.

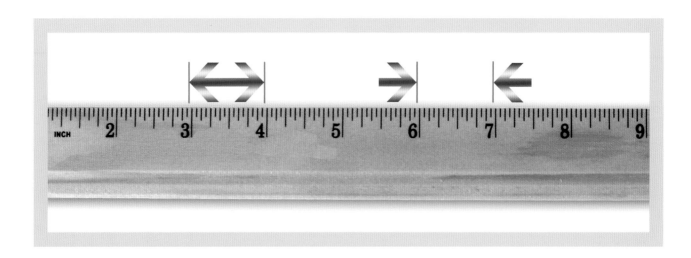

Here is a standard wooden ruler with two separate inches marked with arrows. Which inch looks bigger?

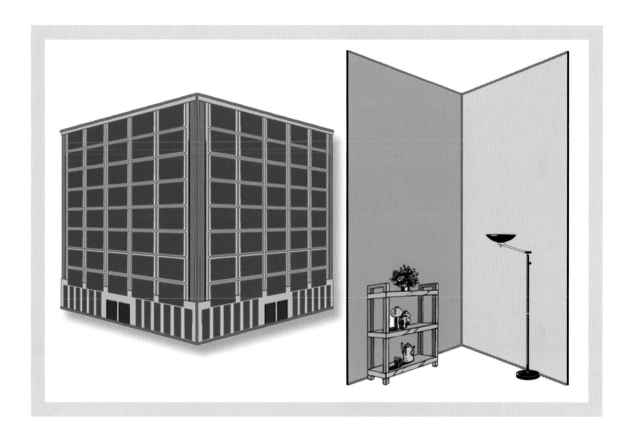

How does the height of the line on the building's outside corner on the left compare with the height of the line on the inside corner of the room on the right?

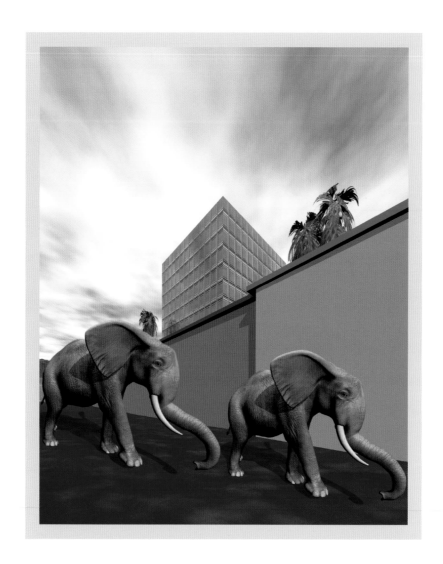

Believe it or not, the two elephants in this scene are the same size.

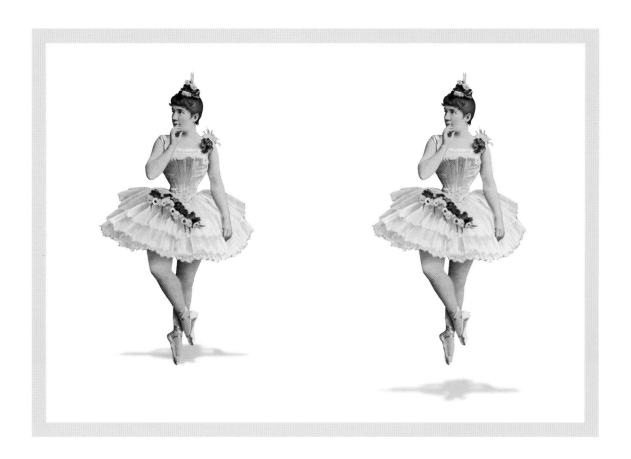

Simply moving the shadow of one dancer to another location can distort our perception. The dancers are perfectly lined up, but which one looks higher?

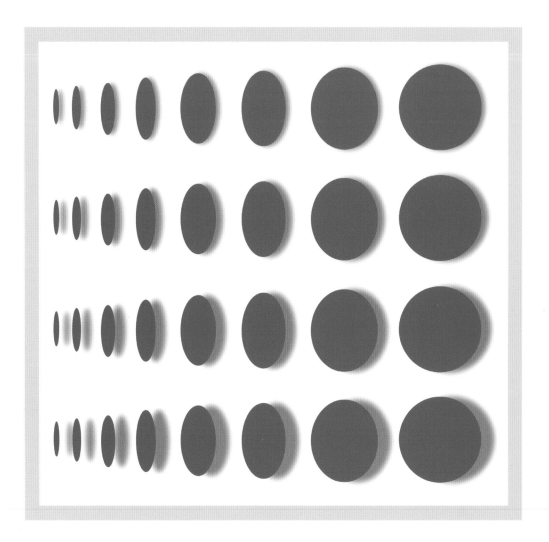

If you run a ruler through the center of each row of dots, you'll find that they are perfectly horizontal and parallel. What's making them look tilted?

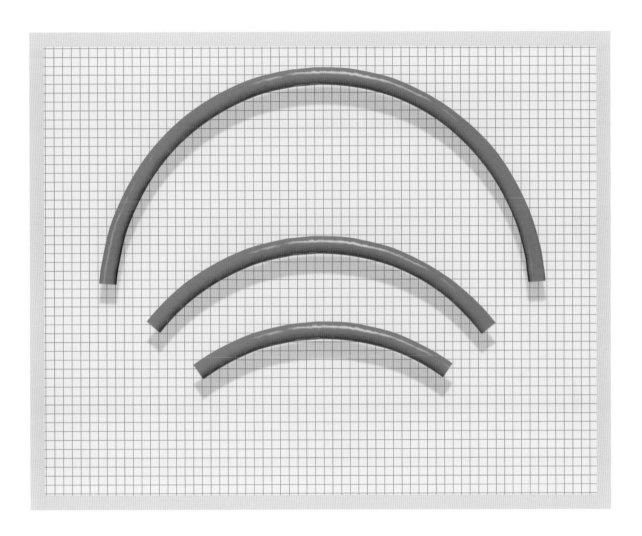

The longer the line segment, the greater the perceived curvature.
In fact, all three segments are part of the same circle!

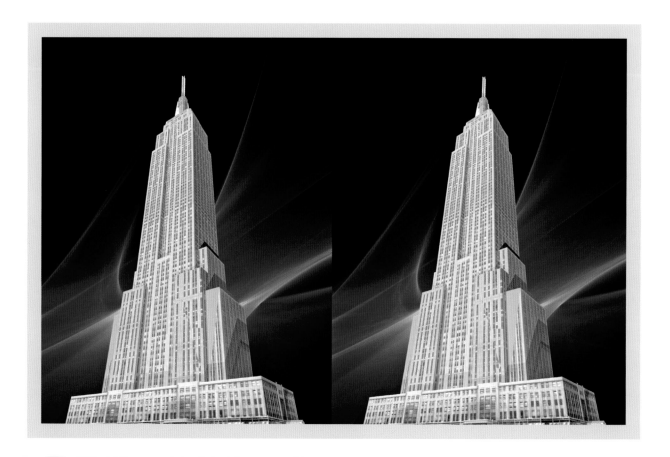

Believe it or not, both images of New York's Empire State Building rise at the same angle.

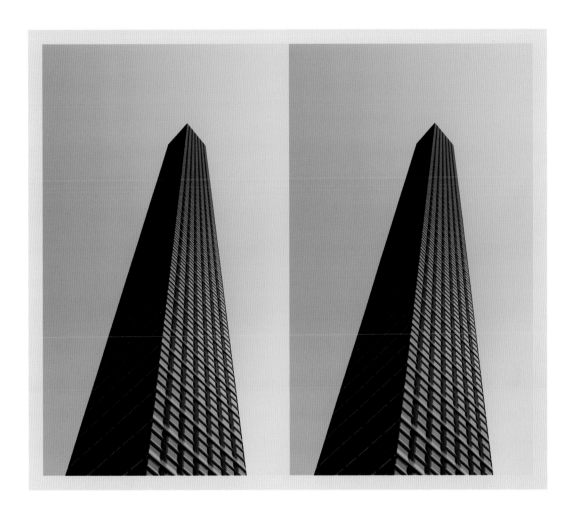

Does the building on the right lean more than its double on the left?

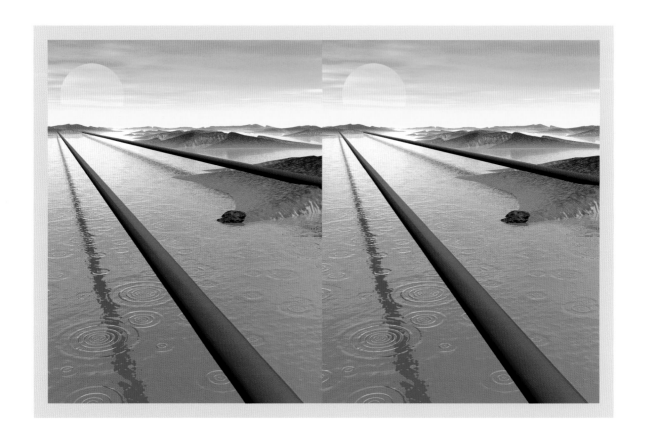

Are these side-by-side images identical or different?

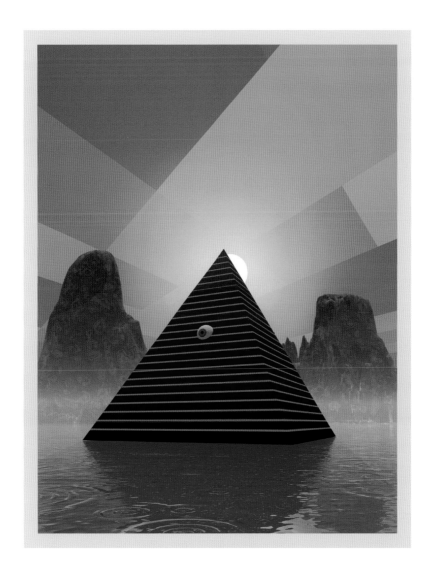

The eyeball is exactly halfway up the pyramid.

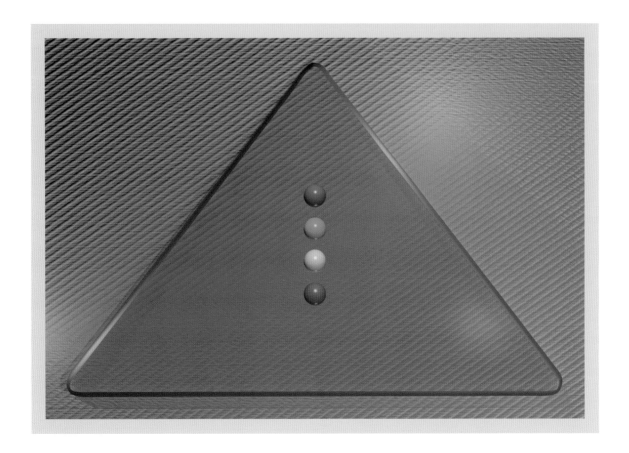

Which colored dot best indicates the center of the triangle? Yellow is wrong. Grab a ruler.

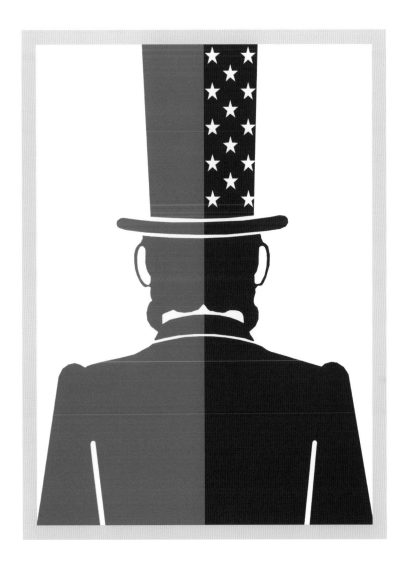

The rule of intersecting lines is shown in the *Lincoln's Hat* illusion, sometimes called the *Stove Pipe* illusion. The hat is as tall as it is wide at the brim. You can use your ruler to prove it.

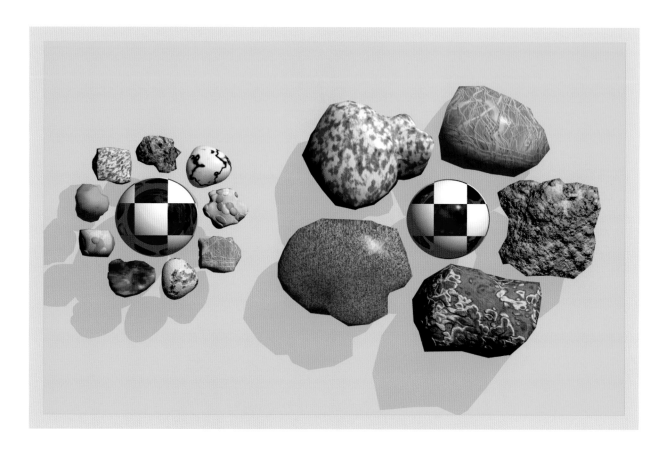

In the *Titchener* illusion, objects of different sizes placed around two identically sized balls distort our perception of their size. The checkered balls in this image are the same size, yet the one surrounded by smaller rocks looks bigger.

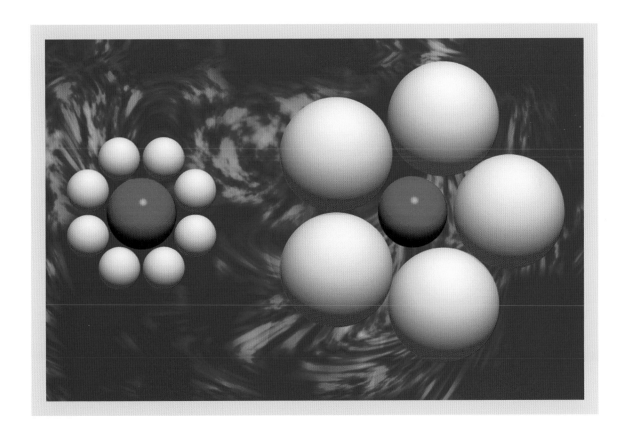

Which red ball is larger? In fact, both red balls are the same size.

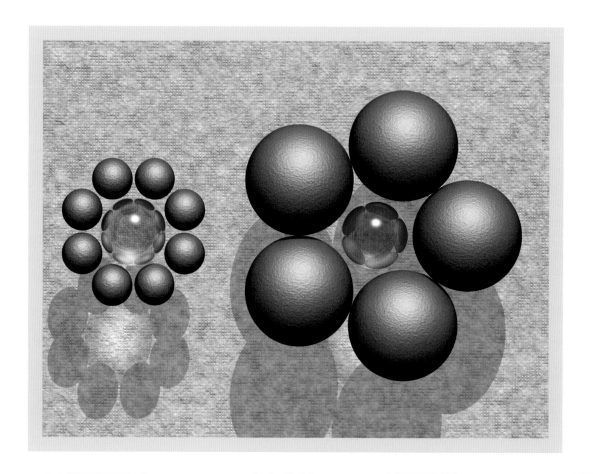

The two rose crystal balls may look different, thanks to the shadows reflected from their surfaces and the sizes of the surrounding cannon balls, but they are the same size.

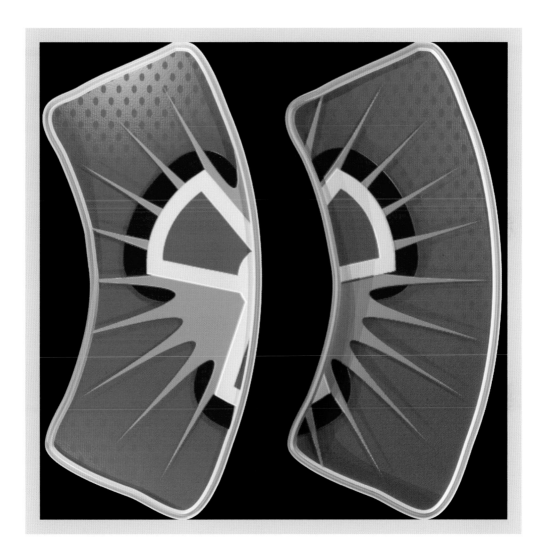

The long curve of one banana-shaped card is purposely placed next to the short curve of the opposite card. Is one banana-shaped card slightly larger than the other?

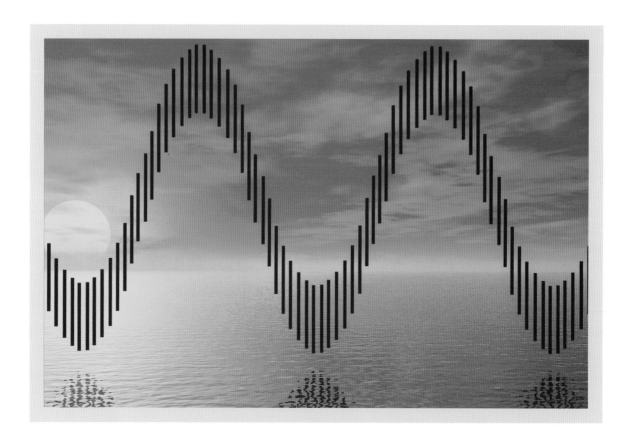

The tiny vertical lines are all the same length, yet they give
the impression that they vary in length throughout.

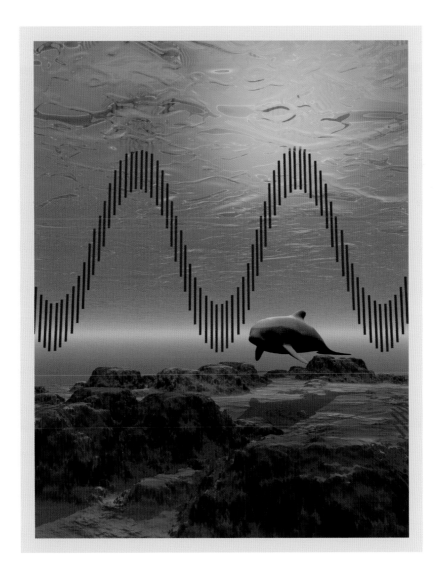

Use your ruler to prove that the lines in this
underwater scene are all the same length.

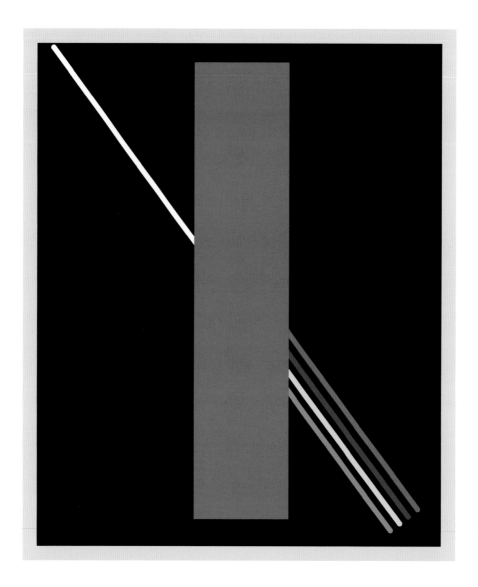

Which color line segment most closely lines up with the white segment on the left?
If you chose the blue segment, look again! Yellow is the correct answer. A ruler will prove it.

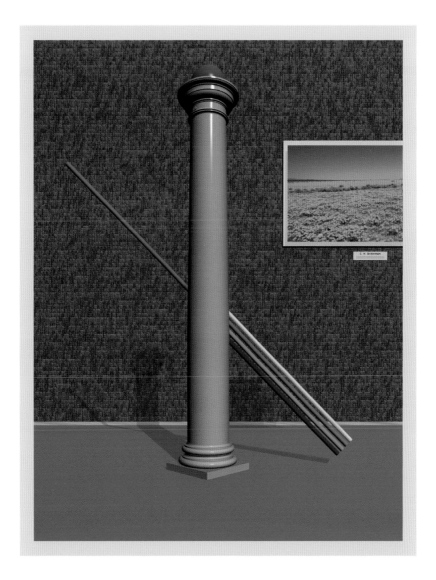

The red line appears as though it is continuous. It is not.

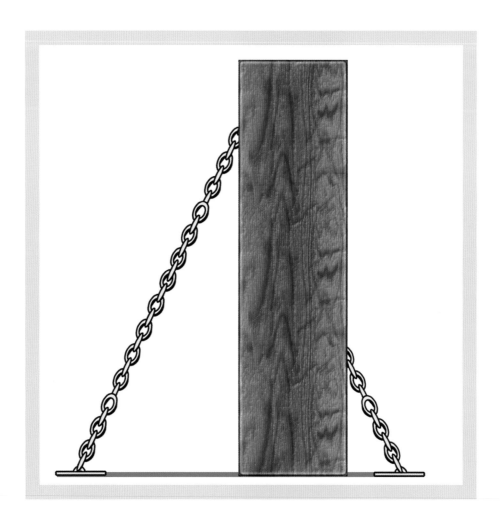

Believe it or not, the length of chain is continuous
and meets the other half behind the board.

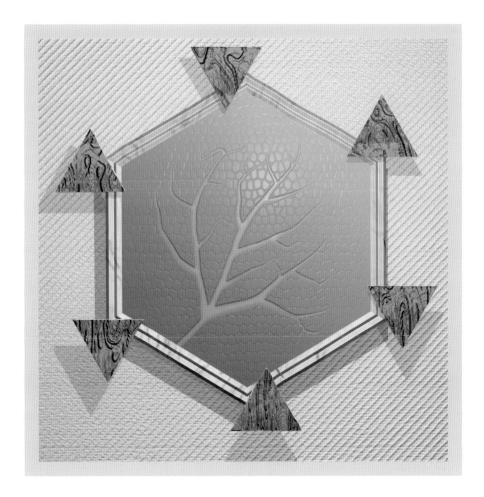

This treaded step plate is being distorted by a few distracting triangle shapes placed at the corners. For some reason, we cannot quite grasp the plate as a uniform hexagon shape behind the triangles.

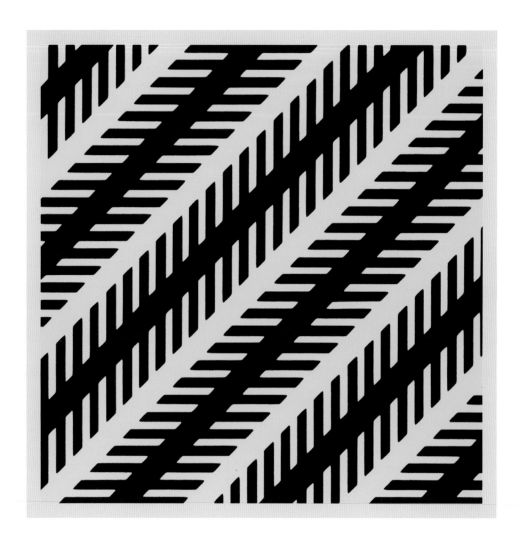

In the *Zöllner* illusion, reversing the direction of intersecting lines in alternate rows makes the parallel diagonal lines appear crooked.

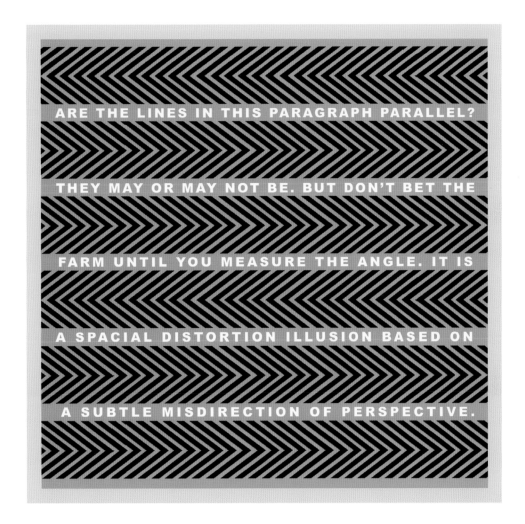

ARE THE LINES IN THIS PARAGRAPH PARALLEL? THEY MAY OR MAY NOT BE. BUT DON'T BET THE FARM UNTIL YOU MEASURE THE ANGLE. IT IS A SPACIAL DISTORTION ILLUSION BASED ON A SUBTLE MISDIRECTION OF PERSPECTIVE.

In this horizontal pattern of *Zöllner* stripes, are the lines of text parallel? Use your ruler.

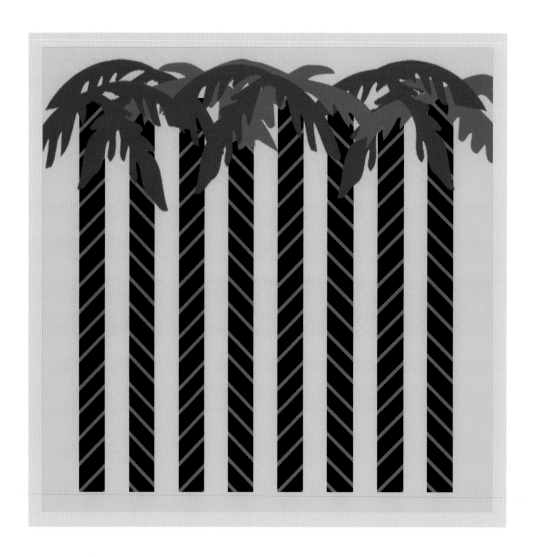

All of the trees in this stand of palms are perfectly straight up and down.

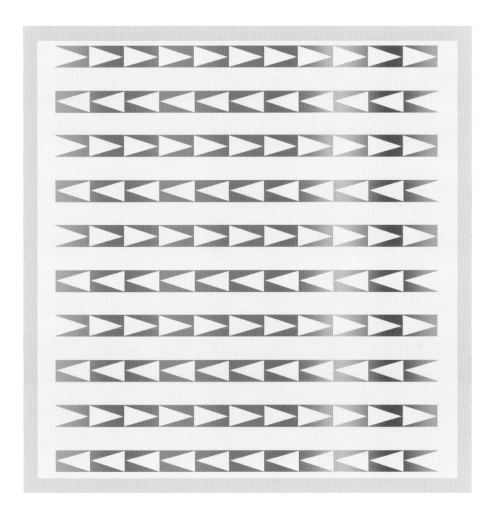

The motif in this distortion effect appears to narrow slightly in the opposite
direction of the arrowhead symbols. Notice that the design is full
of alternating herringbone patterns. Zöllner has struck again!

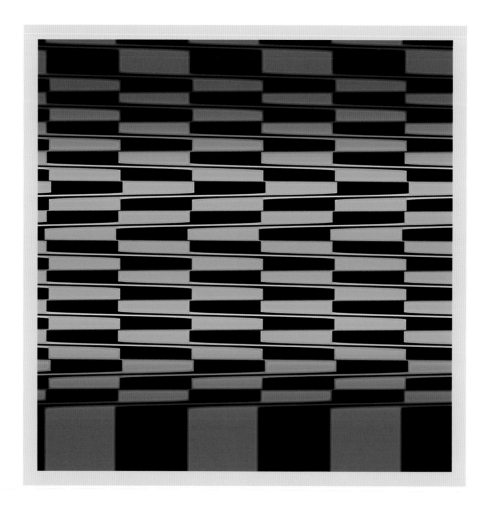

Are these rows of black and white tiles sloping upward or downward from left to right? Or are the rows parallel? Use your ruler.

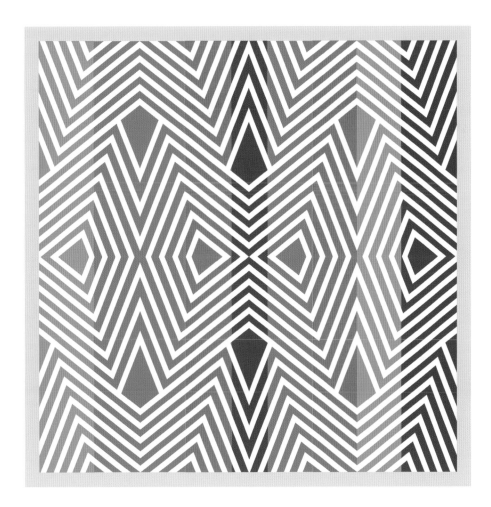

Are the colored stripes of this funky tribal rug design crooked or straight? Use your ruler.

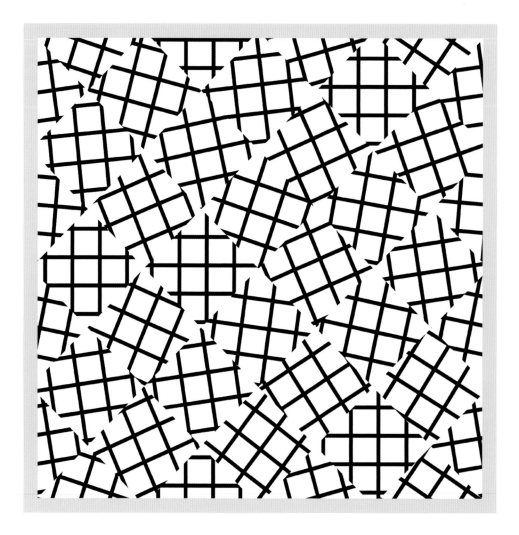

Are these black-and-white squares arranged in neat rows or jumbled together? The differing orientations of their crisscrossed patterns create a visual mess.

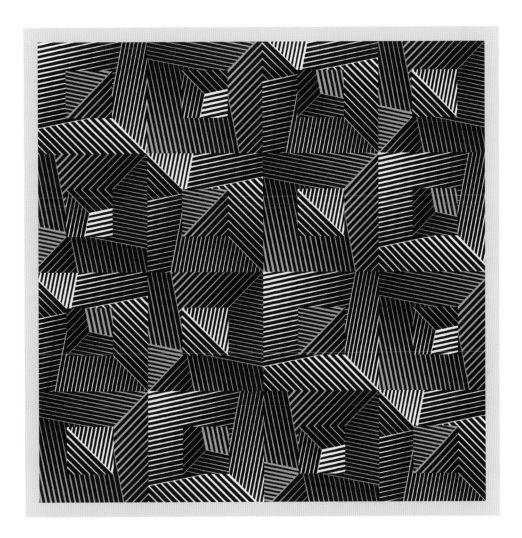

How many squares can you make out of this mess of stripes?
Are they neatly arranged? The varying thickness and orientation of
striped patterns provides the illusion of a jagged 3-D surface.

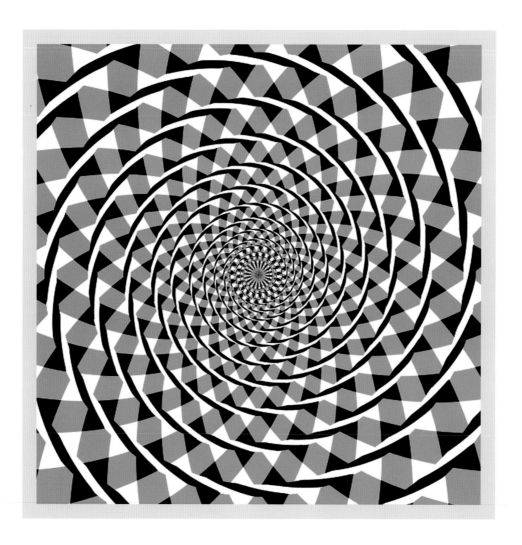

Fraser's Spiral is an amazing distortion that is often called the *Twisted Cord* illusion because of a braided effect within the "spirals." However, this image is not a spiral at all.

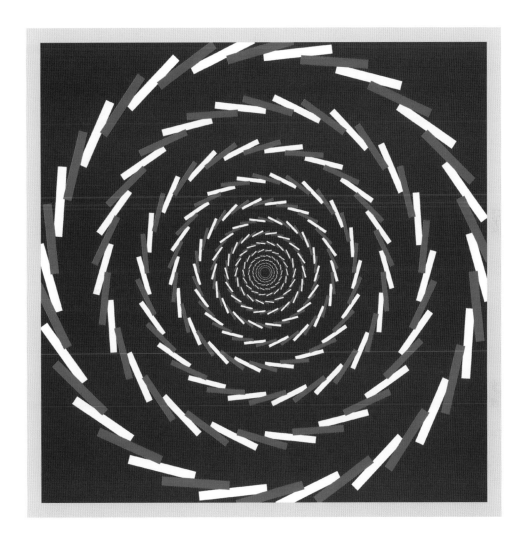

This illustration looks like a spiral, but is it really? Trace it with your finger.

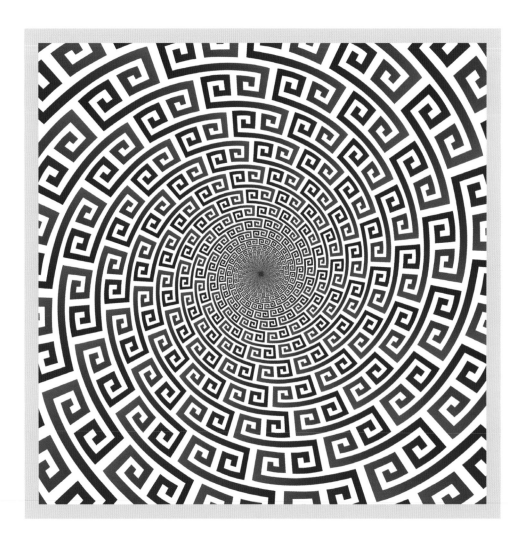

These meandering Greek patterns give the illusion of a spiral, but is the spiral really there?

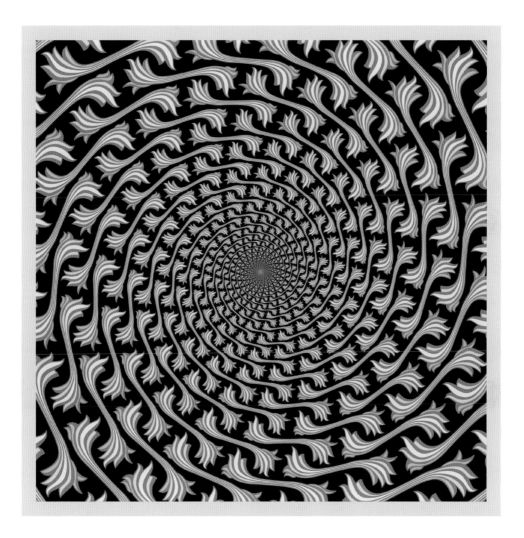

This pattern of flames has the appearance of a hellish vortex,
but the spiral is—once again—an illusion.

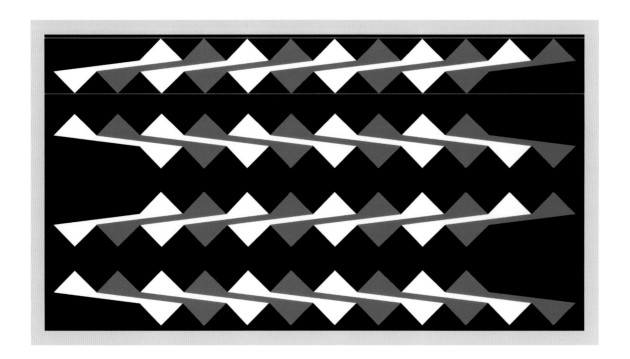

Here is a simplified version of *Fraser's Spiral*. The first row has red guidelines added to demonstrate that the patterns are actually parallel. Each pattern is alternately reversed so that they appear to zigzag from top to bottom.

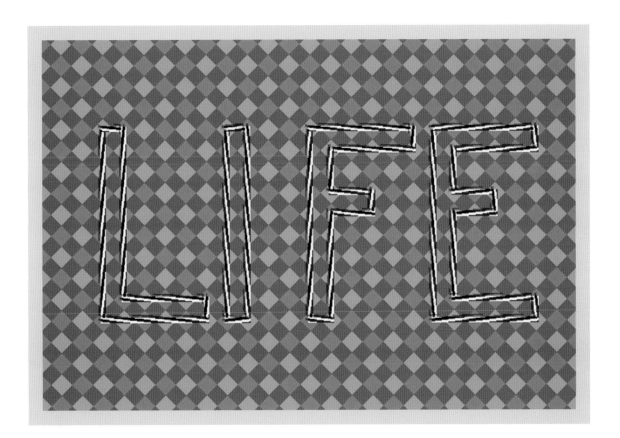

The individual letters for the word *LIFE* in this design are actually straight. However, the braided effect makes them look crooked. Only a ruler will prove otherwise.

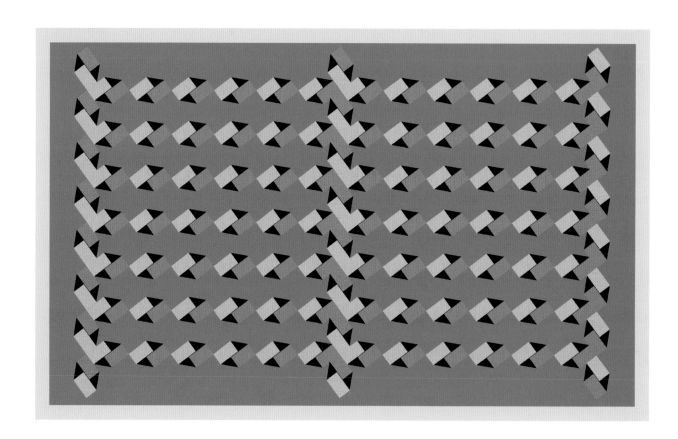

This tilted fence design uses a "blocky" form of the Fraser distortion technique. We can't help but see it as leaning to the right.

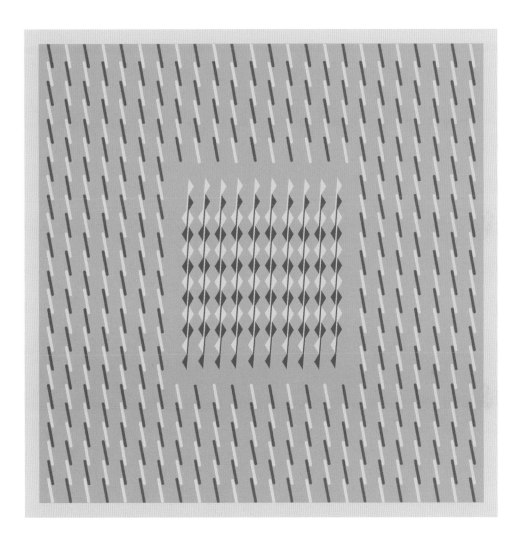

When parallel rows of left-leaning segments are placed around it, the Fraser "twisted rope" effect in the inner square is even more pronounced.

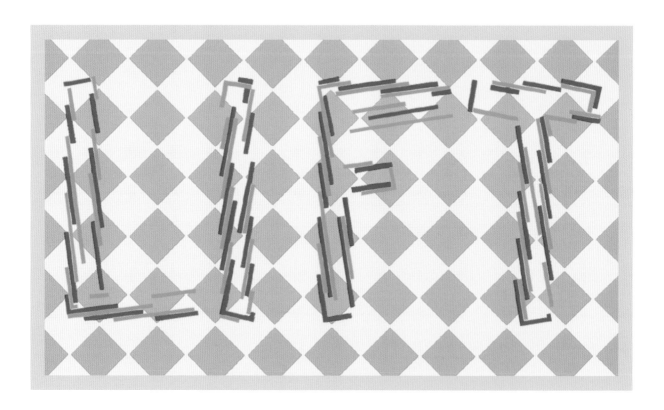

The letters in this image appear tilted, but are they really?

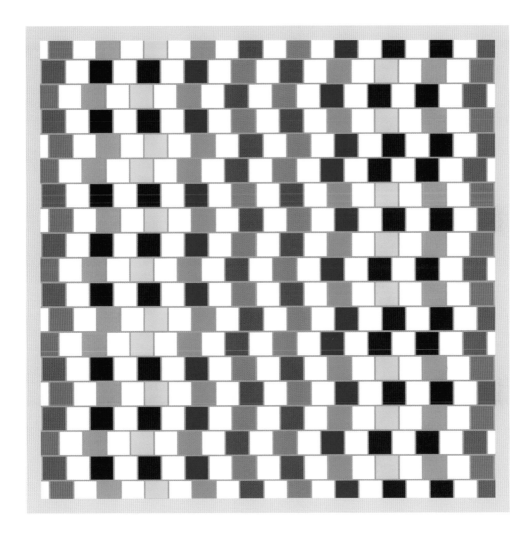

Are the rows in this design parallel to one another? Strategic placement
of colored squares seems to twist them out of shape.

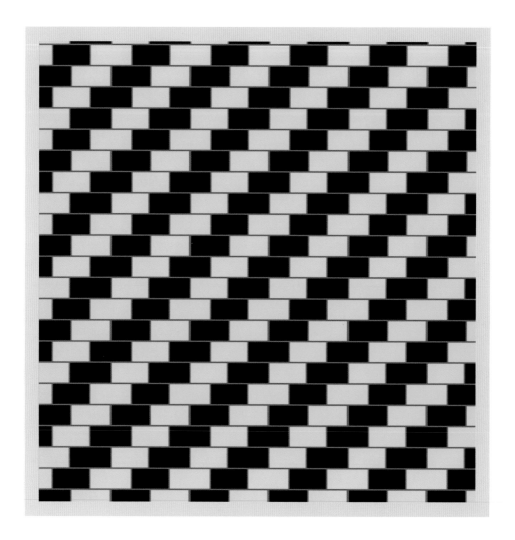

This tilting pattern of tiles is not tilting at all.

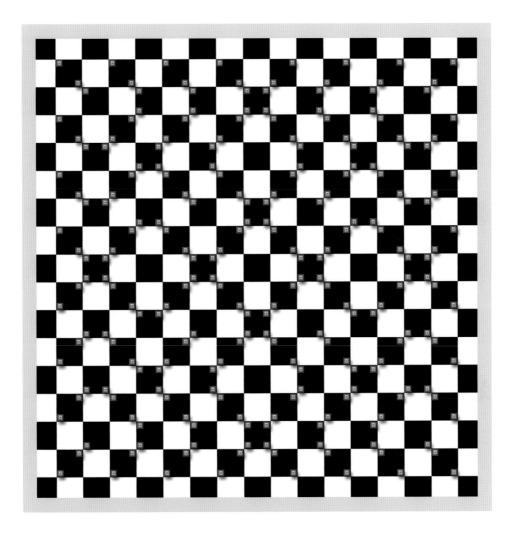

This checkerboard appears at first to be distorted, but it's not. Each of the overlaid elements has very little effect individually, but together they produce a considerable effect. Grab a ruler and see for yourself.

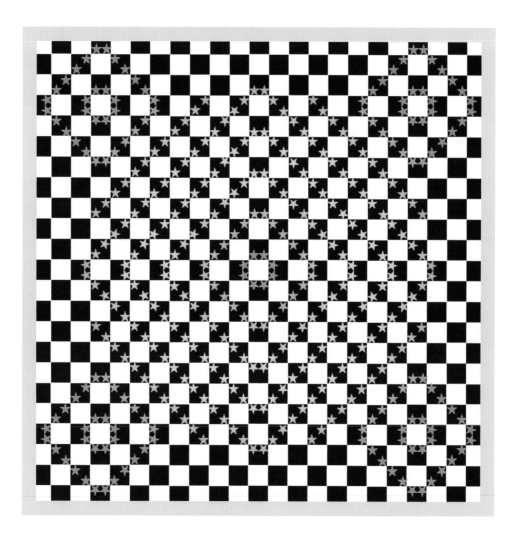

This checkerboard is being visually distorted by stars placed strategically among the rows.

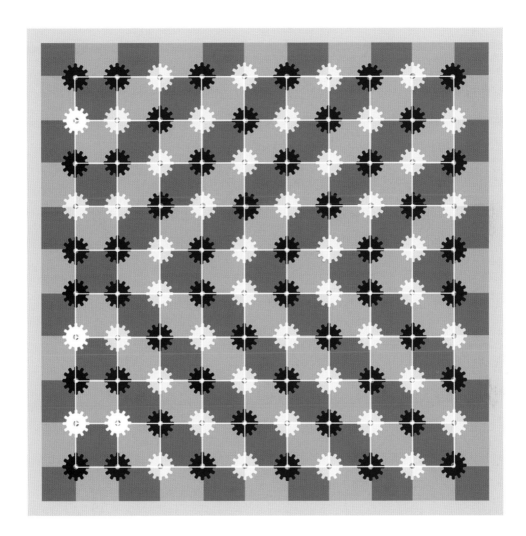

The gears drive the distortion we see here.

AMBIGUOUS
FIGURES

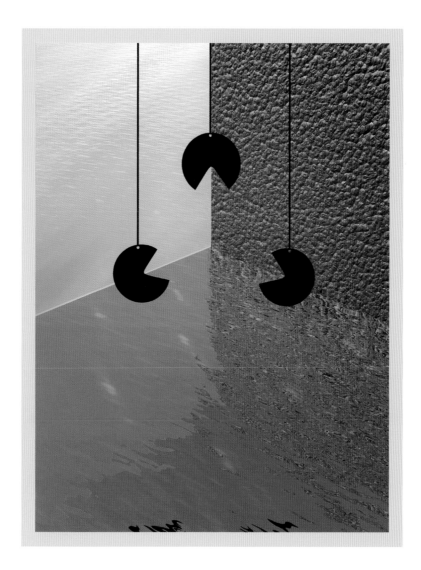

In this scene, we see an interesting kinetic sculpture hanging over a reflective pool.
Can you find a subjective floating pyramid in the scene?

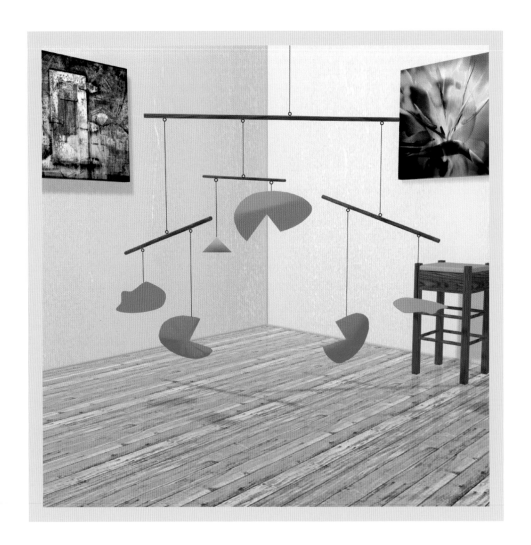

Can you find the subjective pyramid in this scene?

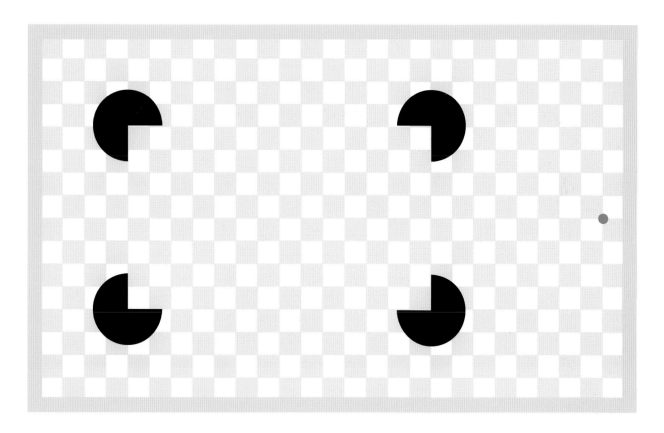

Stare for several moments at the red dot to the right of the subjective rectangle surrounded
by the Pac-Men shapes, but keep the subjective rectangle in the corner of your eye. Did the illusory
contours of the rectangle disappear? Direct your eyes again at the rectangle. Did they reappear?

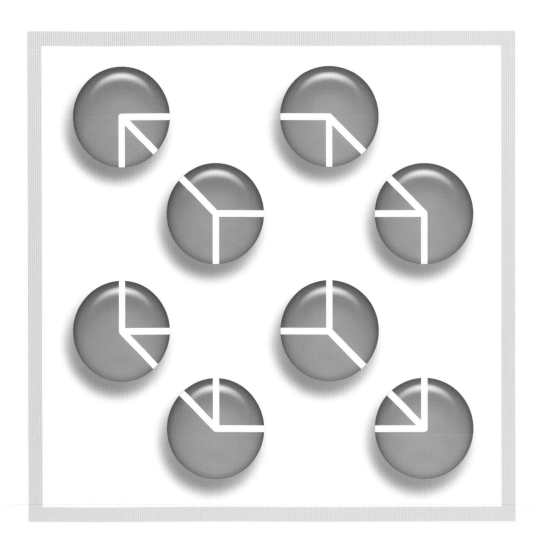

Can you discern the outline of a cube in this collection of green and white circles?

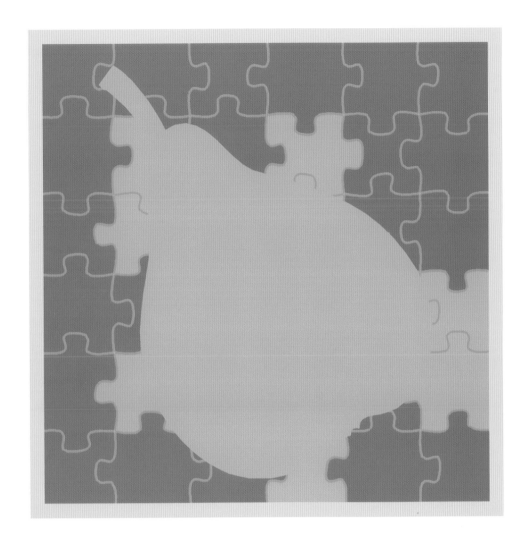

These green puzzle pieces also form the outlines of a certain type of fruit. What is it?

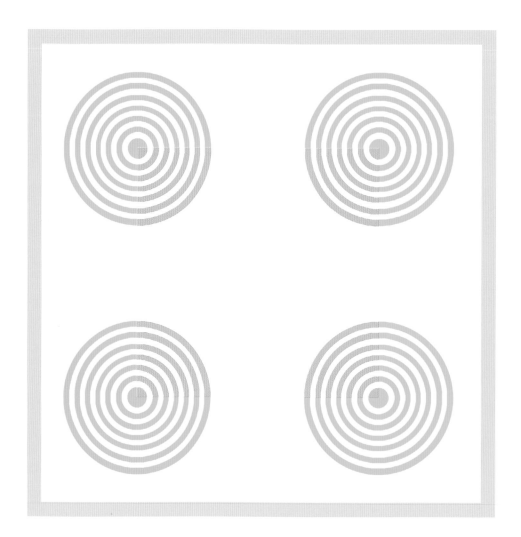

These four concentric circles are each one-quarter purple,
but can you see the square peeking through the design?

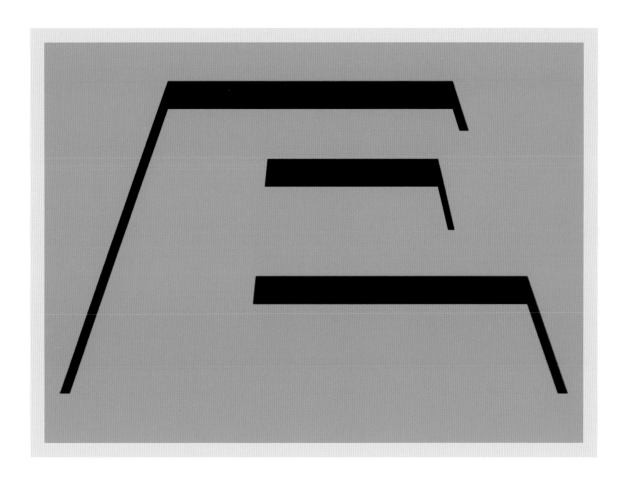

This design may look like a stylish logo for a new condo building, but it is actually something else. What is it? See page 315 for the solution.

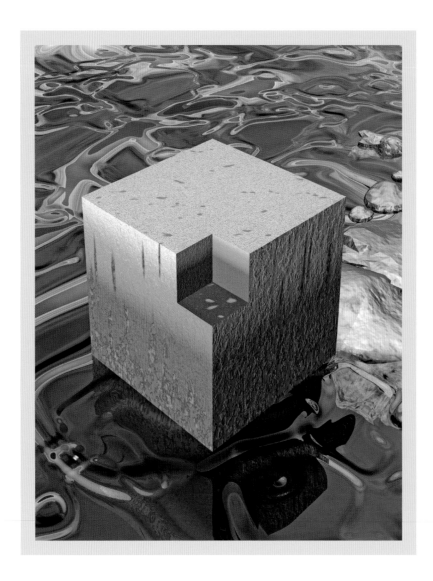

This cube is three-times ambiguous. Do you see the normal cube with a corner missing?
Or a hollow, three-sided room with a small cube sitting in the far corner?
Or a small cube floating in front of a larger cube?

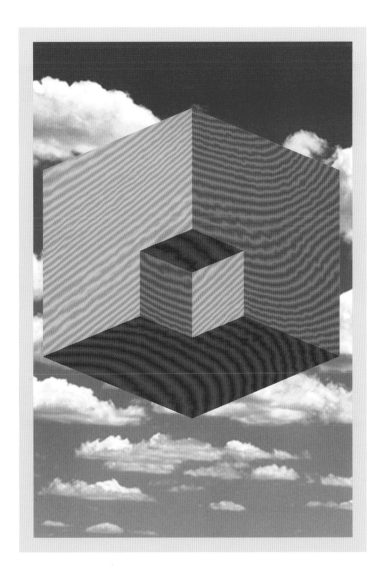

Can you visualize all three illusory aspects of this wooden variant of the cube illusion?

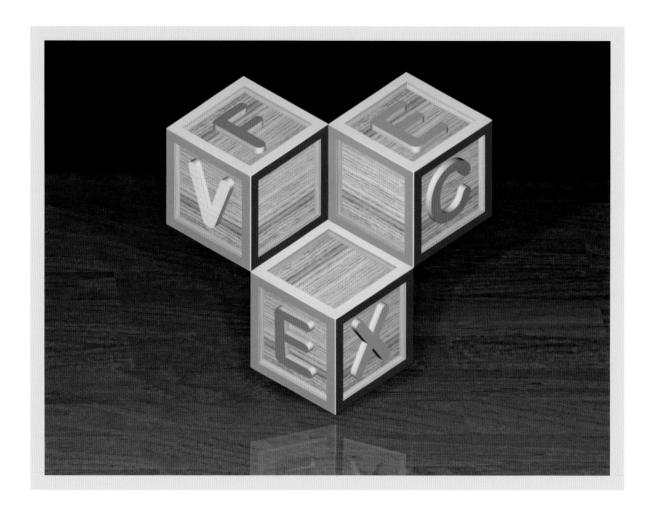

Is this a collection of three baby blocks, each with one blank face, or a collection of four baby blocks, with the center block displaying three blank faces?

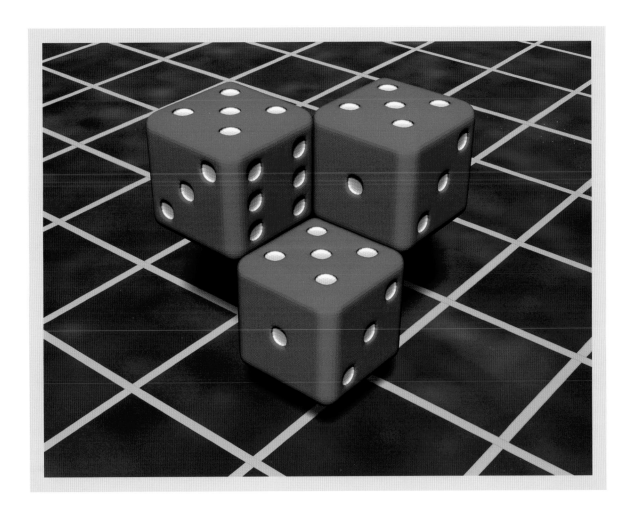

Are you looking at three die, or four?

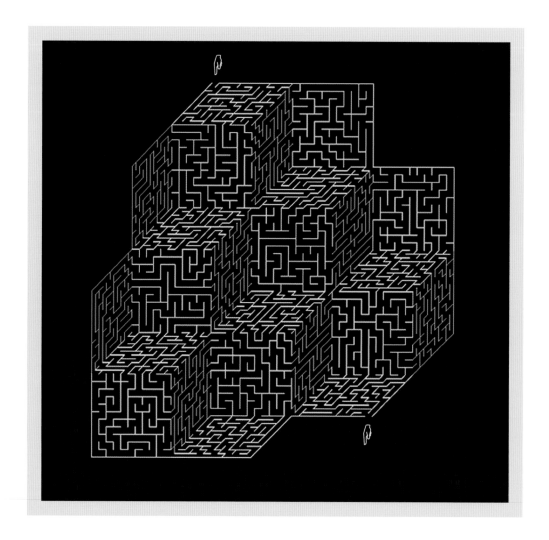

Are there five cubes or seven? Some of these cubes have no right to exist except by virtue of their nearest neighbors. It's also a monster of a maze.

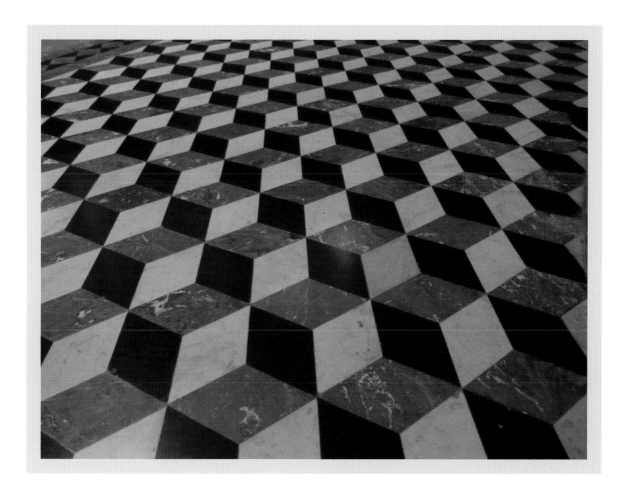

This stack of ambiguous cubes is actually a two-dimensional marble pattern on the floor of the Marmoutier Abbey in Alsace, France.

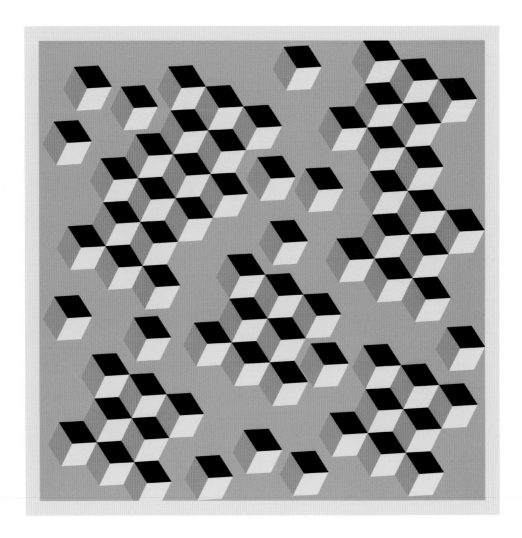

How many subjective cubes can you find in what initially looks like several floating cubes randomly assembled into groupings? Hint: consider for a moment that the yellow faces are reflecting the light of a lamp located above them, rather than below them.

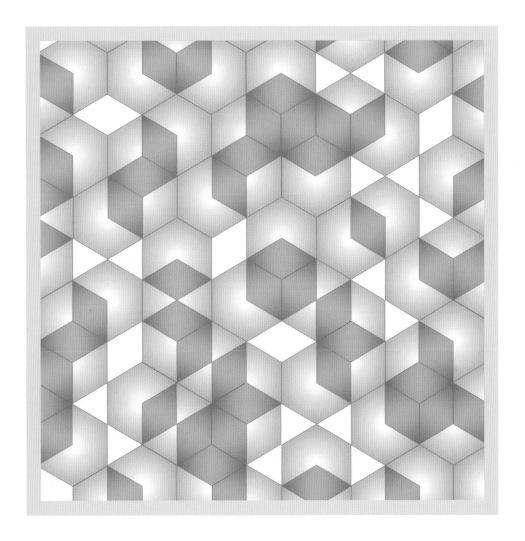

How many cubes can you identify in this design?

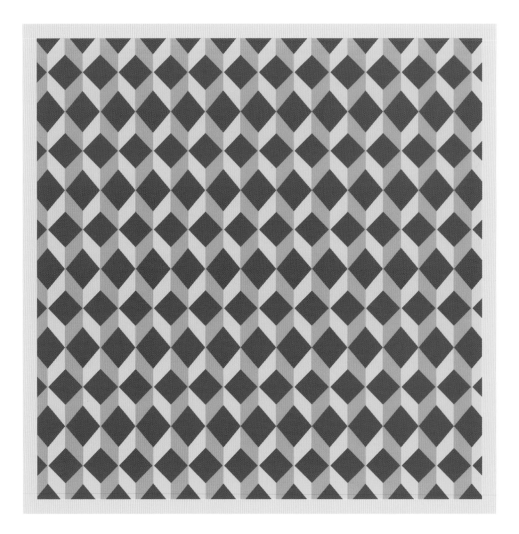

These cubes all have dark-colored tops. Now, visualize all of the
cubes with dark-colored bottoms. They are now bi-stable.

These rectangular bricks have dark faces oriented downward.
Visualize all of the bricks with the dark faces on top, oriented toward the
upper right-hand corner. You are now in the Ambiguity Vortex.

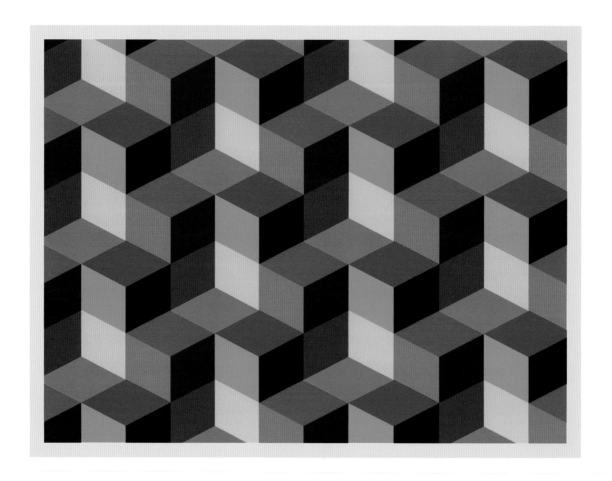

Is the light source shining on this stack of cubes located to the lower left or upper right?

These wooden lanterns could be seen as hanging above us or below us.

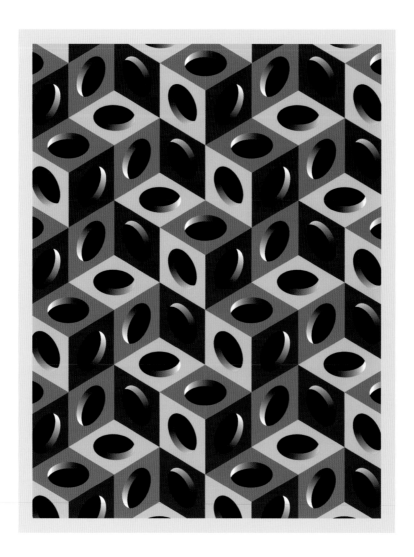

Presented with such a random assemblage of brown, beige, and black hollow cubes, it's not easy to tell where one begins and the other ends.

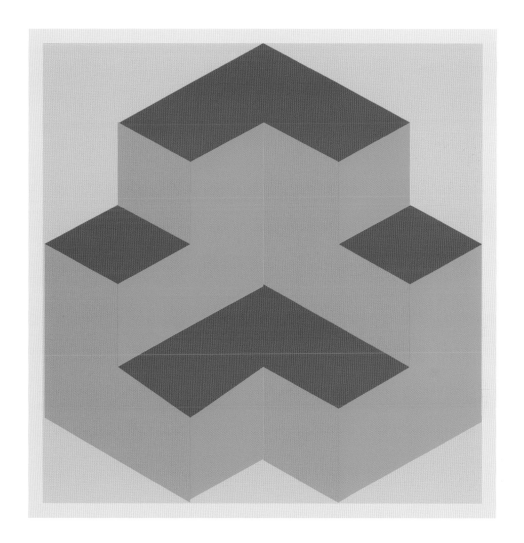

In this an angular 3-D object, or is it an oddly shaped cavity
carved into the space between two adjoining walls?

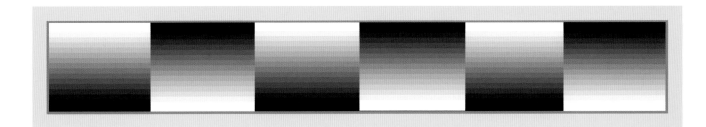

The three sections with light tops look like humps, while the three with dark tops look like hollows. Try to imagine that the reverse is true.

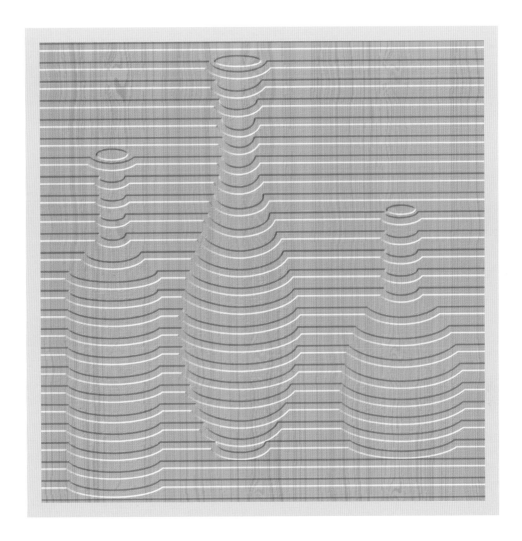

This is a design for a master's class in wood routing. The wine bottles do not exist except for the carefully executed grooves from whence they come.

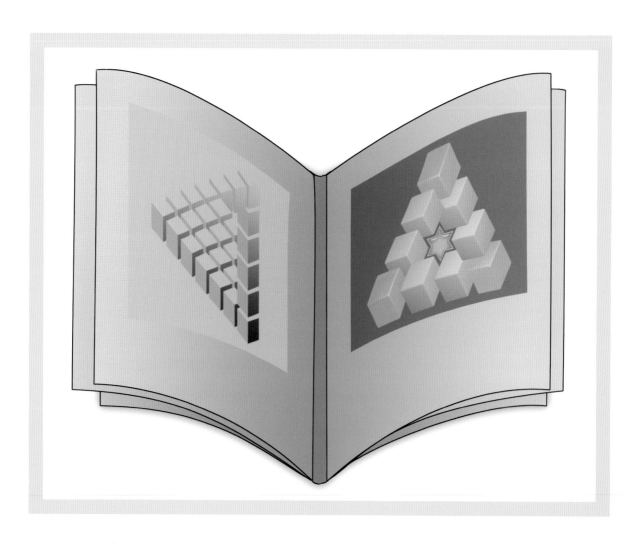

Is the book open and facing you, or is it open and facing away from you?

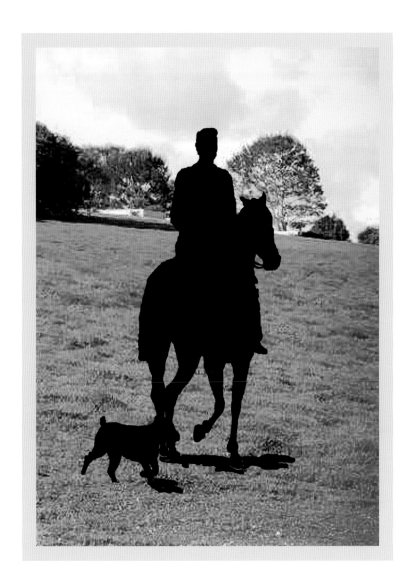

Is this horse and rider coming or going?

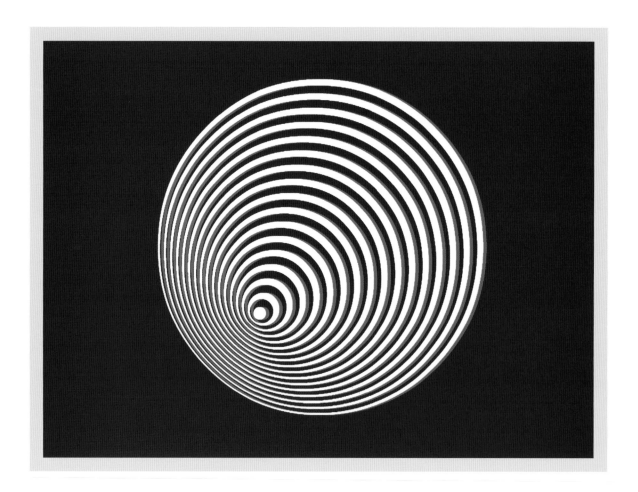

Is this design a cone or a tunnel? It can be both, and our brains are happy to oblige either delusion.

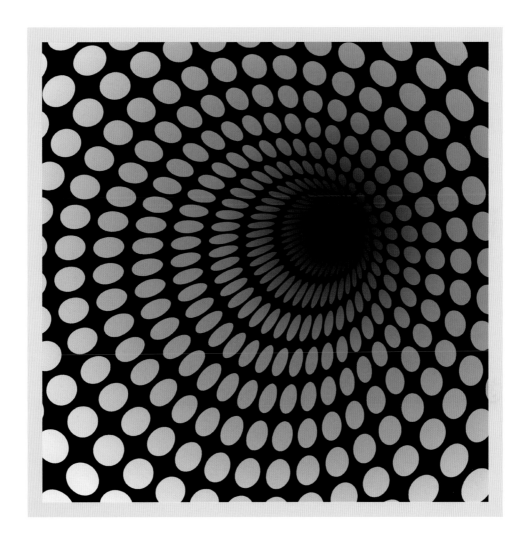

Do you see a wormhole or a circus tent?

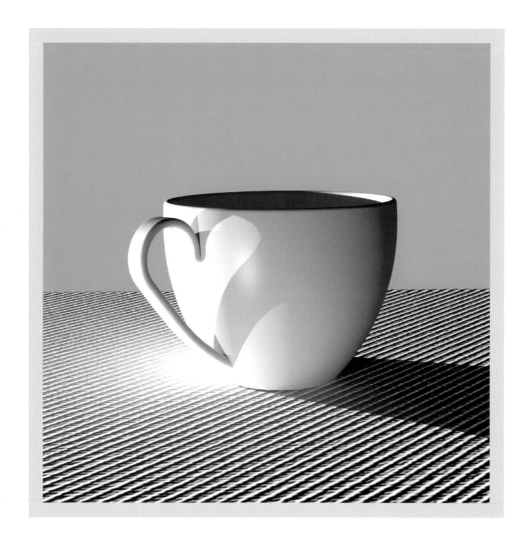

The shape formed by the cup's handle and its shadow makes this design
a great candidate for a Valentine's Day card for coffee lovers.

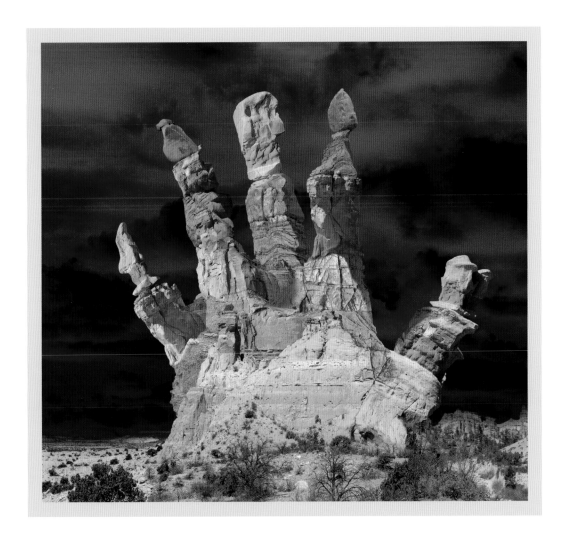

This unusual rock formation resembles the human hand from a distance.

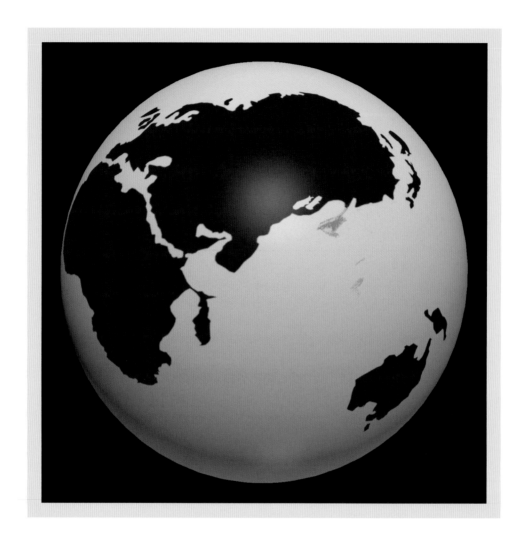

This globe has some familiar-looking continents.
Can you find a profile of a woman in the design?

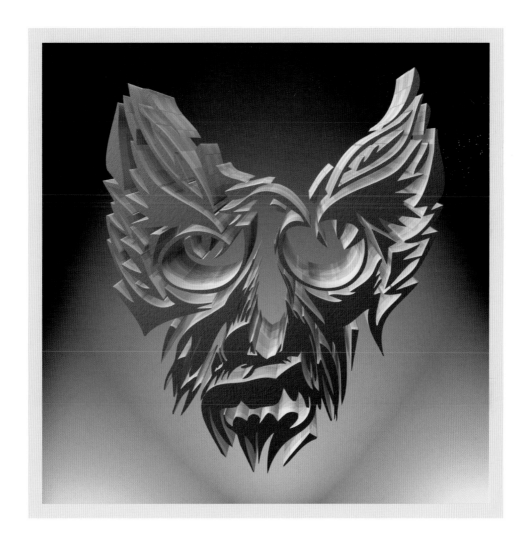

This design for a scary mask can be seen as a bearded wizard, or . . . what?

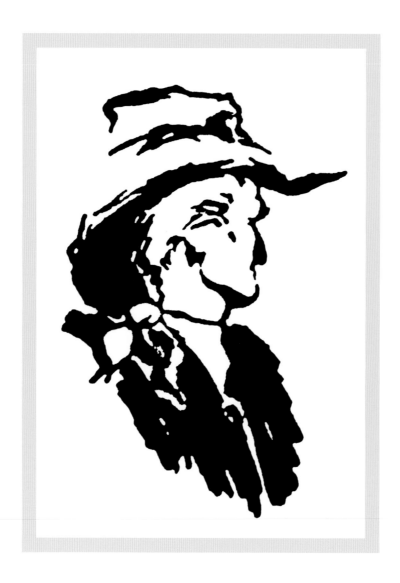

Do you see a grizzly old geezer, or a young cowboy?

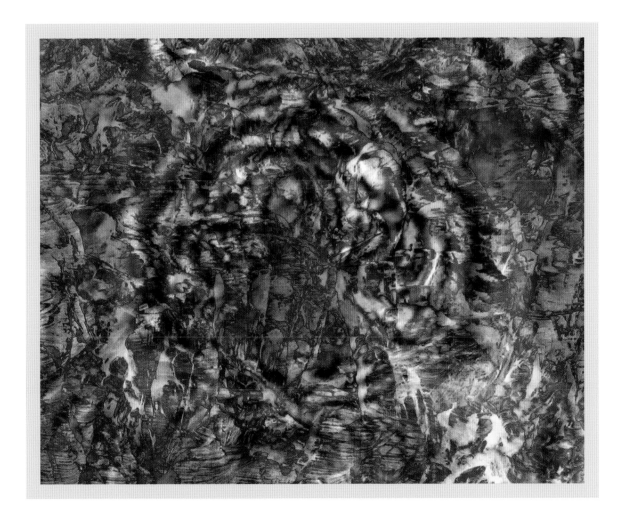

Within this abstract artwork is the face of an animal
that is especially adept at camouflage. Can you find it?

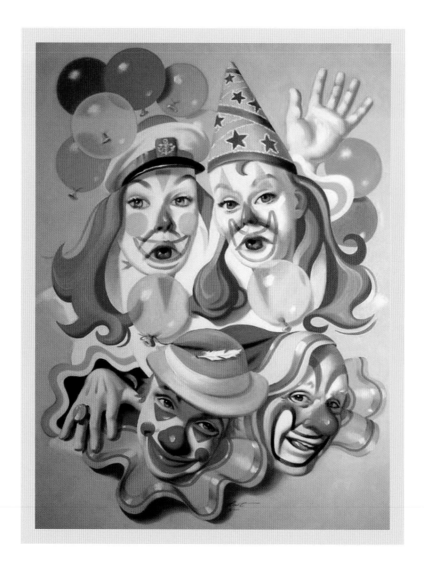

You may see only four clowns until you look closer.

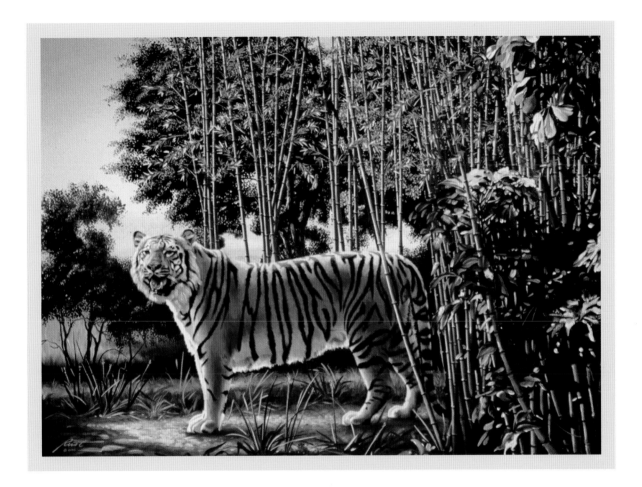

This is a most ingenious ambiguity. Can you figure out why?
Examine the tiger very carefully.

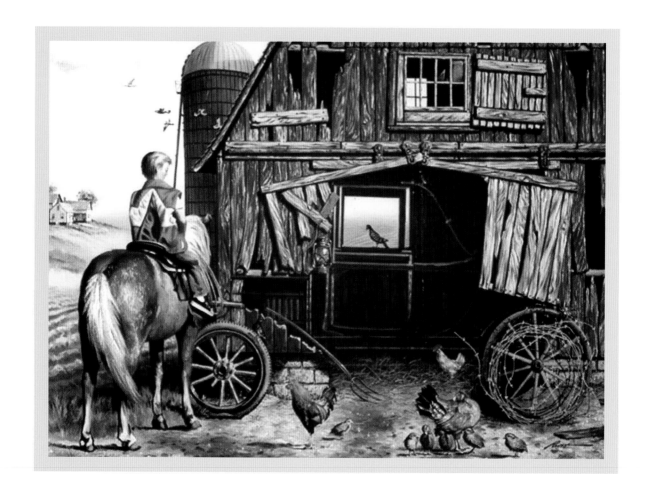

What is the boy dreaming about?

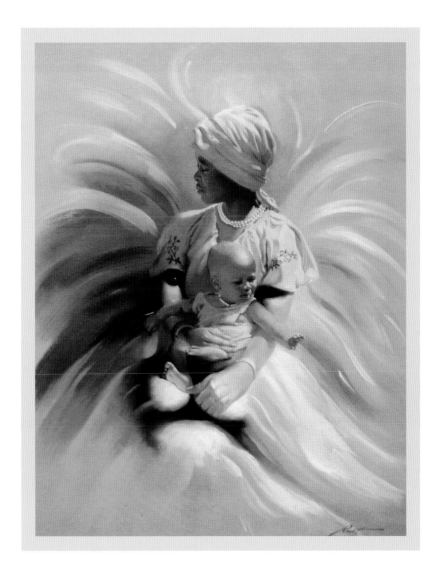

A lovely African woman and her child are haloed
by golden grass in this painting. Where is the lion?

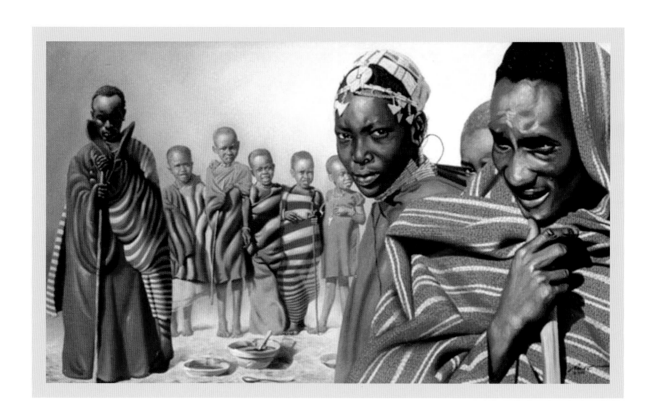

At first glance, there are only nine people visible.
Can you identify the tenth friend?

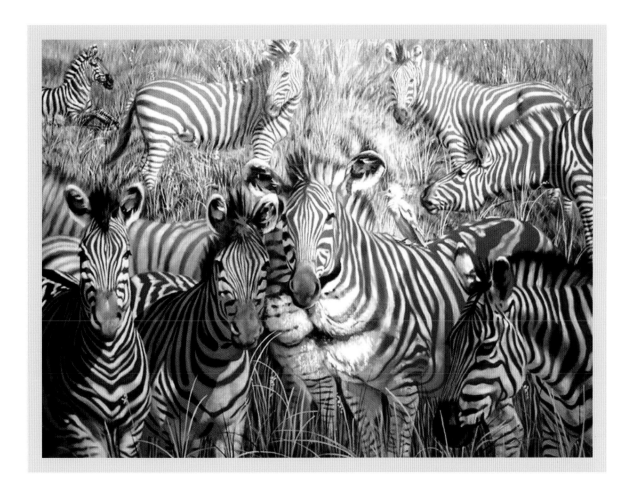

This painting depicts a herd of zebra. Can you find their predator?

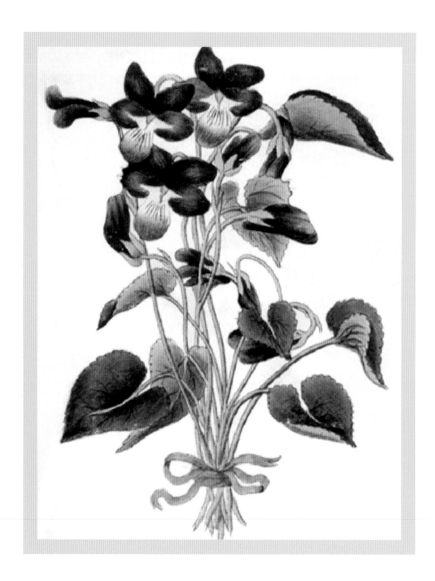

This picture of a sprig of violets contains the profiles of
Napoleon Bonaparte and his family. Can you find them all?

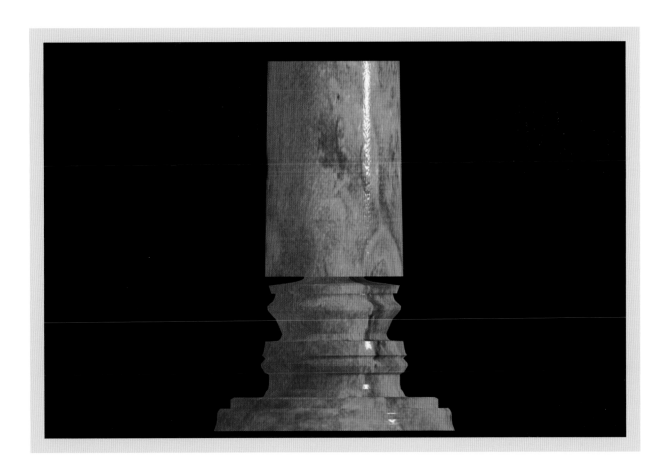

Can you find Abraham Lincoln's profile in this sculpture? Is the profile
part of the sculpture or part of the background? Or both?

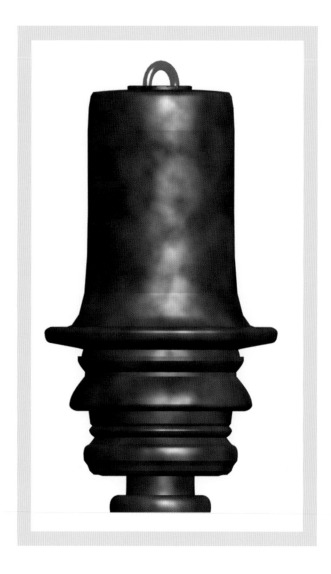

Notice the profile of a popular U.S. president in this design for a bell. Can you identify him?

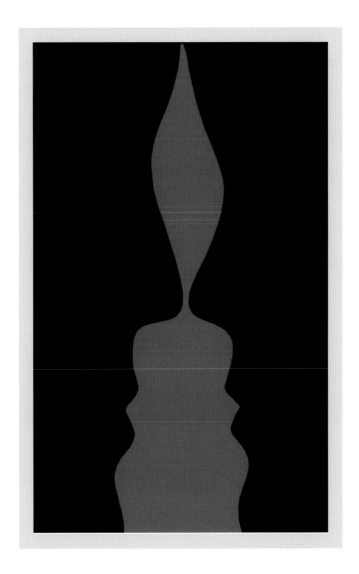

This drawing can be interpreted either as a candle or the profiles of two lovers, face-to-face.

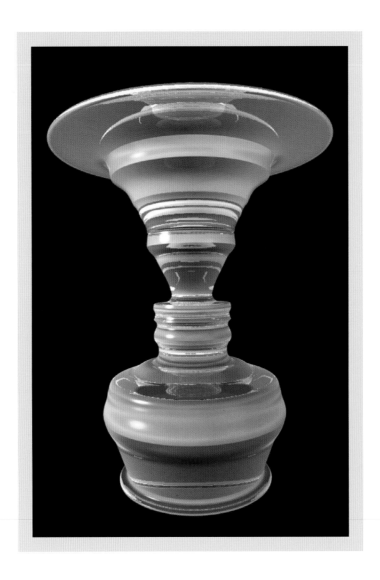

This colorful vase is flanked by the profiles of another U.S. president.
Can you identify him? Hint: examine a dollar bill.

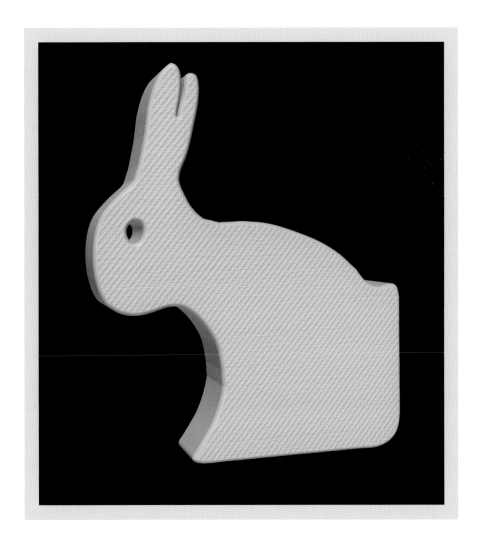

This design for a child's floaty toy could be a rabbit or a duck—or both!

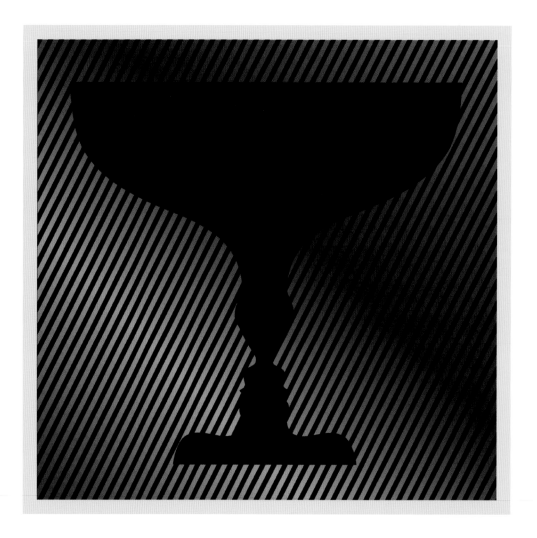

In this classic illusion, do you see a chalice? What else do you see?

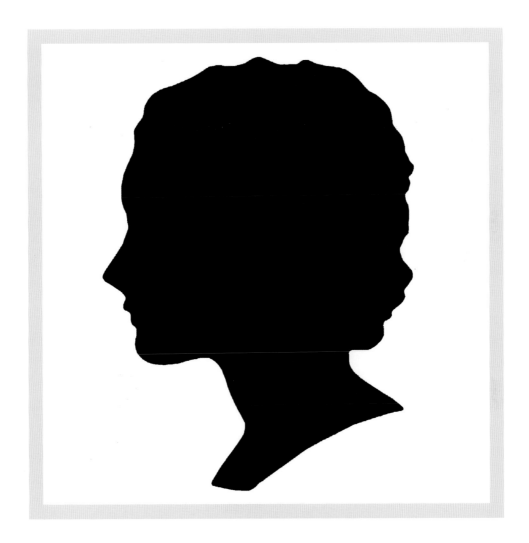

Here is a cameo silhouette of a young mother. Can you find her child's silhouette?

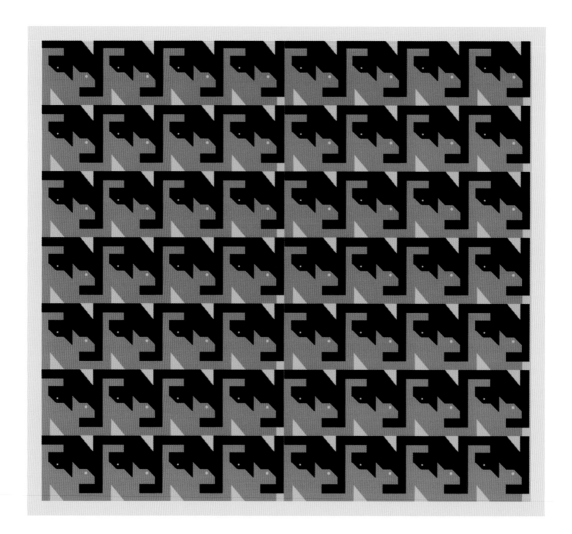

Most of us will see the red cats first because they are upright.
Looking closer, we notice the red-black symmetry and see
black cats in a complementary, upside-down position.

Are these arrows white or green?

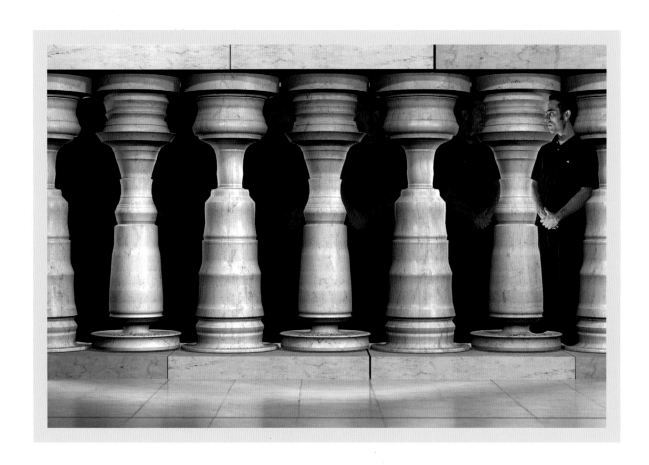

The spaces between these columns do double duty as silhouettes of the artist.

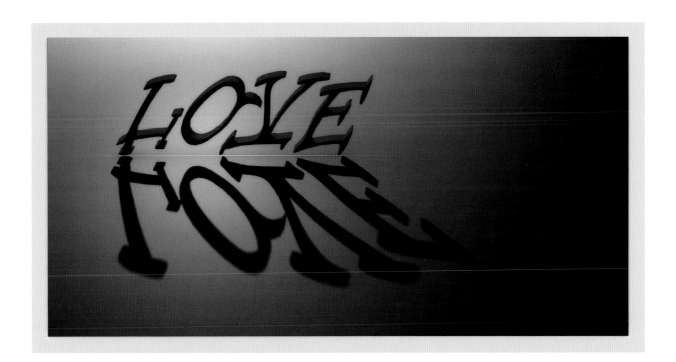

Two words with opposite meanings share the same space.

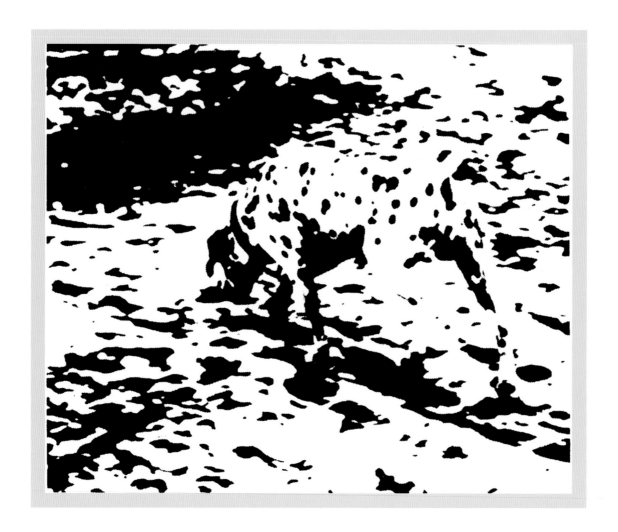

Many of the picture elements that help distinguish foreground from background have been eliminated from this sketch. Can you tell what it is? See page 315 for the solution.

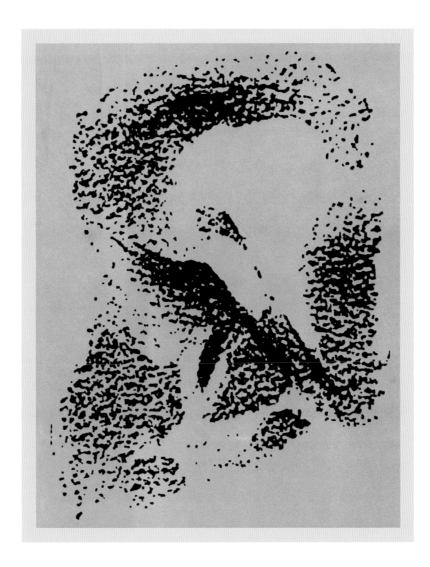

Besides a collection of shadows, what is this?
Hint: the eye that sees all things else, sees not itself.

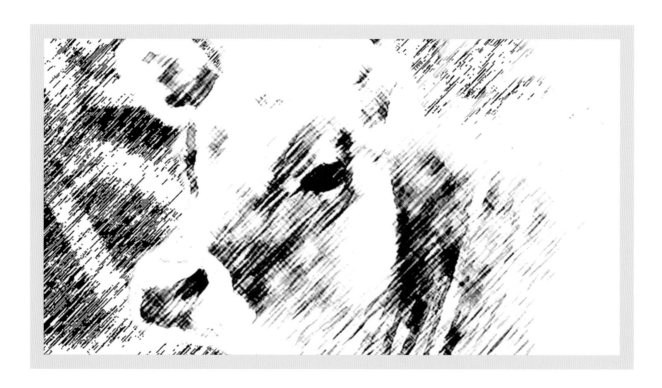

This picture has skimpy visual cues. Can you tell what it is portraying? See page 315 for the solution.

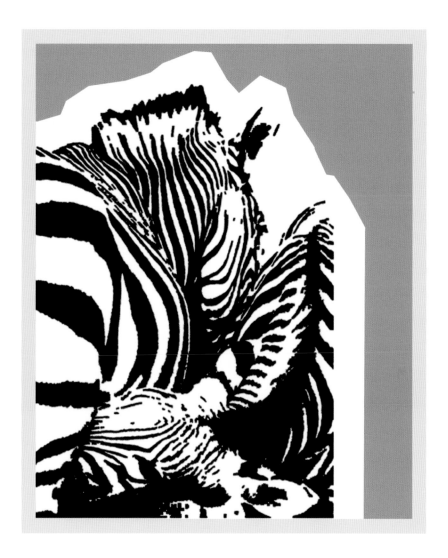

Can you find the zebra's nursing foal in this image?

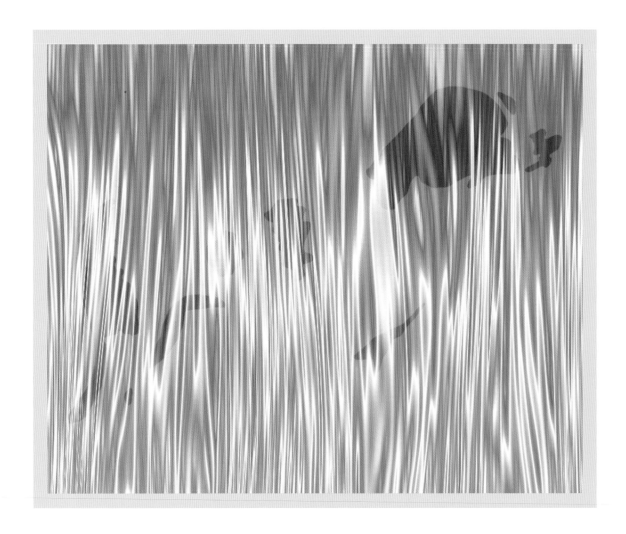

This textured, tempered glass panel is concealing something. What do you suppose it is?

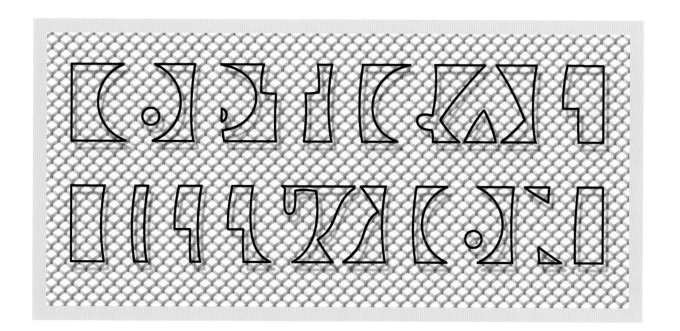

Here, we have an illusion of an illusion.

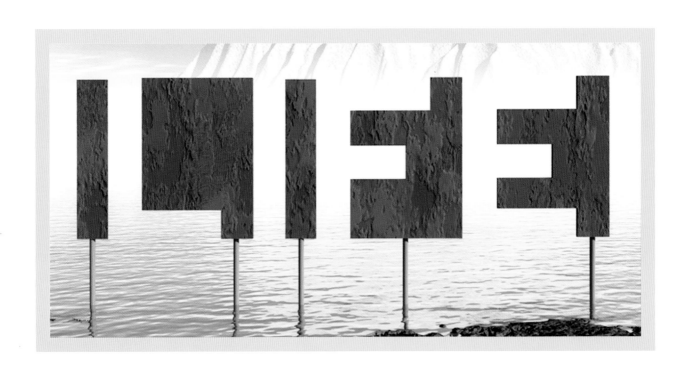

These rusty metal signs actually say something. Can you read it?

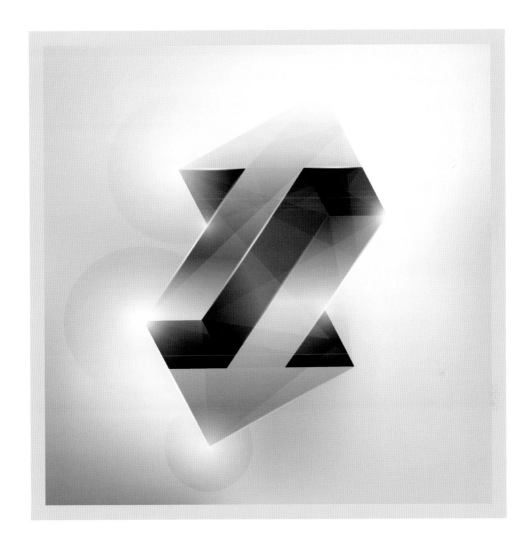

Is the shiny metal arrow pointing upward or downward? Oblige both possibilities.

IMPOSSIBLE
OBJECTS

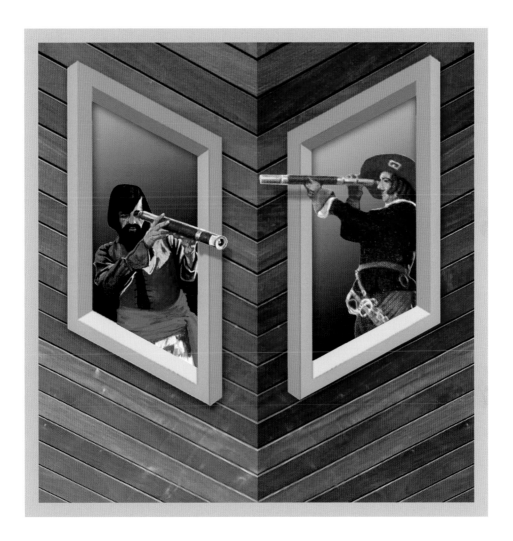

These pirates are having a difficult time finding each other in this picture. What's wrong?

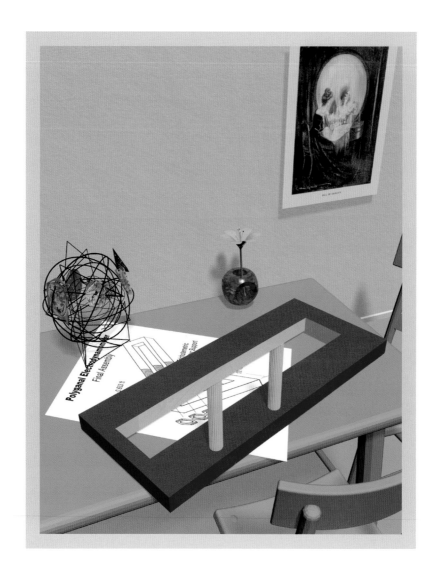

This hollow rectangle inexplicably has two columns connecting the upward face of one side to the downward face of the other side.

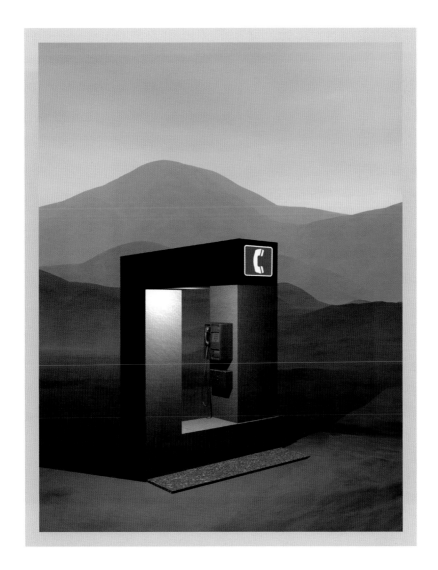

If you happen to be in Roswell, New Mexico, and see this public phone booth, run back quickly to your spaceship because you are not anywhere in the known universe!

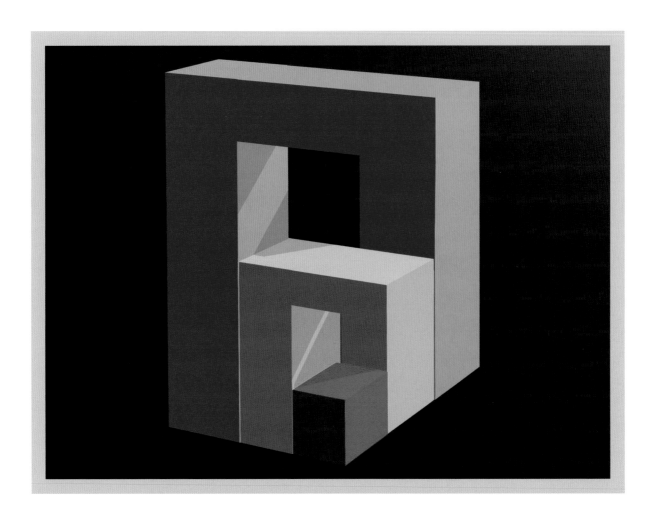

The relationship between these nested objects is not clear.
Are they within or in front of one another?

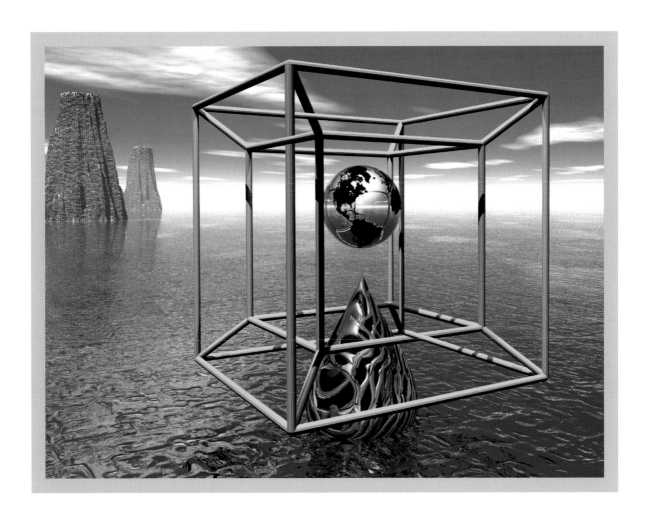

This image of an impossible square within a square is beyond surreal. Can you find all the twists?

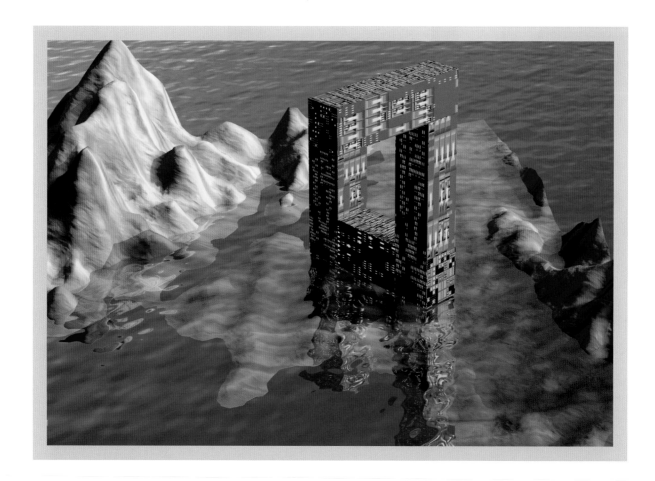

This artist's conception of an ROV (remotely operated underwater vehicle) might have been a candidate to explore the liquid methane seas on Saturn's moon Titan—if it weren't an impossible object.

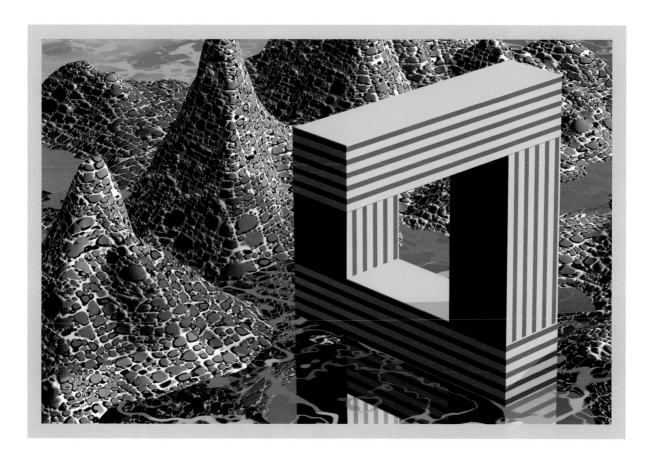

This 3-D structure violates all notions of space and distance.

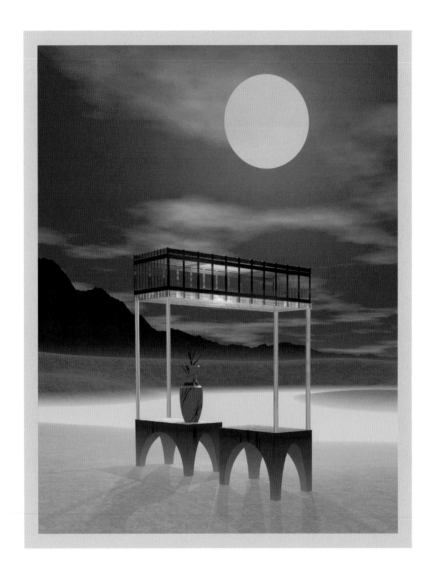

If you come upon this concession stand in the desert, just keep crawling.

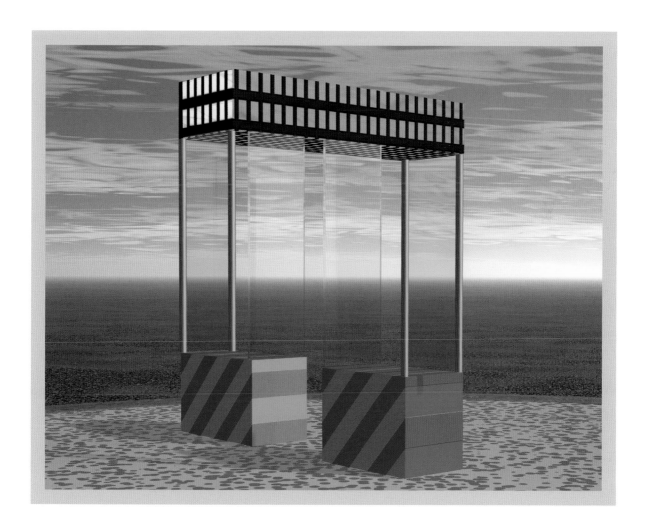

This structure makes sense if you confine your eyes to the sky above the horizon or the ground below, but the two images together defy all logic.

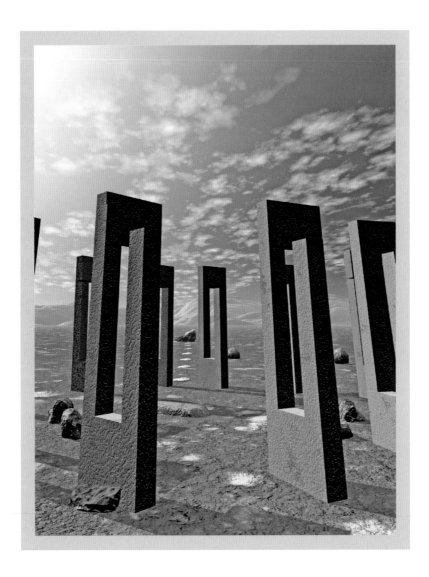

These giant stones appear to have extraterrestrial rather than Neolithic origins.

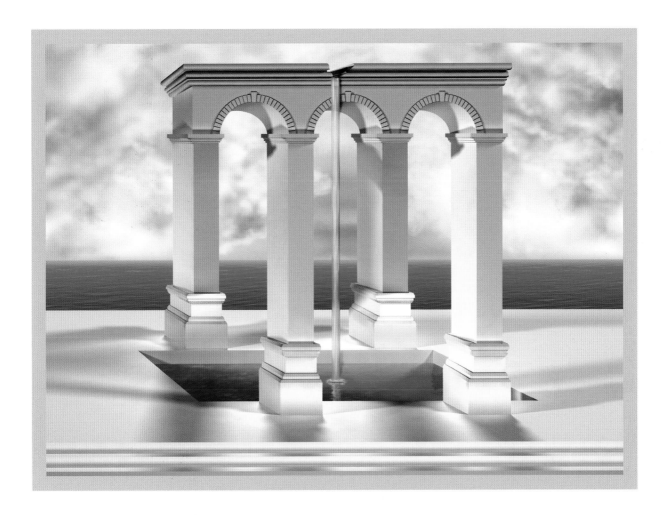

This water feature construction is definitely not possible.

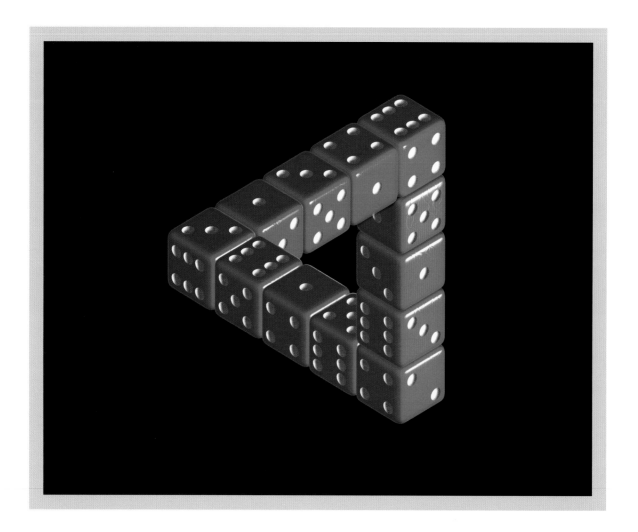

Something isn't right about this arrangement of die. What you're seeing is an adaptation of the Penrose triangle, an impossible object devised by Swedish artist Oscar Reutervärd in 1934.

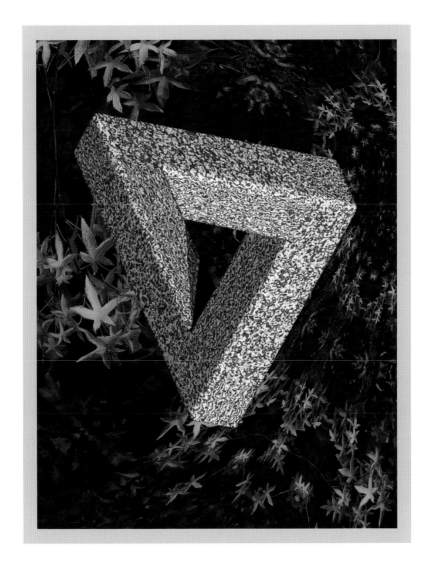

This marble Penrose triangle seems to reflect its leafy surroundings.

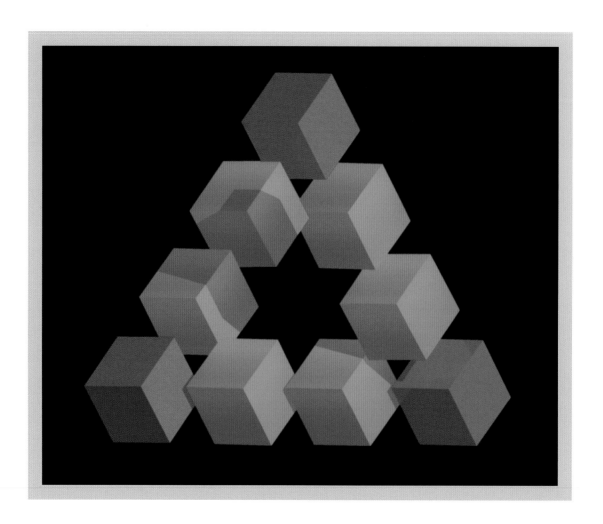

Is this arrangement of cubes possible?

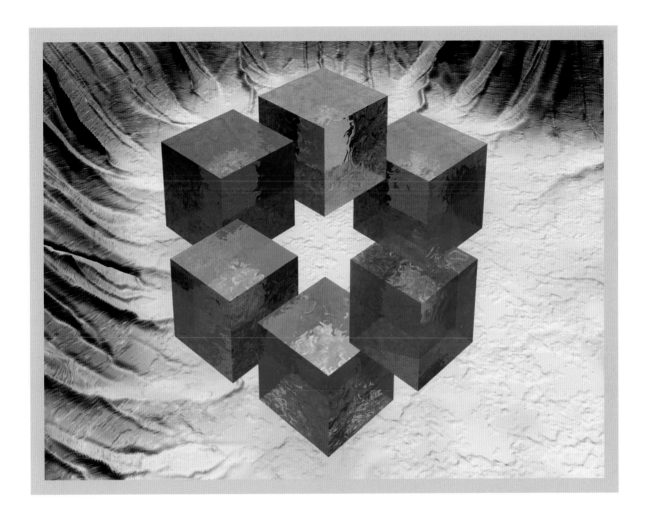

Here, we have an alien arrangement of Martian blueberries.

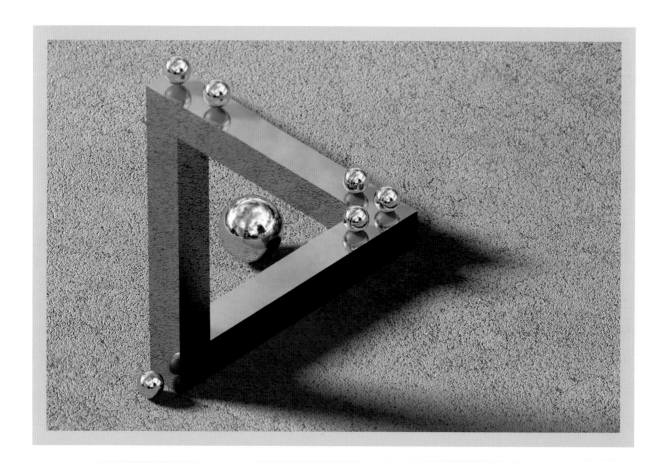

The placement of metal balls emphasizes the impossibility of this mirror-like
3-D model of the classic Penrose triangle. How do they stay put?

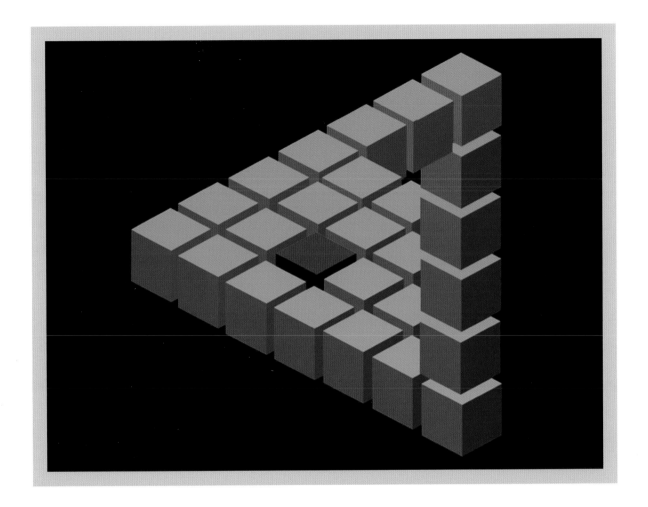

This impossible object is assembled from a matrix of cubes.

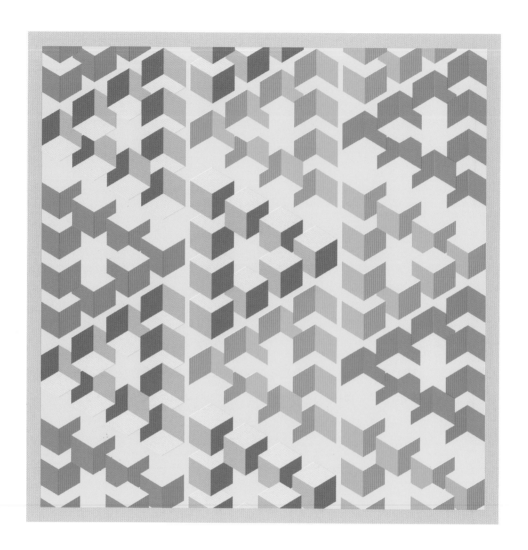

A fun wallpaper shows impossible arrangements arranged in an impossible way.

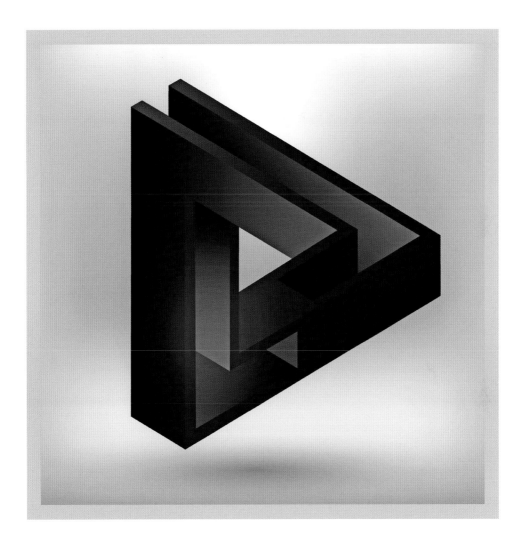

This hollow black triangle makes sense when you take in the top and the bottom of the design, but putting them together is anything but possible.

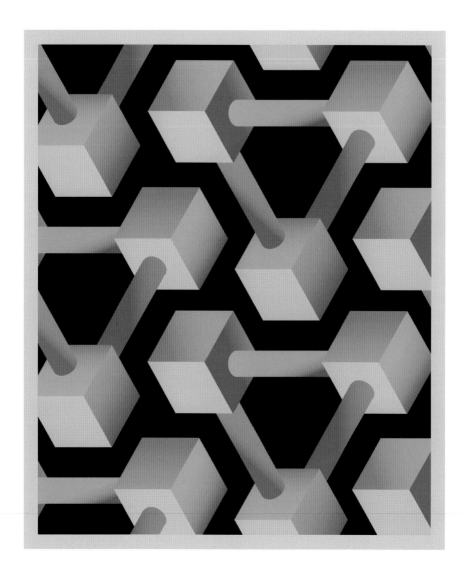

Arranging dowels and cubes in this manner can only be done in two dimensions.

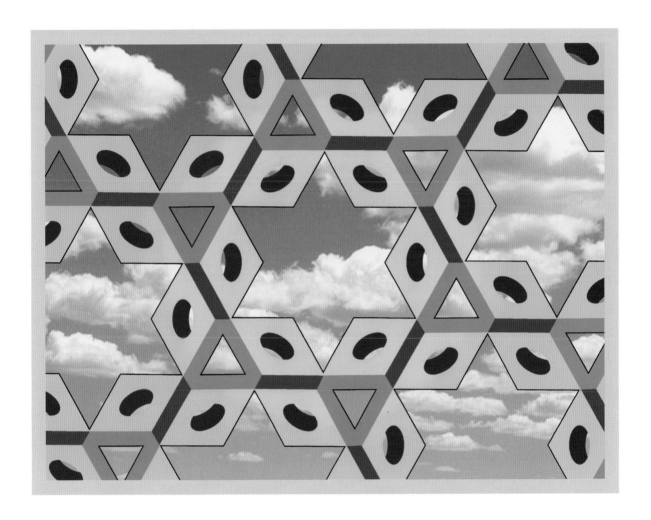

We are looking skyward at this impossible latticework.

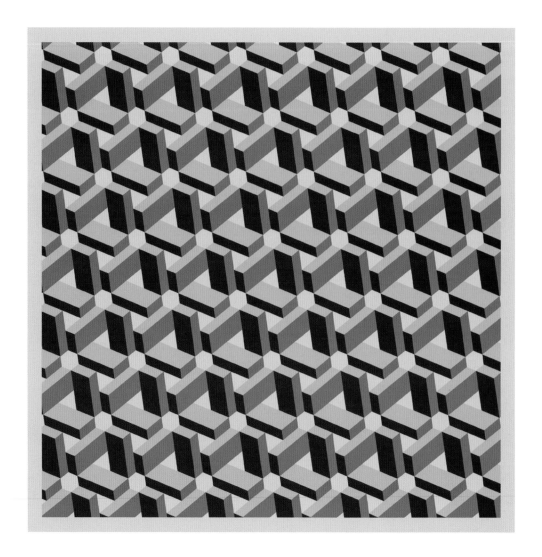

How many impossible triangles do you see in this impossible arrangement of bricks?

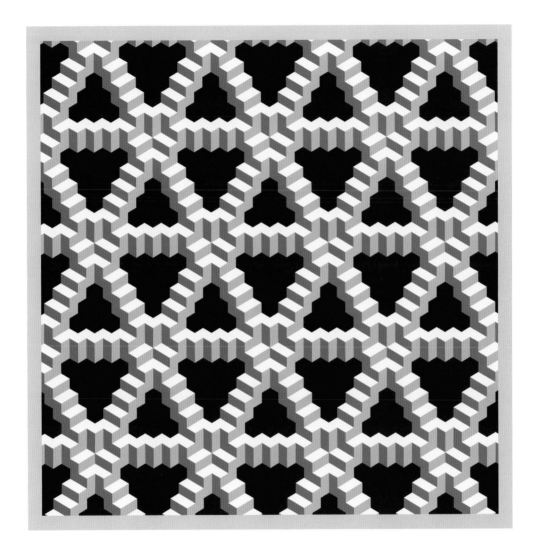

This impossible structure at first seems like simple latticework, but look closer and you'll see staircases leading up and away from you.

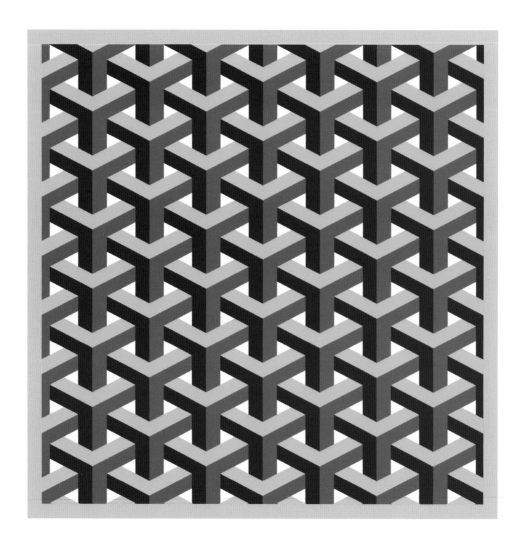

Does this pattern make any sense? Look closer.

Can you make a model of this complicated interlocking of hexagons in 3-D?

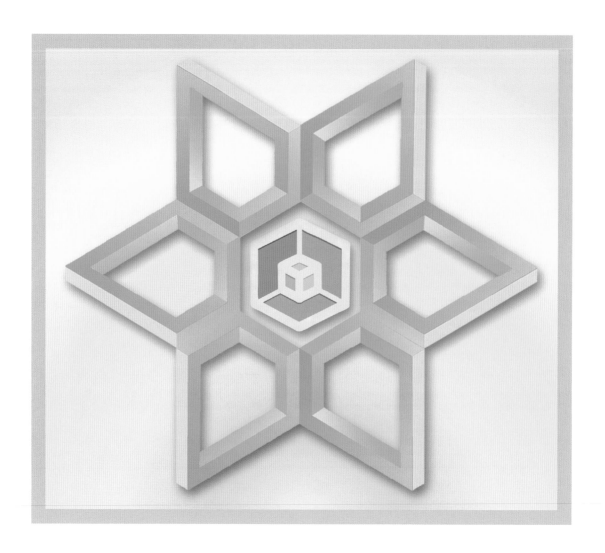

Here, the "petals" are impossible objects surrounding an ambiguous cube.

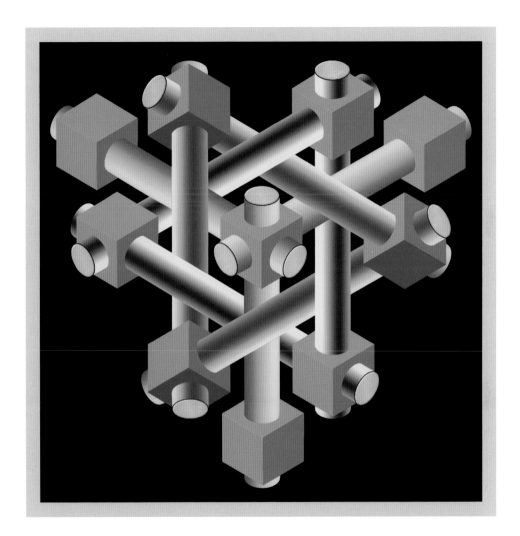

Two impossible triangles are tangled in a matrix of improbable angles.

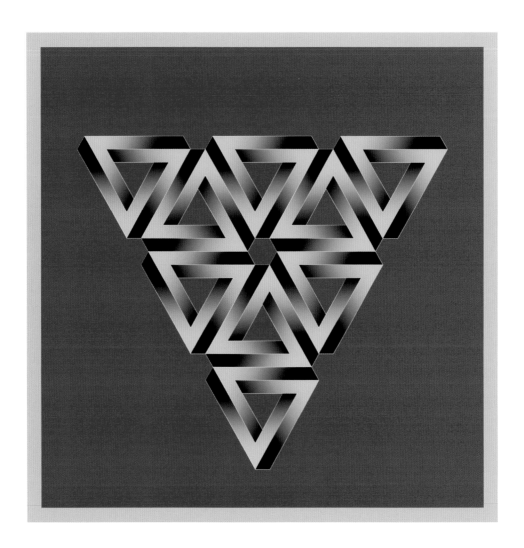

Check out this striking triangular arrangement of Penrose triangles.

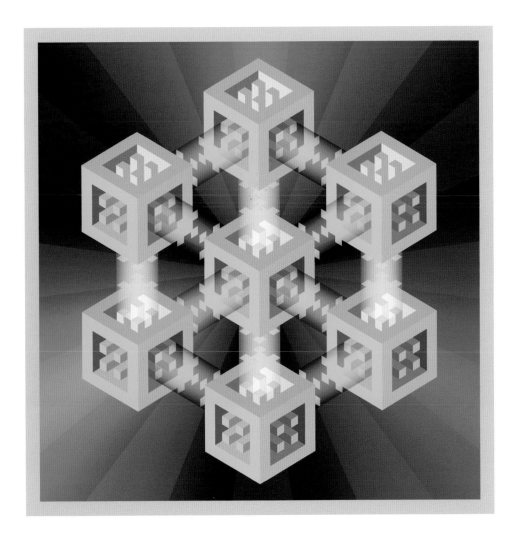

The cubic components of this unusual apparatus are emitting an impossible network of colored light.

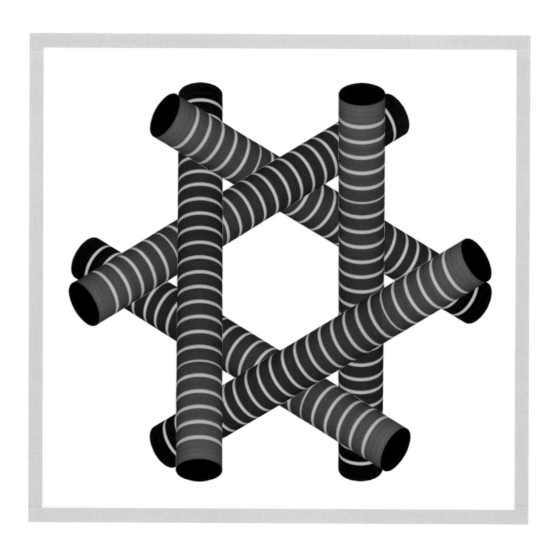

Here we see a curious design with six blue-and-gold interlocking batons. Is it possible?

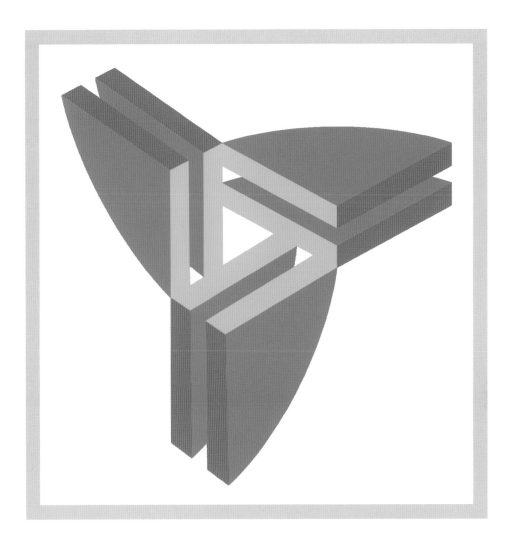

Don't try to build this model in your shop; the parts cannot be grouped in this way.

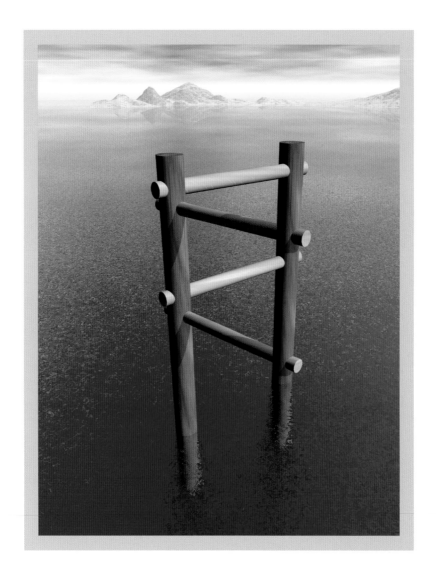

This lonely structure is a set of reasonable parts put together in an unreasonable way.

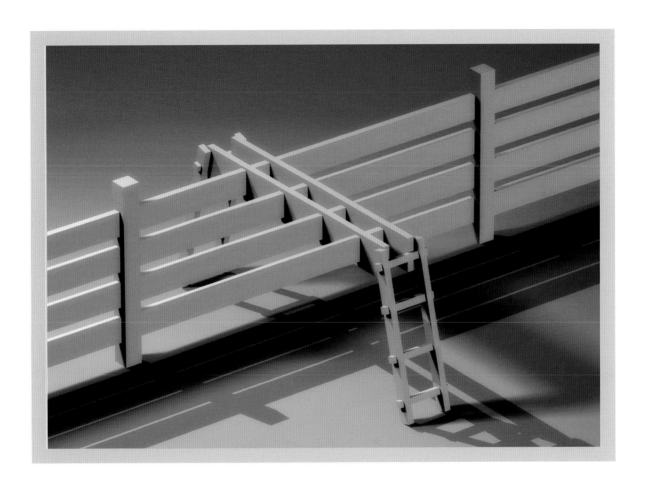

Del-Prete's Garden Fence, a striking and well-lit homage to
the work of the iconic Swiss artist Sandro Del-Prete.

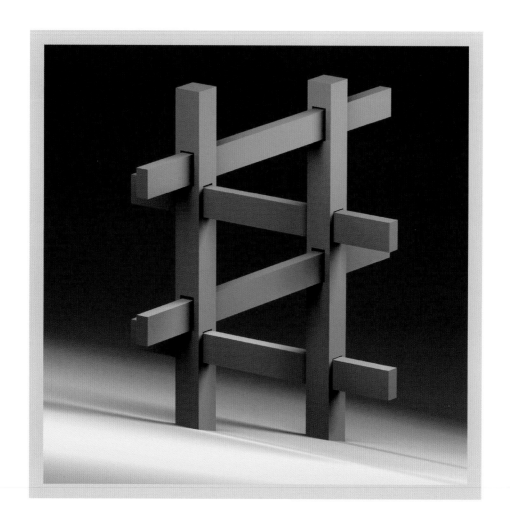

An impossible fence.

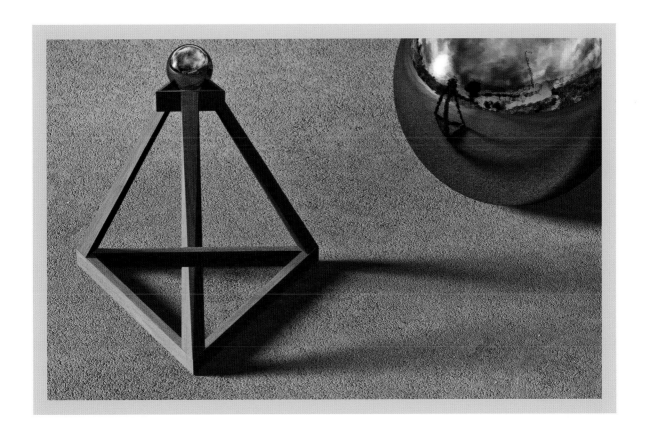

This impossible wooden pyramid looks possible in the reflection of the large metallic ball to the right.

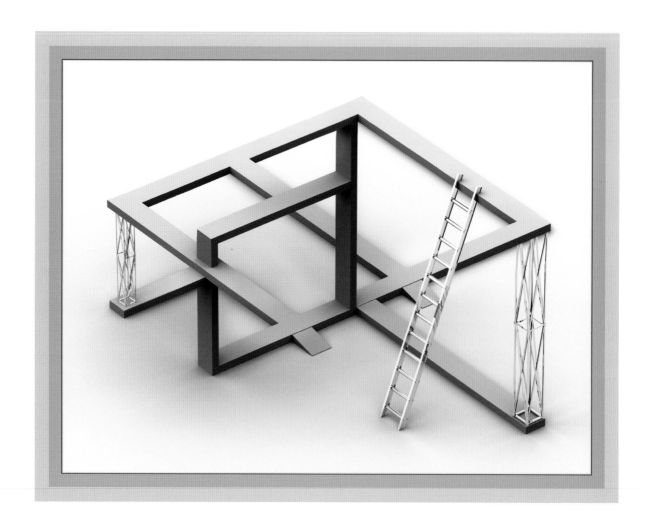

Many people do not immediately recognize the impossible aspects
of this structure until they are asked to take a second look.

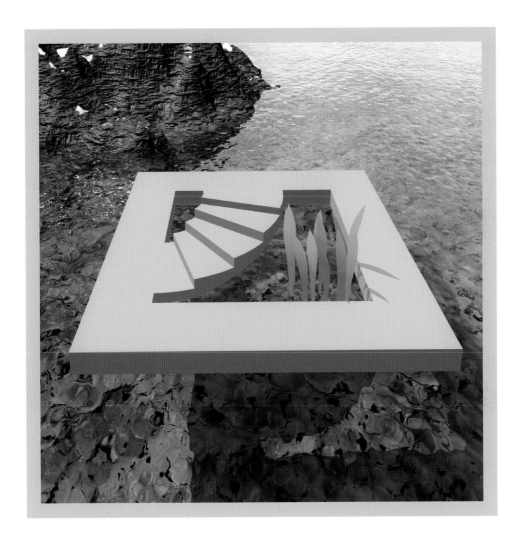

This diving platform is giving tourists a lot of trouble: the stairs lead up to the same level!

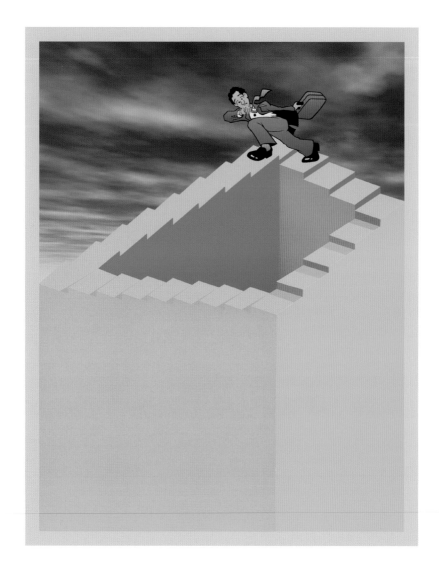

No matter how fast or how far you climb the executive
ladder, you'll find you've been there before.

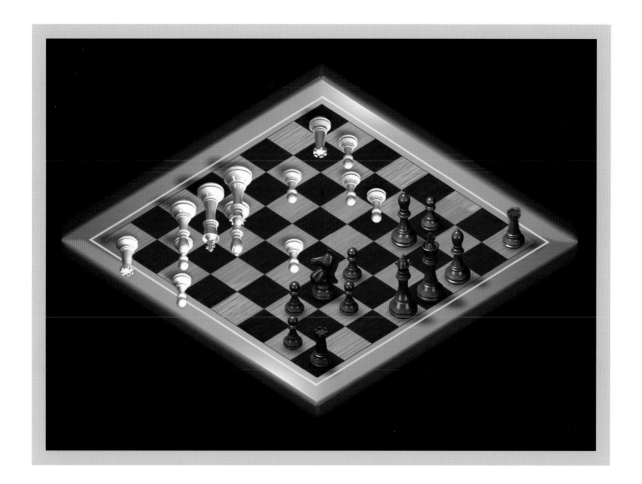

This chessboard has trouble deciding whether it is right-side up or upside-down, since both the top and bottom corners of the chessboard appear to be in the foreground. It is quite impossible.

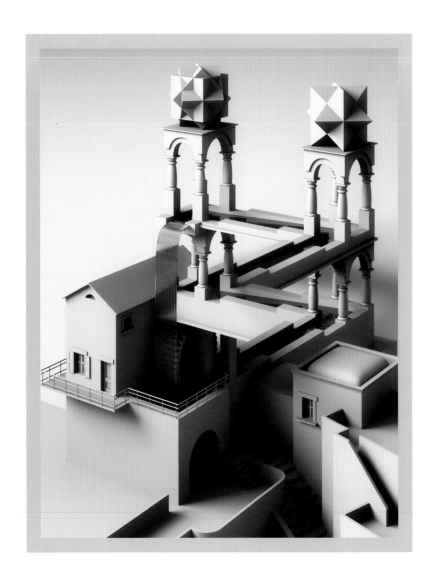

A digital rendition of M. C. Escher's classic lithograph, *Waterfall*.

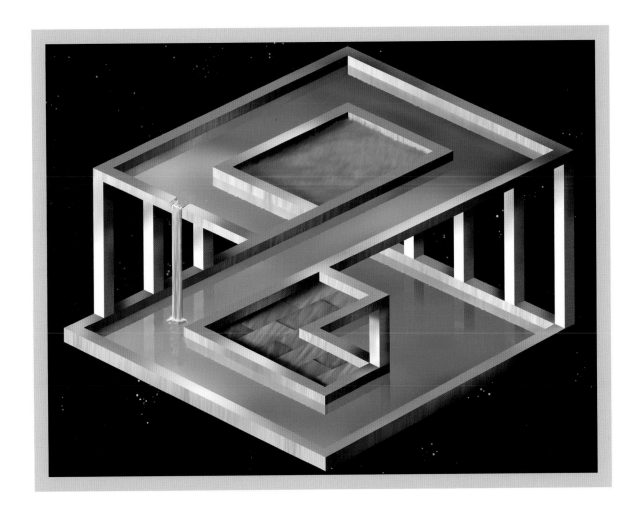

This water feature is clearly from another dimension.

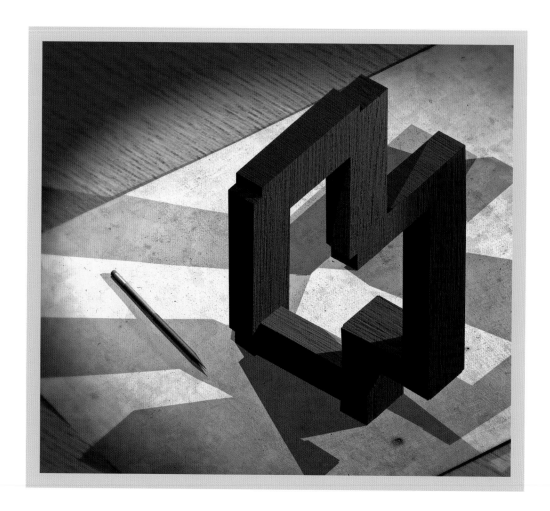

This wooden model may be possible to draw, but recreating it in 3-D would be surely impossible.

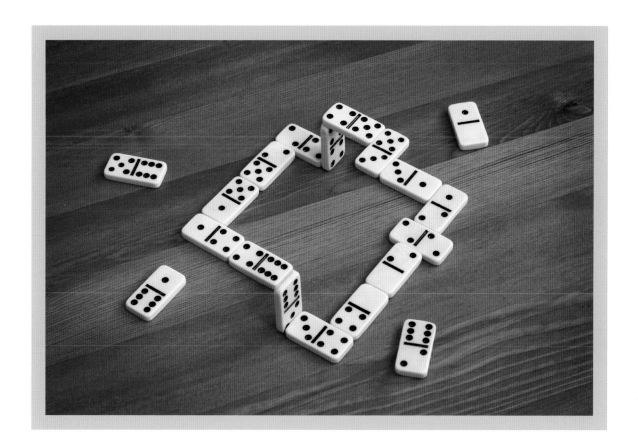

Something about this arrangement of dominoes doesn't make sense.

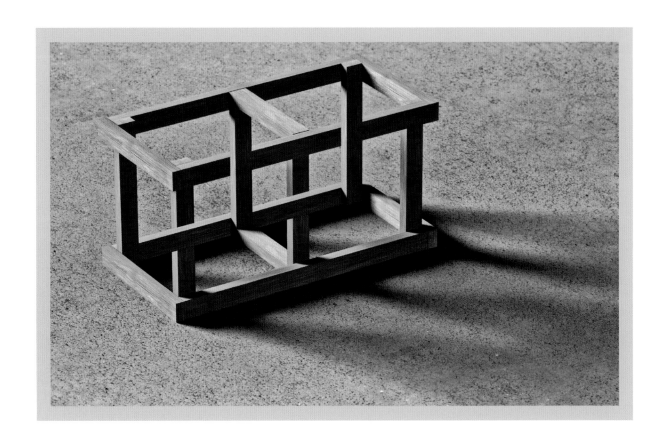

An impossible crate.

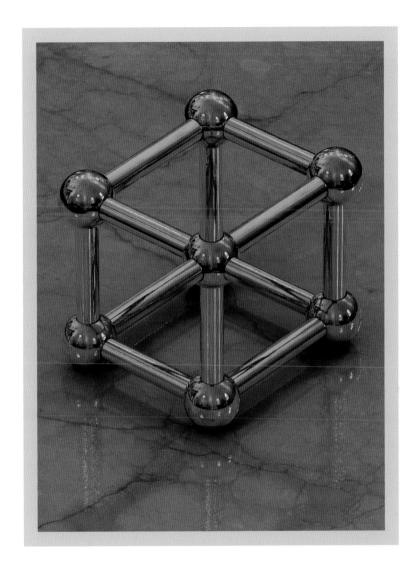

This beautifully rendered, impossible metal cube looks like
a real 3-D object—until you examine the middle of it.

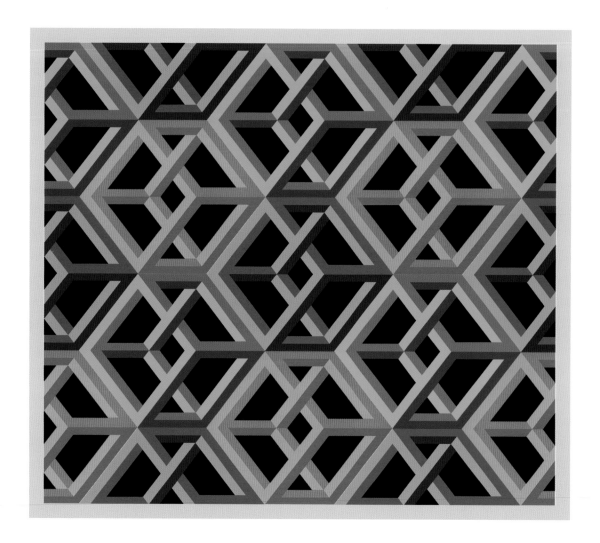

This colorful matrix of impossible cubes is arranged in an impossible way.

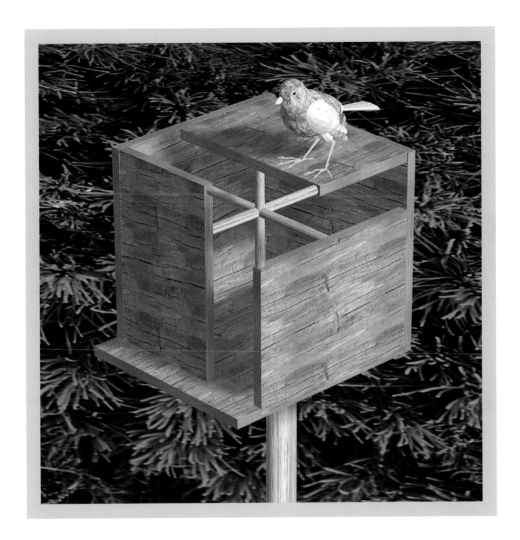

A bird has found a new birdhouse but is totally confused by the architecture. Can you tell why?

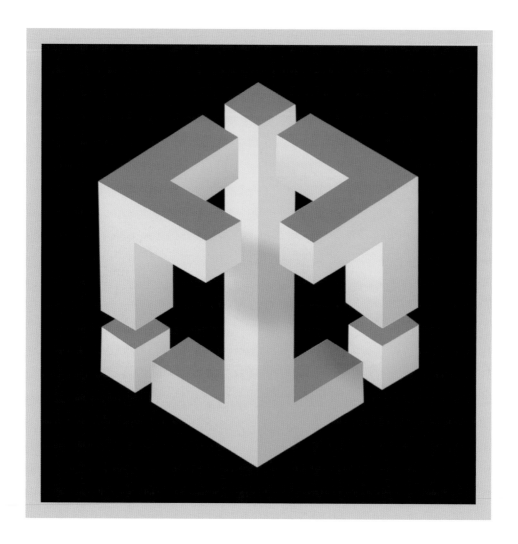

This geometric object has a rather obvious impossibility.

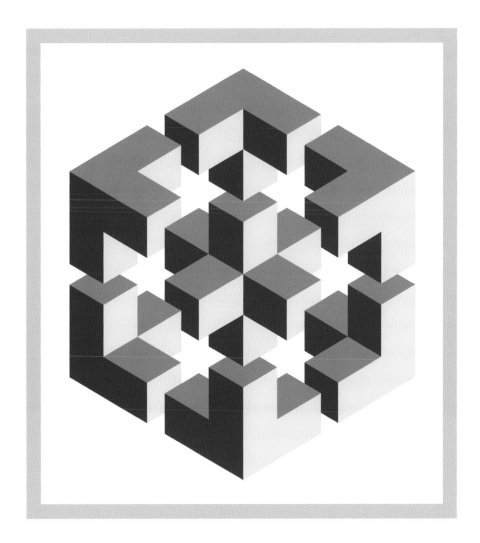

Can this assembly of blocks exist in the real world? Look closely.

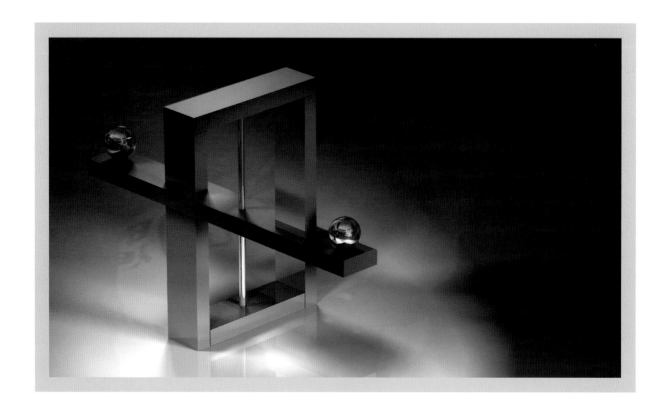

This construction is more than a little unbalanced.

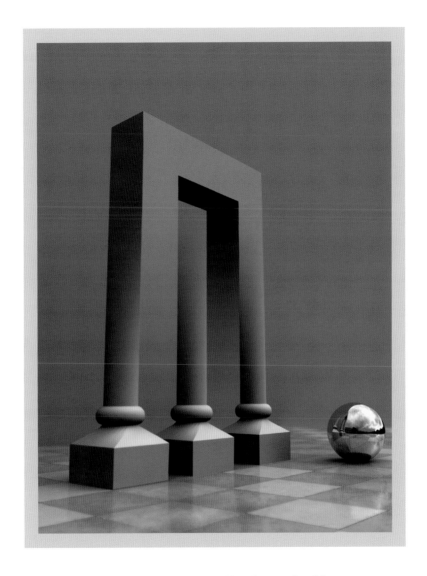

Does this illustration, inspired by the work of American
artist Walter Wick, contain two or three columns?

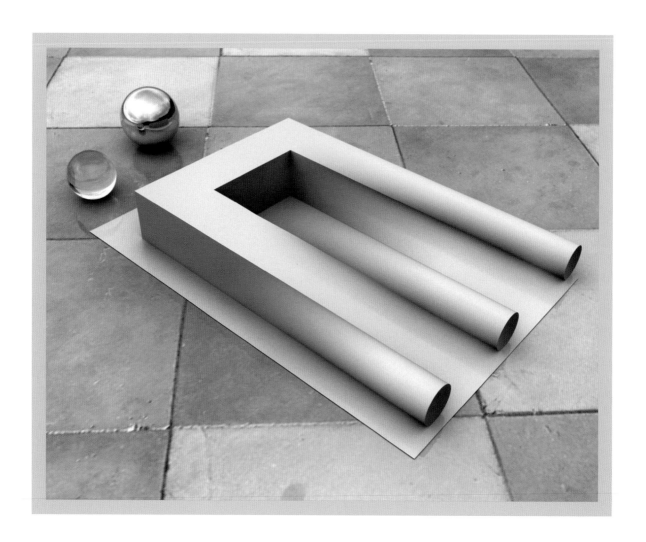

The Devil's Fork.

Polygonal Electrodynamometer
Final Assembly

0.633 ft

Trichotometric
Indicator Support

Ambihelical
Hexnuts
(3.1416 req)

10.16 cm

Rectabular
Extrusion Bracket

This tongue-in-cheek technical diagram contains a devil's fork,
three impossible rings, and an impossible rectangle. See them?

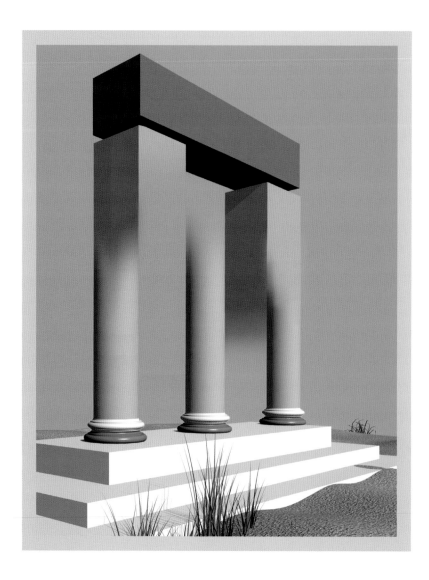

This illusion shares elements with *The Devil's Fork* or *Impossible Trident*.
Square and round columns share contours, and the controversy confuses the eye.
Does the structure have two or three columns?

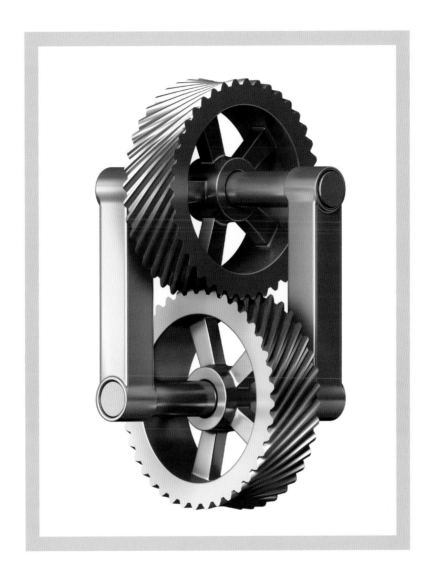

Is this arrangement of gears feasible in the real world?

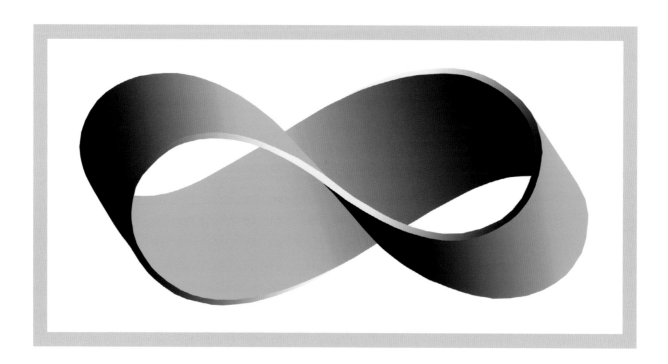

Follow any surface of the Möbius strip and you will traverse the
entire object, just as you would with an impossible triangle.

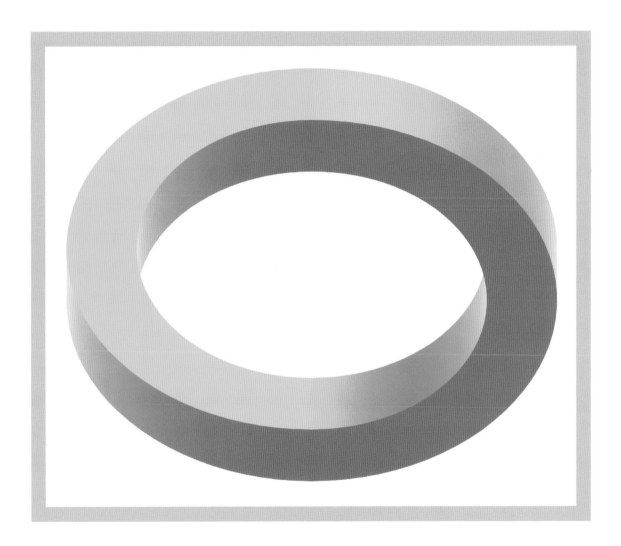

Were it not for the half-twist—exhibited by many impossible objects—
this impossible ring would be an ordinary ring. On the other hand, a full
twist would be too much, turning it into a pretzel. Try to imagine it.

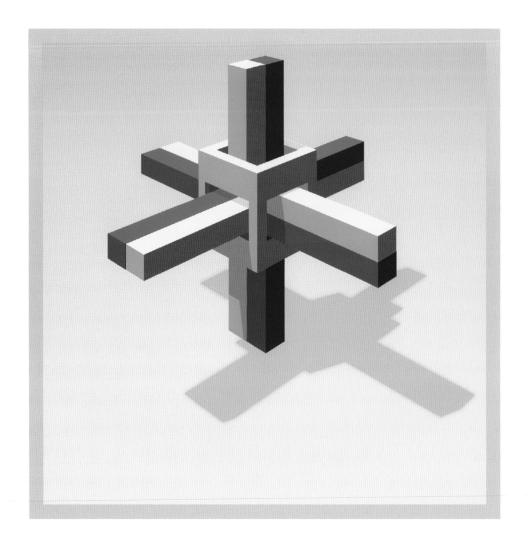

This design hovers on the edge of impossibility. If the four sticks that pass through the central hub are continuous, then they must be twisted.

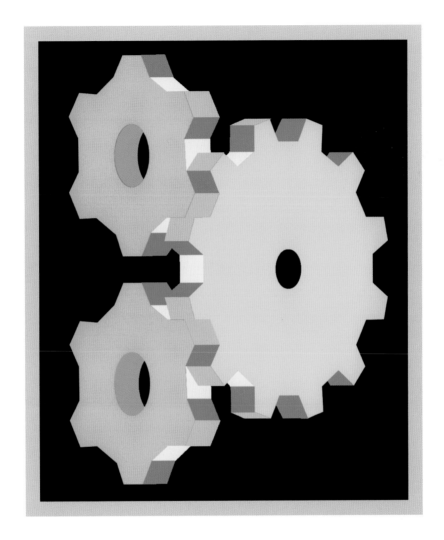

Three interlocking gears? The whole thing is a watchmaker's nightmare.

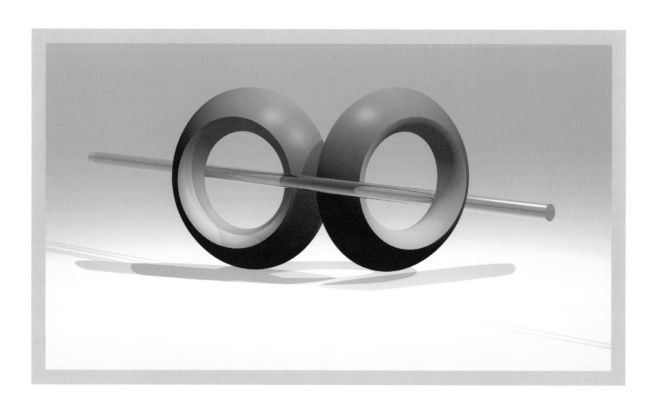

I once saw a trick pencil made out of rubber—this isn't one of those.
I drew a straight straw, but it looks bent!

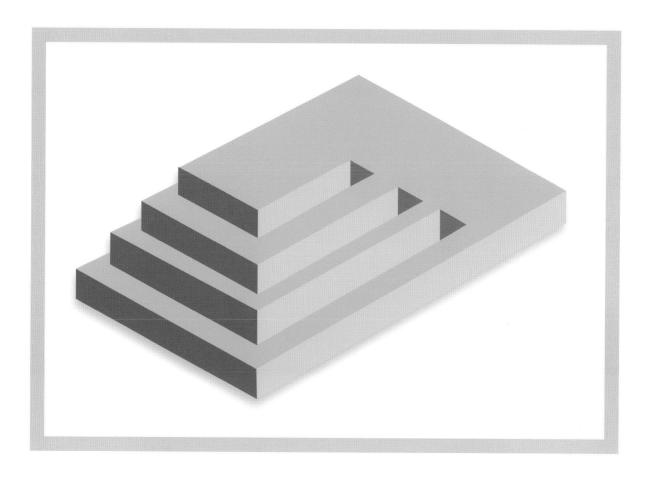

If you climb the staircase on the left side of the image, will you reach the next level?

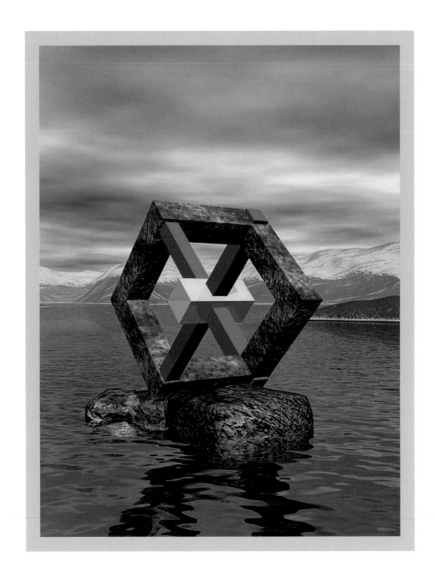

Can this odd-looking water sculpture truly exist in our world?

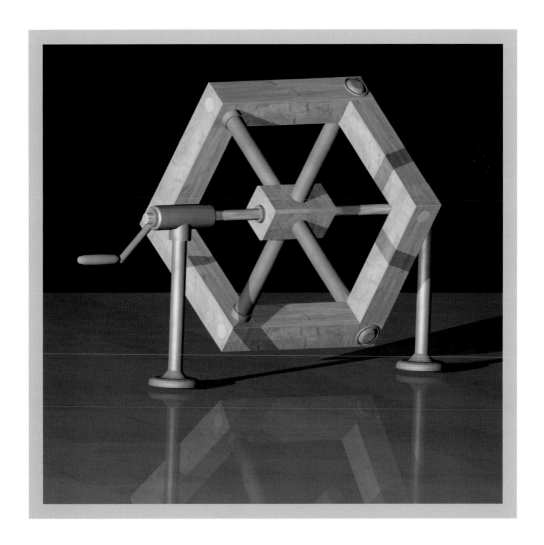

An homage to Sandro Del-Prete's classic drawing, *Quadrature of the Wheel*.
You'll get no work from this gizmo.

MOTION
ILLUSIONS

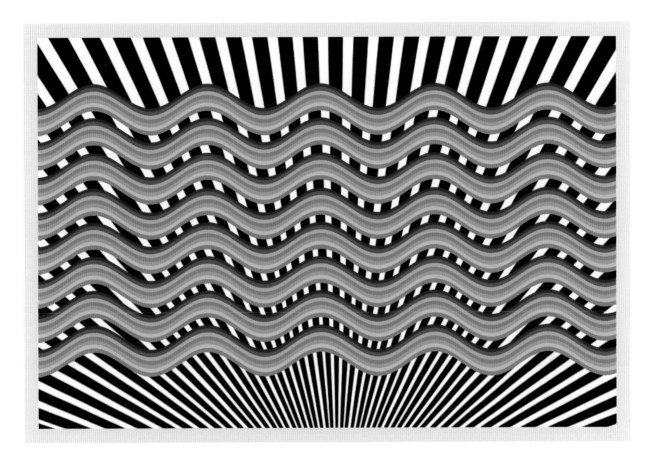

The wavy water designs seem to have debris floating in them,
as afterimage shadows appear willy-nilly along their lengths.

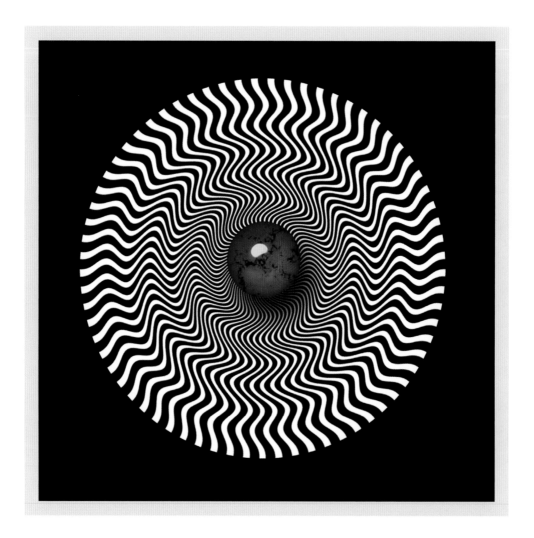

Everything in this design is 2-D. Nevertheless, the wheel appears to have 3-D ripples radiating out from its center. No matter how you rotate the design, the humps and hollows of the ripples remain.

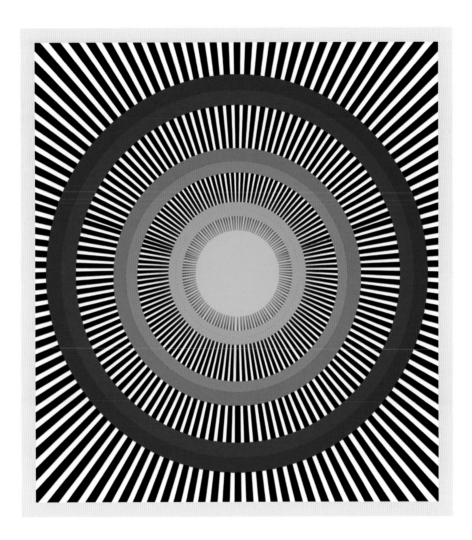

Bright colors and high-contrast patterns cause this design to come alive with flashing afterimage illusions. Keep your eyes moving across the image, and you will see shadows race around the circular forms.

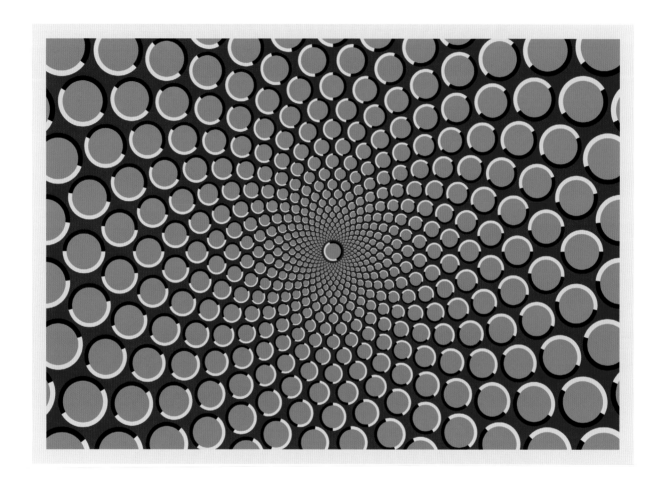

Move your eyes around this image. Does it appear to rotate? In which direction does it rotate?

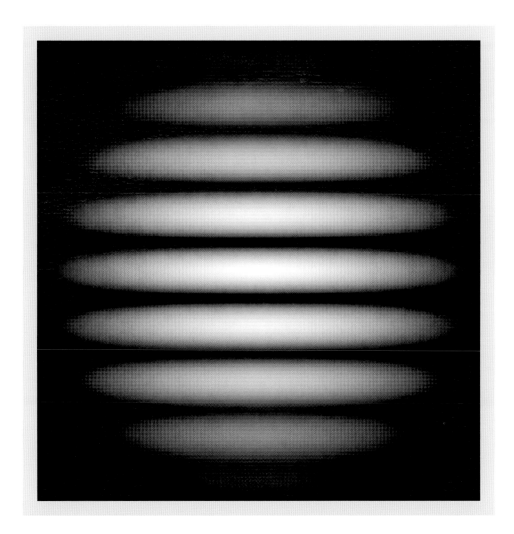

Look at the middle of the image and notice how the outer edges seem to shrink and fade inward.

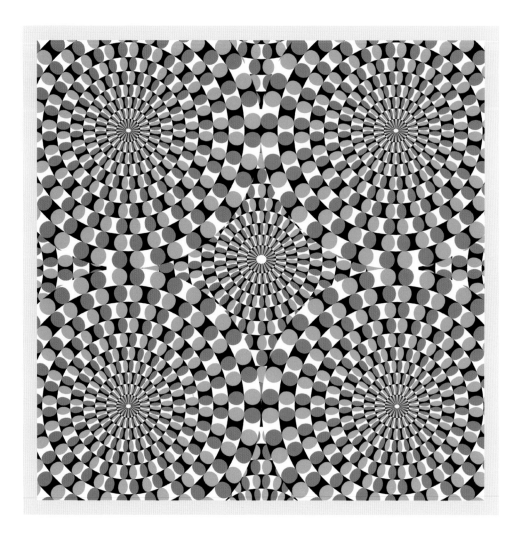

This is an adaptation of Japanese professor Akiyoshi Kitaoka's *Rotating Snake* illusion.
Move your eyes around this image, as you did with the image on page 270.
Are all the circles rotating in the same direction?

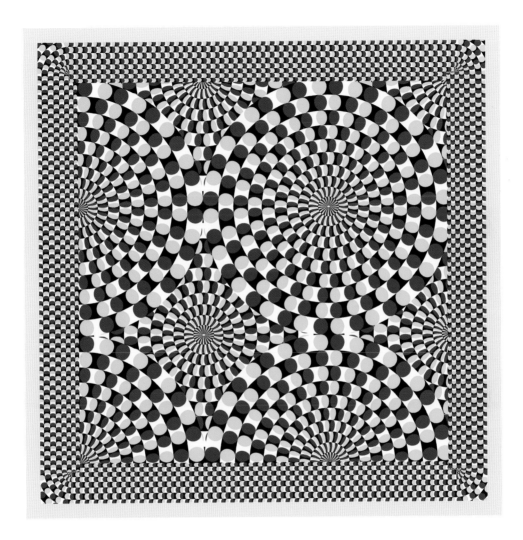

Which way do the circles spin when you move your eyes back and forth across the image?
Do you detect any movement along the periphery?

YOU WILL BUY THIS BOOK
YOU WILL BUY THIS BOOK
YOU WILL BUY THIS BOOK
YOU WILL BUY THIS BOOK
YOU WILL BUY THIS BOOK
YOU WILL BUY THIS BOOK
YOU WILL BUY THIS BOOK
YOU WILL BUY THIS BOOK
YOU WILL BUY THIS BOOK
YOU WILL BUY THIS BOOK
YOU WILL BUY THIS BOOK
YOU WILL BUY THIS BOOK

When you move your eyes back and forth across this subliminal
message, does it appear to ripple and undulate?

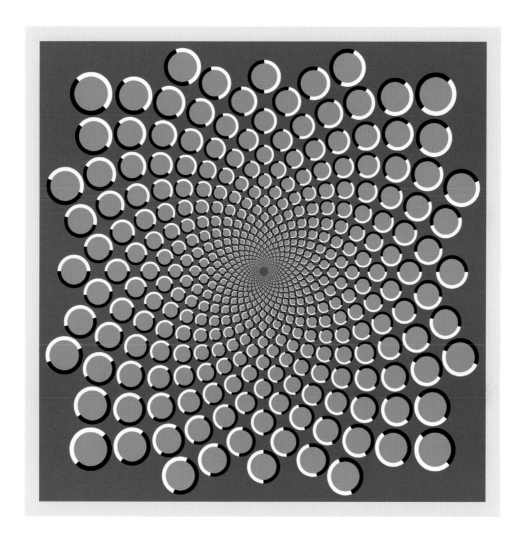

Which way does this geometric flower appear to rotate as you pan your eyes over it?

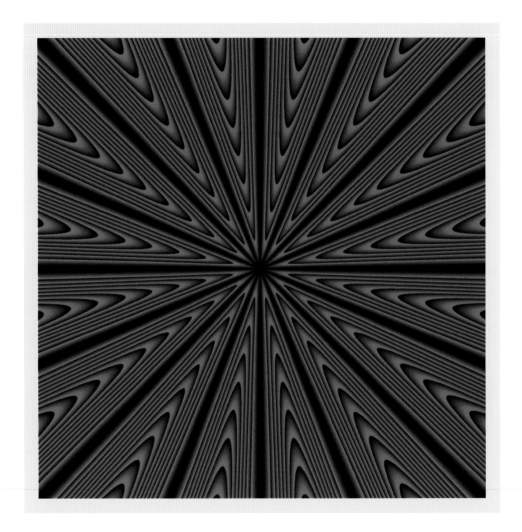

Does this image appear to vibrate as you stare at it? It's almost as if the black areas are sucking the red areas toward them, like a black hole!

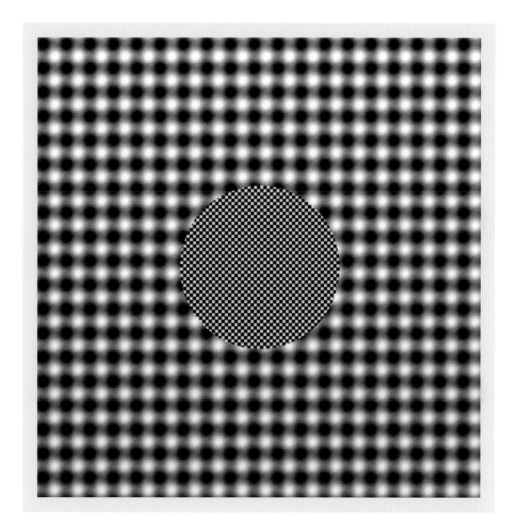

The black-and-white circle seems to hover, stationary, above the quivering, blurry background.

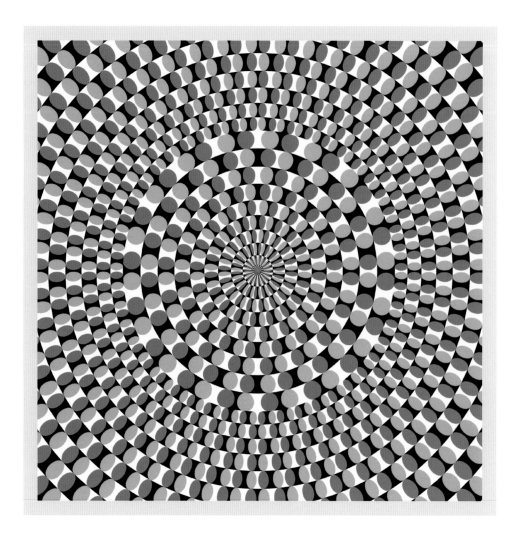

Do the central circle and surrounding background appear to rotate at different rates as you move your eyes around the image? In which direction do they rotate?

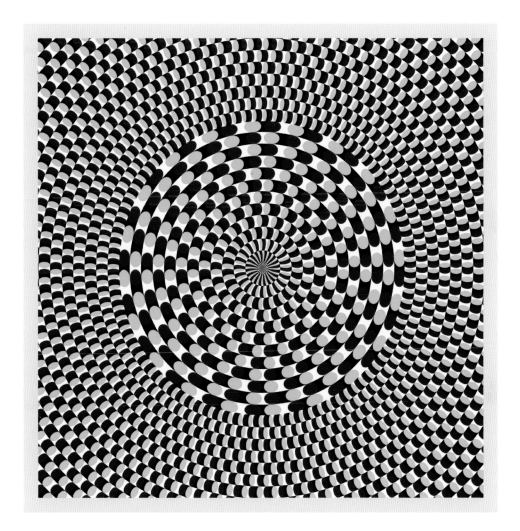

In this image, the central circle is much more pronounced.
Can you see illusory shadows spinning around it at high speeds?

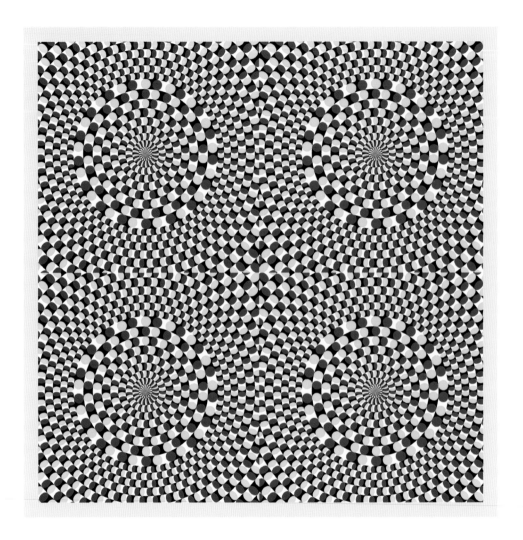

Here, we have four circles instead of one. Are they all rotating in the same direction?
You might also notice that each circle stops rotating when you look
directly at it, making the circles' rotation appear staggered.

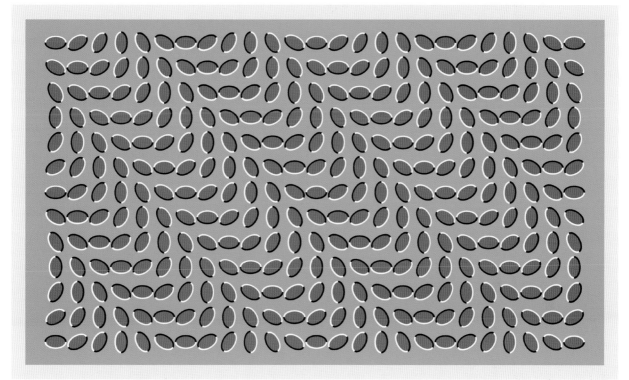

Gently shift your eyes back and forth as you stare at this image. Do you see waves of motion?

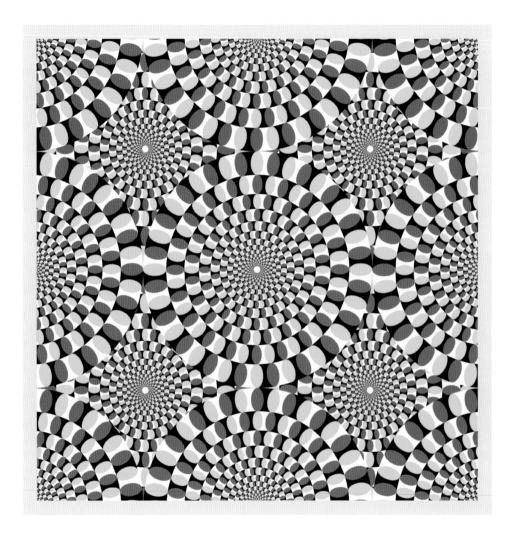

Another adaptation of Kitaoka's *Rotating Snakes*, this image displays a matrix of circles, with another layer of circles underneath. Are they all rotating in a counterclockwise direction?

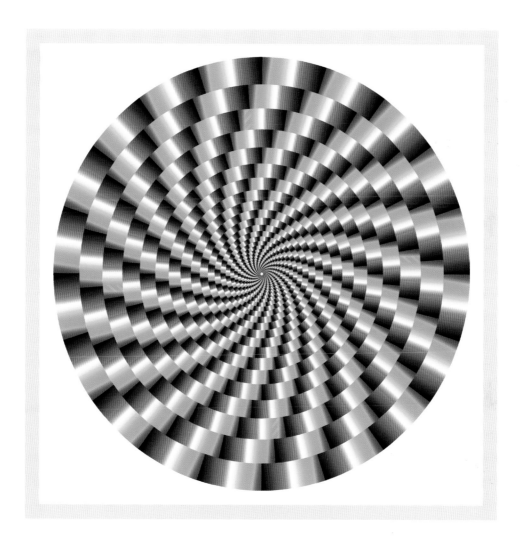

The smooth luminance transition through several hues of the rainbow gives this circle a vibrating appearance, but if you keep it in your peripheral vision, you will also notice a weak apparent rotation.

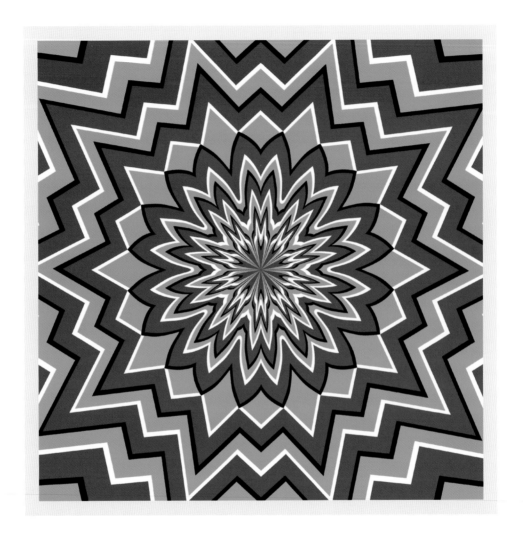

Stare at any corner of this jagged flower pattern and blink
your eyes. Is it moving toward you or away from you?

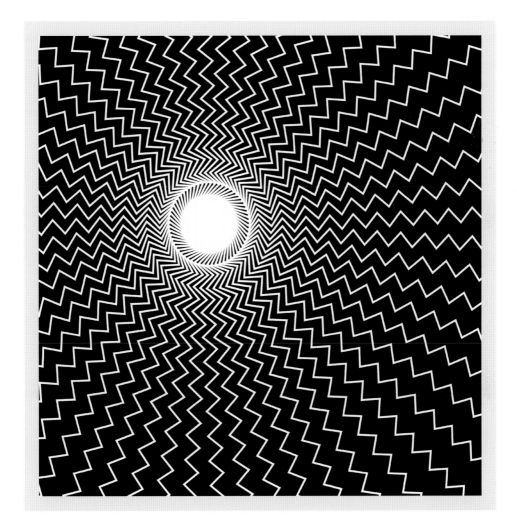

Do you notice ghostly shadows racing around the white circle at high speeds?

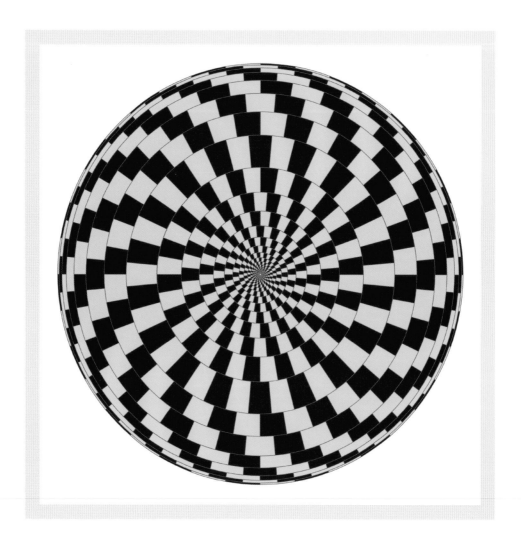

Move your head back and forth as you stare at this blue and yellow round pillow design.
Do the "spirals" (concentric circles, actually) appear to rotate?

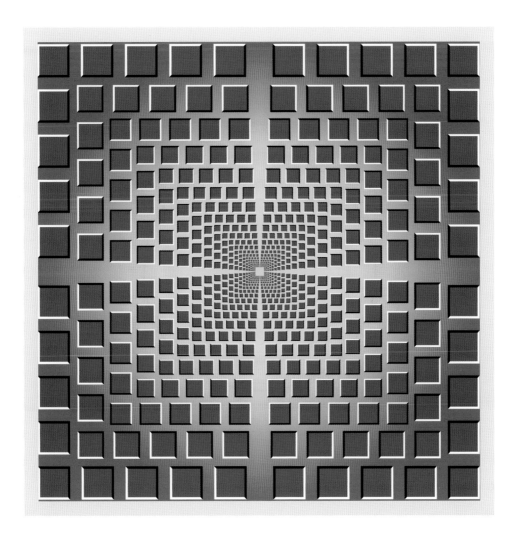

In this peripheral drift illusion, are the purple squares drifting toward you or away from you?

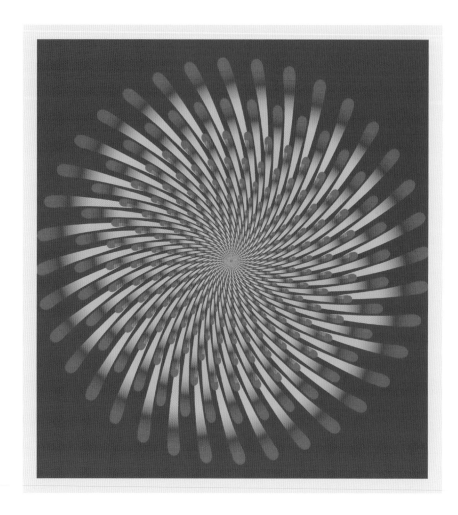

If you stare at this design and blink your eyes, you'll see exploding fireworks.
Notice how the fireworks explode with every blink.

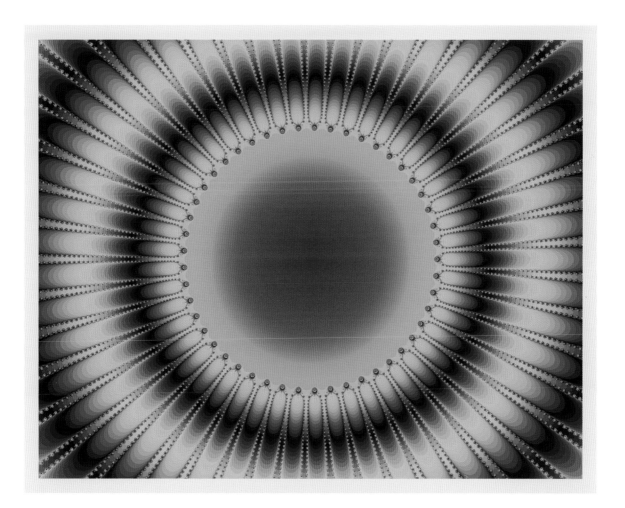

The vibrations in this psychedelic design occur when the afterimages of different colors compete with one another.

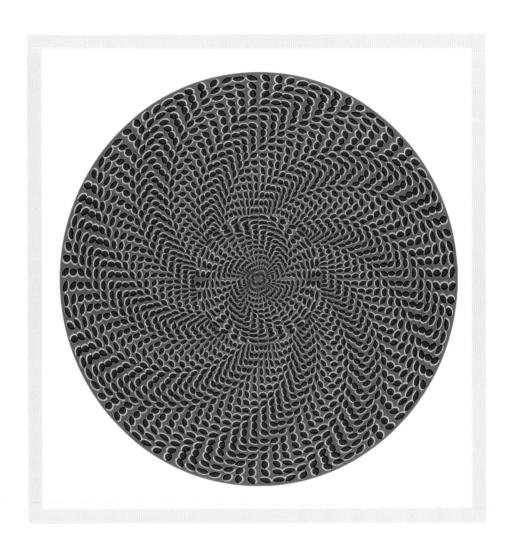

What happens as you move the circle toward you and away from you?

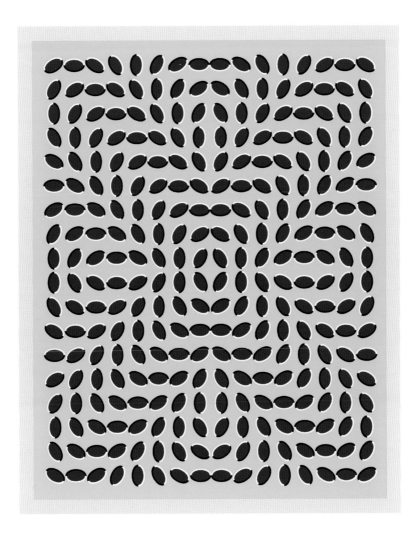

Shift your gaze around on this design, and watch it come alive!

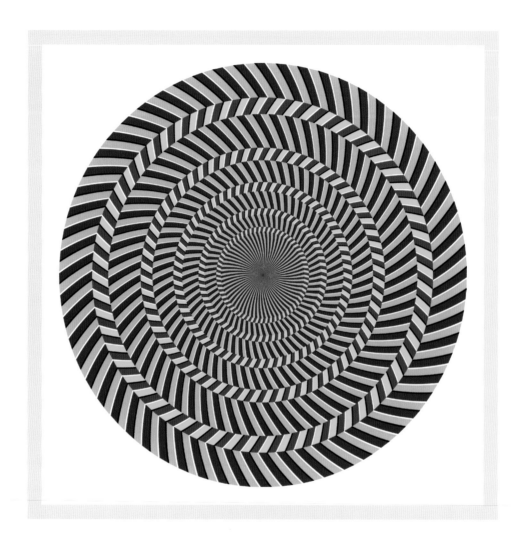

What happens to the concentric circles when you rotate this image?
Are they moving in the same direction or in opposite directions?

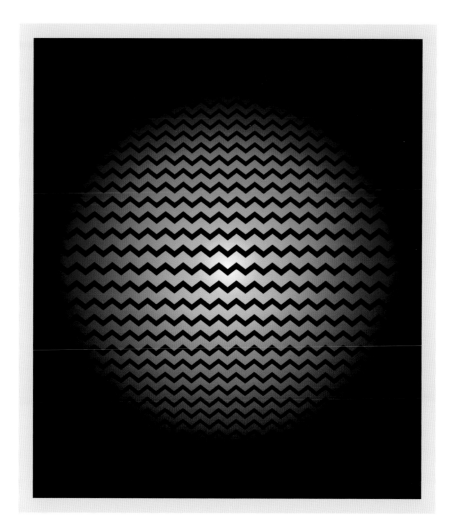

As you stare at the center of the image, the black surround appears to close in on it.

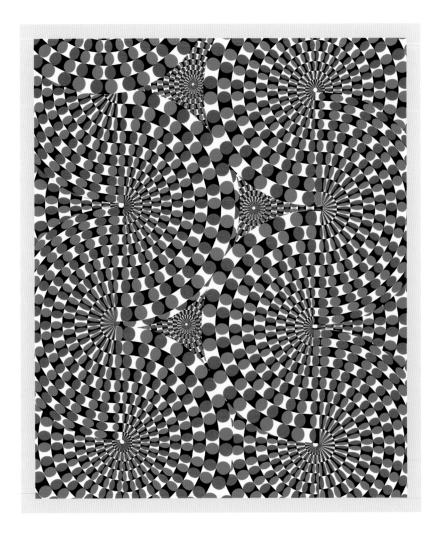

As you allow your eyes to dart from one place to the next,
you might see two snakes slither past one another.

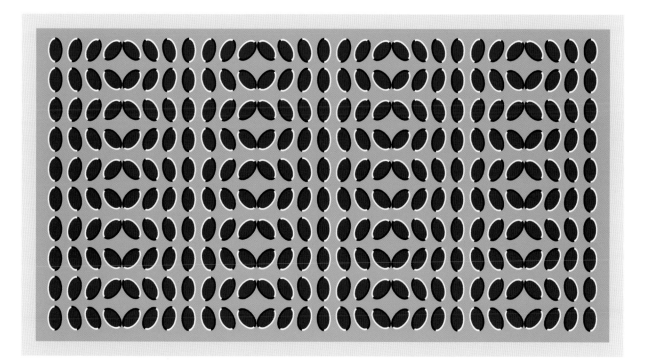

Slowly move your head back and forth, and watch four columns expand before your eyes.

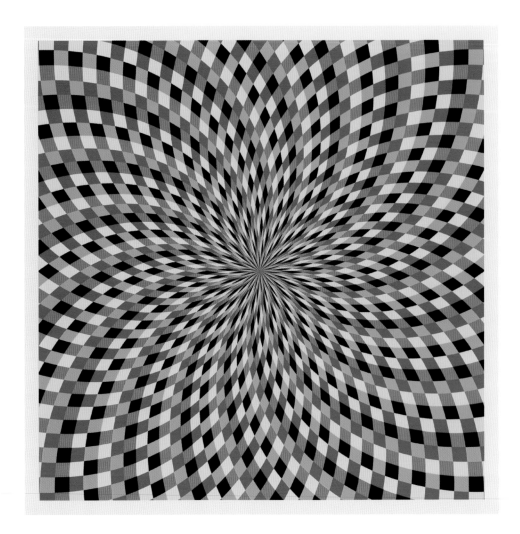

So many competing colors, so many competing afterimages! This design just won't sit still.

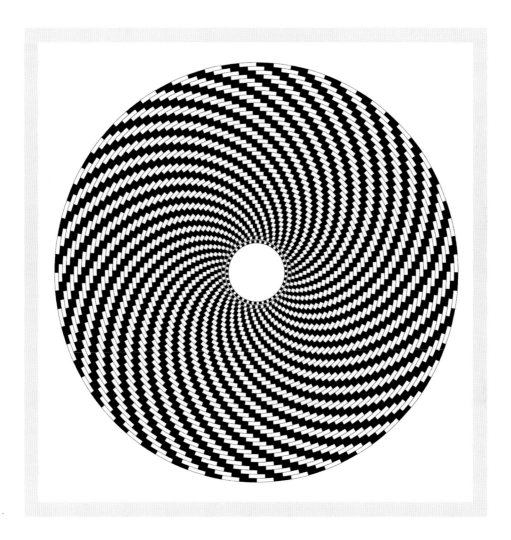

As you run your eyes over this circular design, can you make out any shimmering spirals? The high color contrast and tilting "café wall" effect combine to trick our perception—the spirals are an illusion.

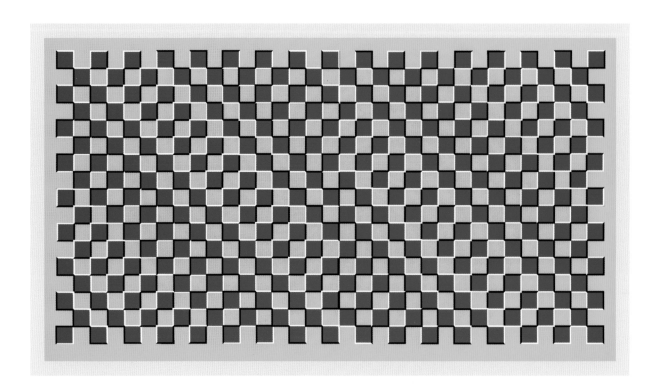

Watch this design undulate as you stare at it.

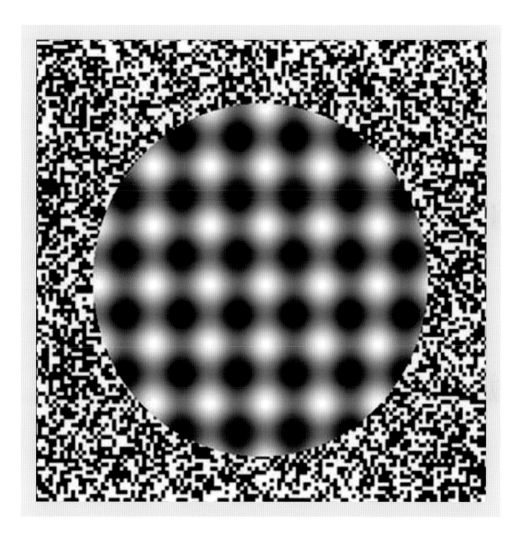

Stare at this design, and the central circle will become unstable.
The more you look, the more it wobbles.

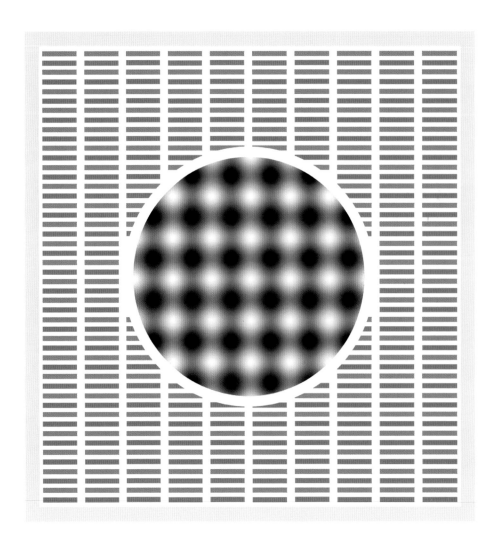

Chaos on top of order will usually produce instability.

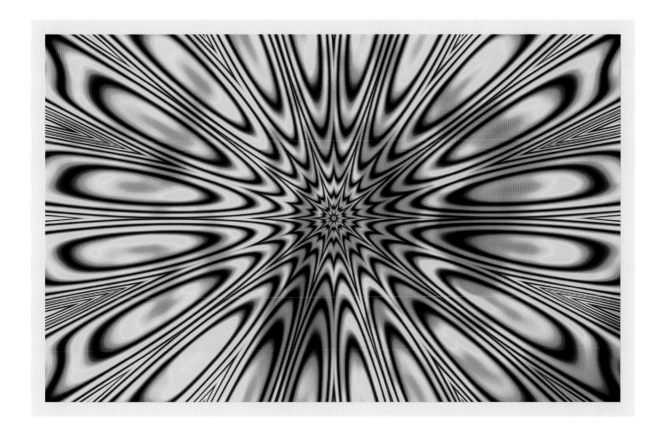

This psychedelic sunburst is anything but stable.

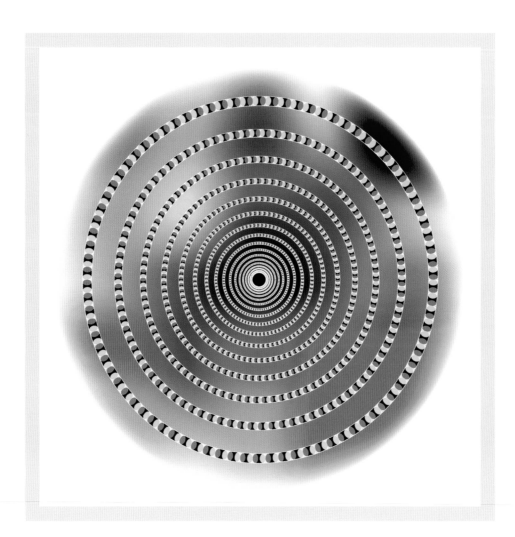

Move this image around in an erratic fashion. Which way are the concentric rings rotating?

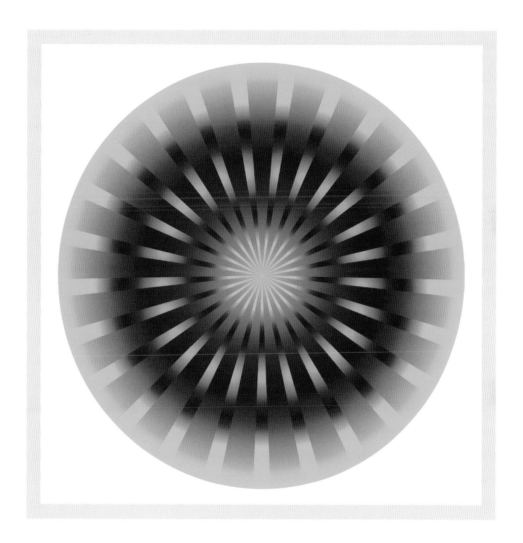

What happens to the purple rings as you move the circle toward you?

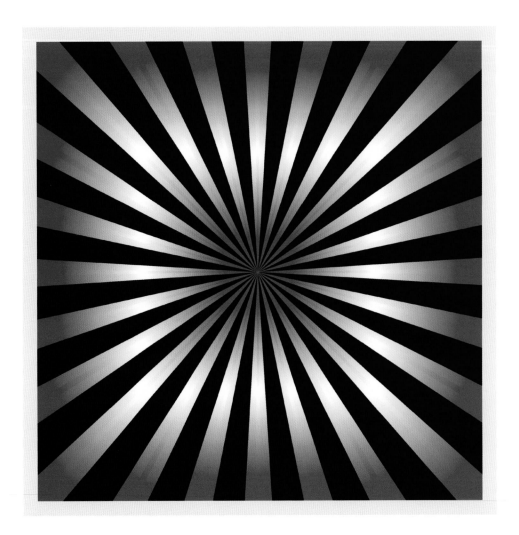

What happens to the white halo when you blink your eyes?

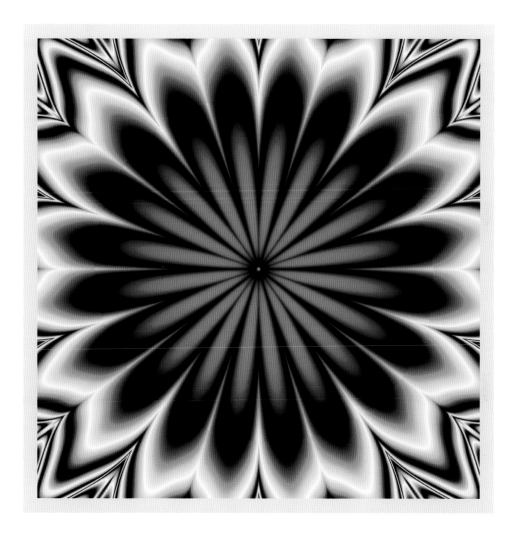

As you move this fiery flower toward you, do its petals expand or contract?

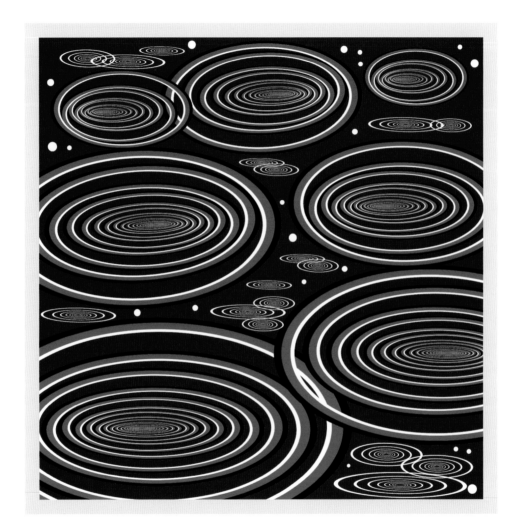

Watch these water ripples expand outward.

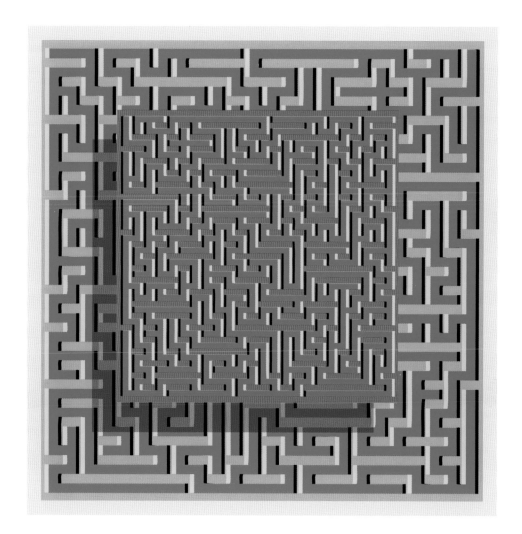

Check out this levitating maze.

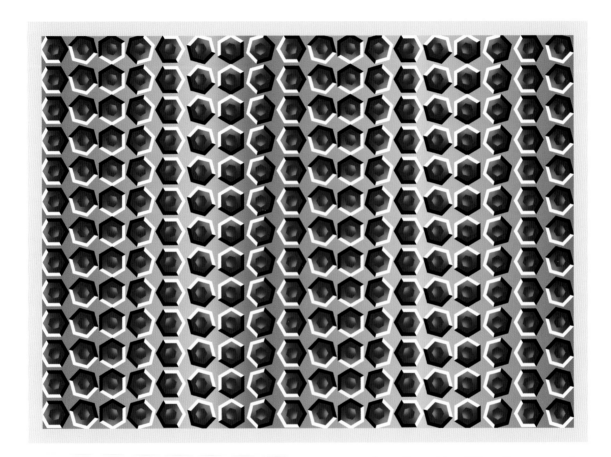

This rippling blue hex nut–patterned sheet metal is quite a sight!

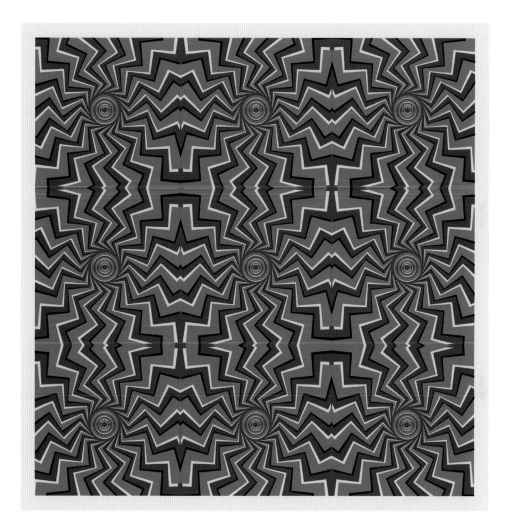

Which way are these tribal patterns rotating?

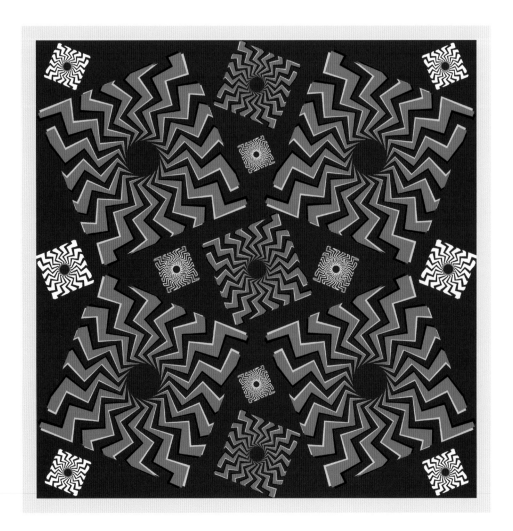

This network of jazzy orange squares just won't sit still!

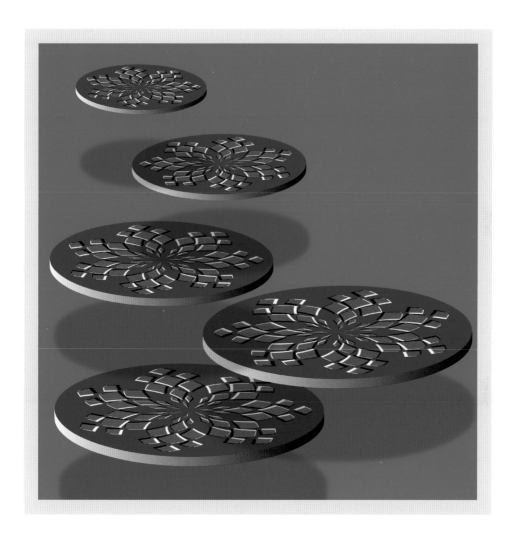

Which way are these floating drink coasters rotating?

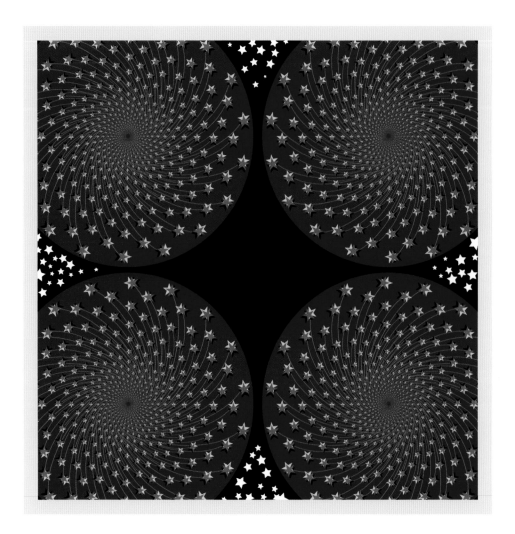

Are these starry wheels spinning clockwise or counterclockwise?

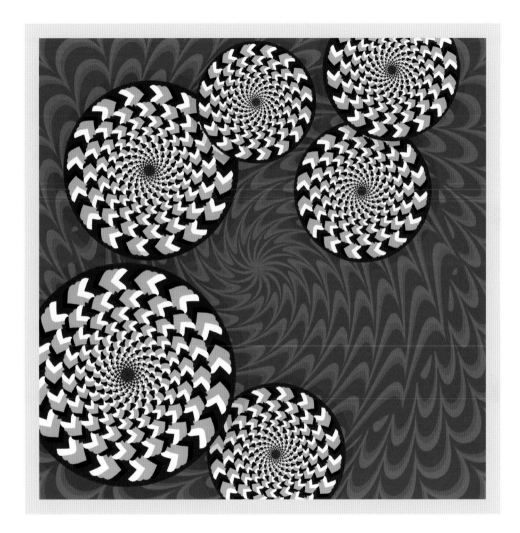

Ignore the psychedelic backdrop and try to figure out which way each of these whirling wheelies is rotating.

SOLUTIONS

Page 13:

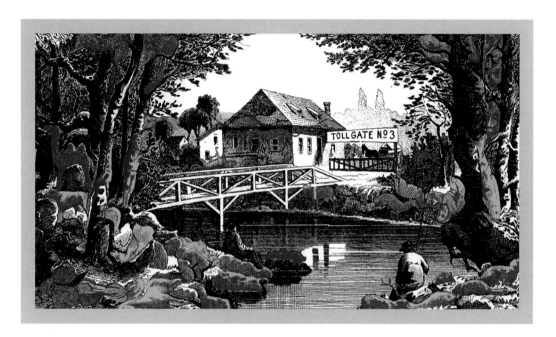

Page 28:

Are we not drawn onward, we few, drawn onward to new era?

Page 29:

You Won't Believe Your Eyes!

Page 30:

Love me Little Love me Long.

Page 31:

Because they steel their corsets, crib their babies, and hook one another's dresses.

Page 81:

From top to bottom: (1) yellow–pink, (2) violet–pink, (3) orange–blue, (4) white–white, (5), yellow–white.

Page 82:

Pink.

Page 149:

Page 194:

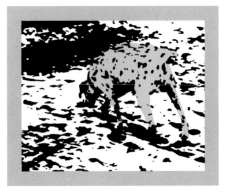

Page 196:

IMAGE CREDITS

© **Robert Ausbourne:** 26–29, 36–41, 45–51, 53, 57–59, 61, 63, 66–73, 76–78, 80–85, 87, 89–123, 132–136, 138–141, 143–150, 152–154, 158, 159, 163–168, 170, 172, 173, 183, 184, 186, 187, 189–191, 194–200, 203–212, 216, 217, 219, 223, 227–229, 232–234, 239–241, 249, 250, 255, 256, 258, 260–265, 267–269, 271, 274, 277, 298–300, 315

© **Tony Azevedo:** iv, 34, 79, 151, 215

© **Chuck Brittenham:** 175

© **Rusty Rust:** 176–181

Shutterstock: © Arkela: 308; © CVADRAT: 124; © diskoVisnja: 54, 55; © Excentro: 162; © Paul Fleet: 243; © Mark Grenier: 306, 307, 309–313; © Patrick Hoff: 244; © jkerrigan: 225; © Silvia Popa: 125; © Skripnichenko Tatiana: 230; © Alexey V Smirnov: 245; © VectoriX: 214; © Robert Voight: 231; © XYZ: 242

© **Josh Sommers:** 192, 193, 218, 235–238, 246, 247, 252–254

Thinkstock: © Aerial3: 293; © Alisa Astrouskaya: 171; © aroas: 272, 273, 278–280, 290, 294; © Atypeek: 281, 291, 295; © Michael Boubin: 301, 305; © Derya Celik: 304; © cepera: 127, 161; © Cienpies Design: 297; © Openko Dmytro: 251; © emuemu: 160; © eriksvoboda: 157; © Paul Fleet: 213; © Remy Gerega: 74; © Mark Grenier: 156, 285; © Andrei Gurov: 302; © Panisa Jantanaseweedol: 56; © Attila Kis: 130, 131; © Valerijs Kostins: 62, 129, 224, 283, 284, 286–288, 292; © Wolfgang Kraus: 75; © Yuri Kuzmin: 42, 43; © Danielle Looye: 60; © Yang Mingqi: 259; © miissa: 296; © Elena Mostovshchikova: 126; © olexius: 220, 248; © Rahesh Patil: 65; © Stacey lynn Payne: 289; © Rogotanie: 201; © Veronika Rumko: 64, 303; © Antony Sald8: 188; © Suljo: 226; © sverdlychenko: 222; © tashechka: 282; © Calin Trifan-pop: 169; © Adrian Vamanu: 137; © VectorWerk: 221; © zhev: 257

Courtesy Wikimedia Foundation: © Jean-Christophe Benoist: 25; © Berserkerus: 276; © Dodek: 52; © Fiestoforo: 270, 275; © Kerrmann c: 155; © Sailko: 19; University of Toronto Wenceslaus Hollar Digital Collection: 12; 8, 15, 16, 20, 21, 23, 32, 33, 35, 86, 128